Observation: Notation

edited by David Cast

Observation: Notation

Selected Writings of Andrew Forge

1955–2002

CRITERION BOOKS

NEW YORK

First American edition published in 2018 by Criterion Books,
an imprint of Encounter Books, an activity of Encounter for
Culture and Education, Inc., a nonprofit, tax-exempt corporation.
www.newcriterion.com/books

LIBRARY OF CONGRESS CATALOGING-IN-PUBLICATION DATA

Names: Forge, Andrew, author. | Cast, David, 1942– editor.
Title: Observation : notation : selected writings of Andrew Forge,
1955–2002 / edited by David Cast.
Description: First American edition. | New York : Criterion Books, 2018. |
Includes bibliographical references.
Identifiers: ISBN 2018006441 | ISBN 9780985905262 (pbk. : alk. paper)
Subjects: LCSH: Art.
Classification: LCC N7445.2 .F67 2018 | DDC 700—dc23
LC record available at https://lccn.loc.gov/2018006441

Contents

Introduction

ANDREW FORGE was a painter and a teacher of painting, known and respected on both sides of the Atlantic, first in London at the Slade School of Fine Arts and at Goldsmiths' College, then at Reading University, and later in the United States at Yale University, Cooper Union, and the Studio School of Drawing, Painting and Sculpture in New York. And it was painting as a formal language and an intellectual enterprise that remained always the passion and focus of his endeavors, amidst all else that he did in his life. But he was also a critic whose writings, spanning almost fifty years, were remarkable not only for the range of their subjects but also for the delicacy and openness of the language he invoked to confront the processes of perception in all their sensual possibilities. Criticism, as Clement Greenberg could note, is a difficult, even unrewarding task, or perhaps, as Forge himself once said, "little more than watching the clouds that pass." But in his hands, such writing became a deeply rewarding way for Forge to examine how artists, whether in the past or the present, engaged all the possibilities within perception and set down these possibilities in the language of the visual arts. And thus, even before those moments in the early 1970s when the role of criticism itself was questioned, as Max Kozloff put it, as being merely a form of exalted public relations for merchandising to the rich and powerful, Forge was invested in a language of personal interpretation that, freed from such pressures, could and would stand the test of time. His writing was also, if more modestly, a record of the philosophical engagement

we can have with what is to be seen in the world and how, as he put it, what we see might be commented upon and transformed within the complexities of drawing. Hence the title of this selection of his writings, taken from the similar title of an exhibition he organized in 2000 at the New York Studio School, observation standing as the record of our perceptions, notation the record of what we then do to describe and define those perceptions.

Andrew Forge was born in 1923 in Hastingleigh, Kent, a village some ten miles south of Canterbury, on a farm that had been recently acquired by his family. His father had been wounded in the battles of the Marne and the Somme, and, by Forge's account, he never fully recovered psychologically from the horrors of that time. It was his mother who first introduced him to the pleasures of painting, showing him, as he recalled, the magic of the figure–field relationship by darkening the background in a picture he was doing of a toadstool. But it was at his first school, the Downs, near Malvern in Hertfordshire, that he received a firmer introduction in art from a teacher, Maurice Feild, a graduate of the Slade School. Teaching there also was W. H. Auden. And it was from Auden's wider circle of contacts that Forge, together with other pupils at the school, Patrick George, Anthony Fry, and Christopher Pinsent, his friends for life, came in contact with a number of distinguished visitors, among them Louis MacNeice, Stephen Spender, Benjamin Britten, and, above all, William Coldstream, who in 1937 had arrived to paint a portrait of Auden. It was through this connection with Auden that during the school holidays he was invited by Coldstream to visit the life class at the studios of the Euston Road Group, nearly fainting, as he put it, at his first sight of a naked woman. Coldstream had another memory of the moment: that Forge was a tall boy, twelve years old, with a prodigious knowledge of the history of art.

The coming of the war in 1939 changed everything for Forge since he was taken out of school after his father had a heart attack and was required to return to the family farm. And it was not until 1947 that he was able to come back to the practice of art, enrolling at the Camberwell School of Art to study under Coldstream and Victor Pasmore. There also he met Kenneth Martin, who was to remain a life-long friend. And with him he spent many hours looking at the latest art magazines from France and discussing the philosophy of abstraction, a topic of great interest since it represented a tradition, represented in England by such recent exiles as Mondrian, László Moholy-Nagy, and Naum Gabo, that was quite unlike what Forge saw as the romantic, inward-turning self-sufficiency of an artist like Graham Sutherland. It was in 1949 that Forge first visited Italy, in the footsteps, as he put it, of Poussin, Claude, Turner, and Ruskin. In 1950 he had his first showing with the London Group and it was in that same year, at Coldstream's invitation, that he was appointed to the Slade, where he remained as a teacher of painting for the next fourteen years. Also there was William Townsend, a Man of Kent like him – to use a traditional description – and a careful writer of diaries, excerpts from which, after Townsend's death, Forge was to edit.

The Slade, as he recalled, was a very exciting place to be, for, after the limited possibilities at Camberwell, Coldstream was determined to open up the school to many points of view about art, bringing in as part-time teachers artists like Lucian Freud and Ceri Richards and encouraging seminars organized by David Sylvester where figures like Graham Sutherland and even Francis Bacon would visit and join in the discussions. It was also then that Forge went to hear Rudolf Wittkower, the Durning-Lawrence Professor at University College London, and it was there, in Wittkower's weekly lectures, that he first came to appreciate the traditions of art

history, allowing him, as he said, to unwrap and discuss a work of art – a pot in the British Museum, a painting in the National Gallery – in all its historical and cultural settings.

He also admired many of the students then at the Slade, among them Paula Rego, Victor Willing, Dorothy Mead, and Michael Andrews.

It was about that time that he began to appear in print as a critic. The year 1953 was an important one for Forge; it was then that he had his first one-man show at Agnews, he did his first broadcast for the BBC, he was first published in *The Listener* and *The Art News and Review*, and he was commissioned by Faber & Faber to write a book on Paul Klee. It was also in that year that he met the critic and artist Adrian Stokes, who was to remain a vital intellectual presence for him until Stokes's death in 1972. Forge's writing continued, some unsigned contributions in *The Times*, many in *The Listener* and *The New Statesman*, and later, on the invitation of Peter Townsend, in *Studio International*, the editorial board of which he joined in 1969. He wrote for fun, as he said, imagining it to be like talking, a way of taking on what puzzled him – Picasso, for example – to see if, in this process, he could make sense of what he was seeing. And if occasionally he was haunted by the range of his artistic interests, from Mondrian to Rubens, as he put it – a taste that marked him off occasionally from some of his friends – it was the phenomenology of looking at art that always engaged him. Yet he was clearly confident in his own account of the task of the critic, which, he believed, was not to locate a painting within a system but to account for the visual journey through the work, step by step. He was fully prepared to acknowledge the value of the language of an earlier writer like Roger Fry, but he also felt that Fry's criticism fell short because it depended on formal values alone and not on all the other aspects of consciousness, or what he called

the enlistment of the onlooker's memories or emotions.

All this time he was painting within the formal tradition of Coldstream, if touched also by the example of the looser, more gestural style of David Bomberg. Yet this he was doing with less and less conviction, even wondering, to account for his doubts about his artistic work, whether he spent too much time in writing. The answer to this crisis, profound as it was, came to him after a trip to the United States when, in New York City, he had been introduced to the circle around Robert Rauschenberg, John Cage, Merce Cunningham, and Jasper Johns. Here he experienced what he called a physical openness and beyondness, a structure of unstructuredness, a certain different way of being in the world. Back in England, in the summer of 1963, realizing he could no longer paint as he had done before, he suddenly saw what he had to do, setting up in his studio the biggest stretched canvas he had and mischievously picking up the first brush he could find to place a simple dot on the empty canvas before him, "a bloody dot," he called it, seeing it as entirely itself, the most real thing he had ever done.

This was liberation, and from that moment forth his work changed from all the looser perceptual realism of his first years to what has been called a cerebral but utterly sensual abstraction of perception. Dot followed dot, and another and another, across the whole field of the canvas, recording in this process at once a concept of painting yet retaining still something of a representation of the world beyond the canvas. The result, for all the limits of the colors, was a deeply complex and sensual optical language in which, as we immerse ourselves in the paintings – and such immersion is a vital part of our activity before them – the dots we see seem to flow towards our eyes as also, in this process, there emerges what has been called a kind of drumming and vibration which, we might like to say, following Forge himself, is the

start of the picture's growth. Then also, if less immediately visible, there are longer strokes of color that move across the surface at right angles to the line of vision, which from the closing of the dots and the intimations of light and space, substance and transparency, there is established a form and a form of representation. By which, as Forge put it, one is drawn to naming and the pictures then have their titles, if sometimes suggested afterwards, *November*, for example, or *Sous Bois*, thinking of landscapes, or the memories of figures in Italian art, as in *Fragments*, *Torso I–IV*, *Todi Torso*. Perhaps, as he has said, it can be feared that the tradition of modernist painting is set upon self-contradiction, bound to a critique that threatens it always with silence or even blindness. But, if so, the answer, a conviction about the meaning of the forms of painting, can come only from the forms themselves. Or, as John Hollander suggested, describing the process of Forge's paintings, in an essay he wrote for a retrospective of his work held in 1996 at the Yale Center for British Art, New Haven, when Forge says "I paint what I see," his claim rests on its reverse "I see what I paint," which rests in turn on yet another statement "I paint what I see of what I have painted."

Yet this was a way of painting that seems, for Forge, to have been realizable only in the United States, where he arrived again in 1973, after having met the American painter Ruth Miller a few years earlier. He had left the Slade in 1964 to become Head of the Department of Fine Art at Goldsmiths' College for six difficult years amidst the tensions of the student protests in 1968 and beyond. He and Miller then lived for a year in Reading where he was Lecturer in the Department of Art at the University, but it was at that moment in 1972 that he received an invitation from the critic Dore Ashton, whom Miller had known from her years in New York in the 1950s, to come to Cooper Union; the fol-

lowing year he was appointed Associate Dean at the New York Studio School. To come across the Atlantic to take these positions, temporary as they were, was not an easy decision since he had family still in England, but the move became a firmer reality when, in 1975, after some hesitations, he accepted an appointment as Dean and Professor of Painting at Yale University. This opened him up to a new range of experiences, new kinds of students, new colleagues in the university, many of whom, like William Bailey and John Hollander, were to become close friends and associates. And if the demands of administration at first took him away from his painting – it was during this period that he found time only to write his book on Monet – this situation in America brought together the personal and professional parts of his life in ways that stabilized and deeply enriched everything he was doing. He had always enjoyed his experiences in the United States; a polite Englishman, always happy to hear his American colleagues hold forth, as he said of his visit in the 1963. Now, no longer a visitor, he came to enjoy the culture so much more, especially, being an old worker of the fields, the varieties of the American landscapes, like the countryside in Missouri, the birthplace of his wife, where the beauty of the light reminded him of that in the South of France. He now had a new place for his painting and a new audience, one that could recognize and appreciate what he was doing in his work and the move he had made from a goal of representing the world to what he could think of as a form of appreciation for that world, or as he also put it, a recognition of it.

The painting of his later years, especially after his retirement as Dean at Yale, when at last he could return to his studio, was at once, in its spirit and form, with the language of his criticism, anti-Duchampian, as he put it: less about semiotics than about the act of vision itself. It is not painting that is immediately easy; or, to put this more gently, It is

a kind of painting that requires us, as we look at it, to move across time, in its way not unlike our responses to the work of Jackson Pollock where, as Forge wrote, you can watch as the gestures within it turn from chaos into order. Perhaps the surface of these paintings provides us with an ambiguous, even exhausting richness; yet, if so, it is one that can be dealt with only over time: with an idea of lingering, of looking at a work of art over an extended period with what might be called a generosity of vision. Such a way of responding to art was there also in his teaching, a process, under his suggestion, that his students came to appreciate, as when Lisa Yuskavage noted the impact of a class she took with him at Yale: "I remember sitting in front of this Rothko…we would just sit and look at the painting. For hours. That's the amazing thing about great teachers. Forge would entertain all comers, he took everyone seriously…. We would let the painting talk to us and the layers unfold. We would just sit and look at the paintings and let them come to us…. I learned to make paintings a long, slow read." And yet, there was much more to his teaching, for his students also remember with deep gratitude the wider remarks he might pose to them about their work, one simple (Colombo-like) last question, as Steve Hicks put it, "that then would gently and quietly coax an understanding of what the student was doing to suggest the assumptions, the intentions." And all this was done in words, as Marc Trujillo explained, "that had a gentle, luminous precision." His generosity and patience were always there, as Tommy Fitzpatrick said, helping him and so many of his students to find themselves as artists; for Hollis Jeffcoat he confirmed by his response to her work that painting could and would be a way of life for her. He was, as Denis Farrell put it so simply, a wise and beautiful soul.

To make a selection of the writings of Forge is not easy, nor was it easy to track down his many publications, by recent

counts over 200 items – though here I was helped immeasurably by the bibliographies compiled by Sarah Sands and Joseph Ryan. The extent of what he produced – despite his occasional remarks about how difficult he found writing – makes choosing one text over another challenging, as does the range of the subjects he covered. I decided, perhaps arbitrarily, that his larger projects – the books on Klee, Vermeer, Degas, Manet, Soutine, Bacon, and Monet – need not be represented here since they are well known and generally accessible. Beyond that, in this selection I tried to represent the record of his artistic history, beginning with his activities in London in the 1950s then moving on to the United States, where his engagement with art and the world of art so vastly expanded. Hence, in the first part, the record of his experiences with English art, in the last, with American painting, while in the central section I have brought together a group of what might be called his classic essays, dealing with artists he admired (Matisse, Monet, de Kooning) and only one on an artist he found less significant (Duchamp), all of whom produced work he found engrossing, all of whom raised for him crucial questions about visual representation and the embodiment of such representations.

The first item, from the exhibition he put on with Adrian Heath, at 15 Lisle Street, London – what he called an artists' collective – was concerned with measurement itself, an idea that was to fascinate him all his life, as seen later in his comments on Kenneth Martin and Gabo and Al Held and Jack Tworkov. Then follows a text from 1956 dealing with landscape painting, an art seen in those years as being essentially English (the political implications of this focus have been examined recently in a number of studies), not only from the examples of Constable and Turner, but also from the wider accounts of the national culture developed in the war and its aftermath. Then follow two of his broadcast

talks for the BBC in the series "Paintings of the Month," the first on a landscape by Rubens, the second on a work by Pissarro. The next group of essays considers topics of importance always in England, namely the relationship of its more adventurous artists with the traditions of late-nineteenth-century French painting, here seen in the work of Walter Sickert and Wilson Steer. Then a record of Forge's interest in David Bomberg, whether in his earliest abstractions or his later, freer works, which leads to an introduction he wrote in 1968 for an exhibition at the then-famous Beaux Arts Gallery, run by Helen Lessore, once a student at the Slade and the daughter-in-law of Sickert. Finally, here we have the record of an exhibition of British Painting in 1974 that Forge was involved with, but which was commented upon very harshly by some. Forge's reply to such criticism ends this section.

The central group of texts is concerned with artists from France and the United States, with whom Forge was always deeply engaged – Matisse, Monet – and also Giacometti, an artist much honored in England in the 1950s and 1960s and someone who, perhaps surprisingly, had a close relationship with the Slade School and William Coldstream. Then comments on the great American artists Pollock, Kline, de Kooning, and Frankenthaler, followed by essays that deal, in the way I spoke of as modestly philosophical, with questions that touched, explicitly or implicitly, upon issues of psychology and epistemology, and, in the last essay, on the personal morality that art, as a product of human actions at their most serious, invokes.

The last section is taken from the writings Forge did in the United States in his later years. Many are about artists, whether in England or the United States, whom he knew personally (and Forge was always a most generous friend): Al Held, Robert Rauschenberg, Jack Tworkov, Kenneth

Martin, Naum Gabo, Euan Uglow, Jake Berthot, William Bailey, and Graham Nickson. The end here can come with the text of the last exhibition with which he was involved, shown at the Studio School in New York in 2000, from which the title of this volume is borrowed. Here he was able to leave his comments on some of the artists – Sickert, Coldstream, Seurat, Stokes, Klee, Martin, Bomberg, Cage, and Giacometti – whose works across the years had always meant so much to him in so many different ways.

The critical writings of Andrew Forge have a particular and highly individual quality. In their language, they reflect his idea of criticism as a form of talking and thinking about questions that often seemed so puzzling to him. In the choices of their subjects, as in the range of the pieces done for the BBC, they reflect the idea of a perfect audience, ready to appreciate the art of all ages, that perhaps now does not exist in any comparable way. And in their form they took advantage of all the opportunities, in general publications as much as in the specialized journals of art, that, in our age of immediate communication, have perhaps also been sidelined and even rendered obsolete. Yet it is wonderful to turn back to these texts and, with them, to think about painting and representation and the reasons why, at any moment, we might feel we need the kind of art of which he speaks with such passion and love. It is my hope that, in the selection I have made here, these qualities in his writings will shine through and will serve artists and lovers of art as they did so clearly when first written.

Some spellings have been changed to standardized American usage.

DAVID CAST

Part I

Measurement and Proportion

Catalogue introduction to an exhibition of the same name
AIA Gallery, 15 Lisle Street, London
May 10–29, 1955

THE PURPOSE OF this exhibition is not to put forward one kind of painting at the expense of another; a glance at the pictures will assure the visitor of that much. Our purpose is to draw attention to a certain factor in the process of painting, a factor which cuts across stylistic differences and may be employed with equal conviction by artists who work directly from nature, or who use nature as a point of departure only, or who evolve their works from forms which have no outside associations; we mean the factor of measurement.

Obviously measurement can be used in very different ways. To the painter who works empirically from his sensations, it may mean no more than a means of checking a proportion which had so far eluded him. But it is not likely to stop there as a mere aid to observation. To measure a proportion is to set one interval against another, to relate like to like, and sooner or later, to abstract a structure of proportions from the whole complex that the eye sees. Measurement of this kind deals with the verification of formal elements observed by eye in nature.

At the opposite pole is measurement which deals with the formal elements special to the canvas. Any rectangle has properties of its own, and the painter may take them as his starting

point, making perhaps a single division which sets out two areas having a known relationship. The subsequent course of the picture will be a development from this relationship.

Artists using either of these kinds of measurement, it will be seen, are concerned with the precise, measurable relationship of areas and proportions; these relationships are the bones of their work. But it is worth noting that the man working in front of nature advances by extracting simple forms from something complex, while the man working from his canvas advances by elaboration. Both approaches are represented here; in certain pictures they may coincide, that is to say, proportions measured from the thing seen *and* from the canvas may be welded into a single system. In others (and here again stylistic extremes meet) the final dimensions of the work may be arrived at by a sort of growth outwards; the first measurements providing a formal theme which in its development provides, among other things, the shape of the work.

Measurement as a factor in the artists' method is particularly out of vogue at the moment. We are still in the backwash of Romanticism. Any school (such as Expressionism) which puts a premium on the free intuition of the artist is bound to turn its face against measurement. But today (thanks to this same Romanticism) we accept Temperament everywhere; a painting does not have to be all gesture and feeling in order for us to feel the personal compulsions behind its making; and the fact is that there are and always will be artists whose deepest intuitions respond precisely to that which is verifiable, clear cut and objective. Beside their need for a kind of certainty, arguments which connect measurement with the academic are irrelevant and old fashioned. For X who discovers that from where he is sitting the tip of the nose comes *exactly* halfway down the side of the chest of drawers, or for Y, who discovers that he can make a

black square move *exactly* into its socket, measurement is not a handy help, an easy road to the ideal, a formula or a beautifier, but a constructive adventure.

ARTISTS: David Wilde, Patrick George, Francis Hoyland, Prunella Clough, Harold Cohen, Martin Froy, Patrick Dolan, Marlow Moss, Anthony Hill, Adrian Heath, Kenneth Martin, Mary Martin, Victor Pasmore, Denis William, Elliot Seabrooke, Patrick Symons, Andrew Forge, Euan Uglow, B. A. R. Carter.

DRAWINGS: William Townsend, Anne Buchanan, William Coldstream.

SCULPTURE: Marlow Moss.

MOBILE: Kenneth Martin.

Some Recent Landscapes

Catalogue foreword to an exhibition: "Ten Years of English Landscape Painting: 1945–1955" Institute of Contemporary Art, London February 25–March 10, 1956

THE PURPOSE OF the present exhibition is to explore some aspects of landscape painting in England at the moment. All the painters represented are young, that is to say, they have reached maturity as painters since the war.

In his epilogue to *Landscape Into Art*, which appeared six years ago, Sir Kenneth Clark recognized two factors that seemed to cast a shadow upon the immediate future of landscape painting. On the one hand, within the realm of art, we lived in the climate of the museums. The existence of a "pure aesthetic sensation" was implied, and we were driven towards an increasing purism: "…Dangerous as purism is to all the arts, it is particularly troublesome in landscape painting, which depends so much on the unconscious response of the whole being to the world which surrounds him." At the same time, in a wider context, faith in nature itself, that one unifying motive in all earlier approaches to landscape, had become less and less easily tenable. "Nature" could no longer be believed in in purely sensuous terms; science had removed the human measure.

To what extent has this pessimistic conclusion been borne out? It is true that science has placed any unified idea of nature outside the painter's immediate grasp – but this has served to strengthen not weaken the value to him of his

sensations. Thus, in none of the pictures here is nature approached as a sort of living tablet of the law: this approach seems to have been most fully developed among those artists who are working in the Mondrian–Klee–Gabo constructive tradition. Nor is nature approached as a force outside human life – no picture contributes to a mythology of natural forms or reflects a terrific vision from which the human scale is excluded.

The painters represented, Lanyon, Fry, Sutton, Bratby, to name four who are working from extremely disparate positions, tend to paint landscape from within their own experience. The operative motive in their work is not to do with an idea of nature with a capital N so much as with their own response to their surroundings. (A rather different approach is shown by Peter Kinley; here the associations of landscape are drawn upon to deepen and enrich what is, in fact, a purely aesthetic effect.)

There is no intention, here, to herald a landscape revival. However, it seems likely that more pictures of landscapes will now be painted for the very reason that our awareness of the disparity between what is known about nature and what is available to our senses has yielded a peculiar freedom. The modern landscape artist has nothing to lose when he is told some unimaginable fact by a scientist, for he knows, when he turns to the scene in front of him, that he cannot define a cosmos in its terms but only in terms of himself.

ARTISTS: John Bratby, Derek Cawthorne, Harold Cohen, Sheila Fell, Martin Froy, Anthony Fry, Patrick George, William Gear, David Houghton, Patrick Heron, Peter Kinley, Norman Town, Phillip Sutton.

Rubens as a Landscape Painter

The Listener
October 8, 1962

THERE IS A real difference between landscape and still life on the one hand and figures and heads on the other. A stranger across the street gestures to you and you understand, or think you do. Something has passed between you. But a tree across the street is just a tree across the street – until one day it is in flower or its leaves fall into the gutter and you feel something. What you may feel depends on you – it is something that *you* have brought to the tree, not something the tree has communicated.

This obvious fact has not got much to do with the content of painting as we know it, but there is a connection between it and the conditions under which landscape and still life became possible subjects for painting. Landscape and still-life subjects, in themselves, are of limited interest: they can be decorative or symbolic. But to be expressive, landscape must depend on what the artist brings to it, his own experience of it, the interest he attributes to it – and in the history of painting this did not happen until the artists themselves had reached a certain degree of self-consciousness as artists – or, rather, until what they were doing was recognized as somehow different from the work of craftsmen and decorators and until the ingredient of personal expression in their style was accepted as part and parcel of the value of their work.

This happened during the mid-sixteenth century, in the aftermath of the High Renaissance. It was then that the

foundations were laid for many of the conditions of art that have been with us ever since: the notion of the artist's personality as something exceptional; the notion of the evolution of art as a series of debates about style. It was at this time that artists first painted pictures without any figure interest, that is, landscapes and still lifes. At first the new subjects were hardly important: aesthetic novelties for a specially sophisticated audience. They were to become much more than this during the seventeenth century.

The *Landscape near Malines* [Fig. 1] is an unspectacular picture of an unspectacular place. The flat country runs away into the distance, an expanse of cool wet meadows dotted with willows and alders, to where the woods gather up into a solid clump on the horizon. Overhead the sky is watery and gray, filled with broken cloud. Everything is cool, reserved, gray, blue, silvery-green. The picture represents a place for its own sake, and not for any transcendent meaning that can be attached to it. It does not tell a story about the place; it simply remakes it.

There is an extraordinary contrast between this picture and the rest of Rubens's work. All his life he had worked as a public artist. Everything that left his studio, whatever its individual quality, had the same tone of voice, worldly, assured, energetic, luxurious. A religious altarpiece or a great state decoration was on the same level as the architecture it adorned. It represented a power that was recognized for what it was and that embodied itself openly in these works. And the easel-pictures too – portraits of grandees or mythological scenes, allegories, lion hunts – all offered a field of entertainment and opened up a world where men and women were like the heroes and heroines of myth, human, even gross, but always larger than individuals, always standing for more than they were; transfigured by rhetoric, allegory, a public style. It is as though the pictures were scenes from an unending pageant.

These qualities are present also in the earlier landscapes. It is easy to imagine that a painting like the *Shipwreck of Aeneas* is a presentation on a stage; and as with a stage presentation everything focuses on the human meaning of the scene. Certainly landscape meant nature to Rubens, the outer world of the elements and the seasons, the opposite of what is man-made. But it did not mean what it was to mean to some later artists. There is no horror, no hanging over an abyss from which all human feeling and all human content is excluded. Everything is tied to a human scale and a human meaning. He almost always uses landscape with an emblematic resonance, which infuses it with some specifically human content.

AN IMAGE OF PEACE AND PLENTY

In the center of the magnificent *Allegory of Peace and War*, a fawn is offering the children a cornucopia. Grapes and apples stream out of it and a leopard rolls over on its back like a cat and stretches up to tangle its paws in the vines. Apart from the amazing design of this group, its luxury and its physical promise, it seems to me one of the most wonderful images in painting, embodying the whole notion of peace, with its reference to the earth, to fruit and animal, to fierceness and disorder resolved, to grace and refreshment, to texture, fur, horn, the skin of grapes, the sheen of sunburnt skin, not merely as an abstraction but as something physical, felt in depth. And beyond this group, where one can look into the distance between the closely massed figures, the glimpses of the countryside have this same emblematic quality – there is a hint of light and serenity; in the war figures that are raging and tearing Mars away from his family, there the country is black and desolate; reddish

gleams suggest burning farms; black clouds drive like smoke; everything expresses destruction.

I think we are justified in reading many of Rubens's complete landscapes in this sort of way. A picture like the *Rainbow Landscape* [Fig. 2] is not exactly a view of a particular place, it is more like a general survey, a number of incidents and details gathered together and co-ordinated by a tremendous imaginative *tour de force*. What it signifies is not so much a place as a view of the world.

This treatment of landscape had a long tradition behind it. *The Harvesters*, by Rubens's great precursor Brueghel, is so inclusive that it is more like a geography book than like any later landscape; and it is more like a season than a picture of a particular time of day. Brueghel's pictures are developed out of a tradition that can be followed back to the medieval calendars, the Book of Hours, and the carvings of the Gothic cathedrals, a tradition which exemplifies the years, the world, and the condition of man. Rubens was still in touch with this tradition: he was the last significant artist to make these universal statements in his painting. Although the *Rainbow Landscape* is far more sophisticated and stylish than *The Harvesters* it has much in common with it. There is the same inclusiveness, as though he wanted to put everything in, the life of the peasants, the animals, the weather, the vegetation, crops, lie of the land, the way the trees grew.

IMPERSONAL TERMS

So the *Rainbow Landscape* and its great companion the *Château de Steen* in the National Gallery are in a sense no less public utterances than Rubens's figure pieces. Yet there is a difference between these two pictures which were painted

fairly late in his life and the earlier works. By comparison an earlier picture like the *Shipwreck of Aeneas* is a story-teller's scene, a world where the split and jagged trees are like shattered heroes and the elements unfold like the incidents of a dramatic epic. Its hold on us depends on Rubens's marvelous orchestration, his imaginative grip. The trees and rocks and water are piled up as if by a wild natural architecture – they have the decorative plasticity of a baroque dome. The sensation of space, the *feel* of the picture, is entirely artificial. Really it tells us nothing about the feel of landscape; its terms are impersonal, decorative (in the highest sense), and rhetorical.

But the late pictures do tell us something about the feel of landscape. To put it at its simplest, they are warmer, and they carry us into their distances instead of flinging us around within the walls of the picture. It is impossible not to read a new intention into these pictures, and a changed relationship with the landscape subject. He was doing something more or less unprecedented: he was painting landscape as a direct personal experience. For the first time in his life he was dealing with things on a level which did not belong to the world at large and could not conceivably be handled by anyone but himself. Entertainment, decoration, public purpose is beginning to give way to another motive, something narrower in a way, but more highly charged. He had married Hélène Fourment in 1630, and bought his country property, the Château de Steen, a few years later. He spent much of the time that he was there working directly from nature. There is a vigorous searching quality in his drawings at this time, as though for all his skill and experience in representing everything, still he found himself looking at trees and bramble bushes for the first time, his curiosity really aroused and having to revise and extend his formulae. At the same time – and it is

expressed directly through his new closeness – there is a tender feeling, a solace in the independent life of the brambles and hedgerows, the non-human life of cows. The image of the cornucopia lies behind it all – but it is as though instead of setting the cornucopia up as a familiar expression of a familiar idea, Rubens was discovering the meaning of it afresh in actual plants and actual places.

A NEW ATTITUDE TOWARDS PICTURE SPACE

Parallel with these outward changes, and involving a much deeper revision, was a new attitude towards the picture space. In a sense landscape painting is the expression of landscape space. Out of doors everything stretches away from you, everything runs away interminably. The sky over your head is the same sky that you see at the horizon. The features in a landscape are negligible compared to the features on a face or the limbs of a body; they are tiny and their distinguishing tone is insignificant and they are not part of a self-contained pattern. The more you look at a figure the more you become aware of its presence "out there" – your eyes go out to it and touch it, it seems self-sufficient and "whole." But the more you look at a landscape the more you realize its complexity – the "whole" is something which wraps you round and is vast and endless, and to give it shape or an anatomy you have to choose a part of it and give it precedence over the rest.

The anatomy that Rubens gives his landscapes is extremely complex. It is drawn from Brueghel's slanting panoramas and from the architectural formula of the Roman painters – but the main ingredient is the characteristic movement of his own figure compositions. All the spatial properties of his landscapes are harnessed to this

movement – the *perpetuum mobile* which reaches its most extreme in the late *Peasant Dance*, where the figures make a great undulating coil into the depth of the picture round which the eye spins first one way and then another, but always going back to the center of the dance. And in the *Shipwreck of Aeneas* we have seen Rubens effortlessly doing this sort of thing with landscape features, making them swing round and round, the big arc of the rainbow answering the arc of the curving path and bridge, the round trees echoing the boiling clouds, the whole lie of the land returning the movement of the sky, and this endless movement, returning on itself, standing in for the endless extent of landscape space.

But in the later *Rainbow Landscape* this solution does not work exactly. It is as though his new, more personal attention to landscape made it harder for him to accept the efficient virtuoso answer. His handling of the spaces is less compact, and his style loses some of its consistency. The dramatic raking perspective of the trees on the right seems conventional compared with the vivid and organic drawing of the stack and the cornfield on the left. Even the rainbow, which returns the movements in space from distance to foreground, seems a bit of a device. The distant part, the view across the fields on the left, is rather different. It seems more whole and more embracing than any other part of the picture, and it is this particular passage which leads us back to the picture at the Barber Institute, the *Landscape near Malines*. In itself this passage in the distance of the *Rainbow Landscape* is not in the least dramatic – but it plays a dramatic role in the picture. You are led to it deliberately, as if to a final conclusion. Here all the busyness of separate incidents is resolved: everything is unified and calm. Arrived here, one feels suddenly released – no longer tied to categories of things and no longer involved in watching events.

The quality that we find in this single passage is present in the whole of the *Landscape near Malines*. But the picture is self-sufficient: it is not an incident in a scheme of incidents. Of course Rubens is concerned with taking you into the picture, leading you here and there. All the familiar machinery for describing space and manipulating movement is here, but its character has changed with the changed purpose of the picture. The wood on the horizon functions rather like the central tree in the *Peasant Dance* and the curving bank in the foreground wheels out from it rather as the dancers wheel out from their center; but in the landscape this turning movement is not contained inside the picture. Space seems to stream out at the open ends of the picture as vigorously as it streams back towards the horizon. The whole landscape turns in front of us, not with the coiling artifice of one of the earlier pictures but with the simple single unfolding that our own movement brings to landscape. Apart from the brown banks in the immediate foreground (which are merely conventional) every part of the picture is connected with every other part of the picture. There are no disparate incidents. Sky and land interpenetrate – the cool reflections place the sky over the foreground of the picture, and the way in which the clouds are drawn into the movement of the trees is far more than a compositional device. It tells us something about the way that Rubens understood the relationship between them.

Look at the boundary of the field that runs in a straight line from near to, on the left of the picture, the middle distance in the center. There is nothing else like this in painting – like the way in which this line opens up the spaces and concentrates the whole expanse of the landscape along its length. Traveling along that edge one seems to gather up the whole area between the bushes in the foreground and the wood behind. Look at the way in which the groups and

lines of willows measure out the landscape, making endless shapes between themselves. As one's eye discovers first one permutation, then another, each new shape redefines the extent of the landscape and offers one a new way of grasping it.

What has been dropped, here, is the public utterance, the storytelling, the traveler's tales, the general reflections. What has been gained is a far closer sense of what Rubens himself is about, the particular affections of his eyes – and, inseparably from this – a far closer sense of the actual, of what it is like to look out across wet meadows, to project oneself into the distance, to feel oneself surrounded on all sides by air and daylight. And beyond this, a new sense of the potentialities of painting. For what he seems to be doing is, for all its unspectacular character, more ambitious and more far-reaching even than the invention of an imaginary decorative world. It is the transformation of the real world into the world of his painting.

The Listener
October 12, 1961

THIS IS A picture [Fig. 3] of a real road; it was painted from one particular point on the side of the road and was almost certainly carried through in a few days. We can be fairly certain, too, that while he was painting it Pissarro believed that he was being governed by the evidence of his eyes; that the painting was, in other words, based closely upon his impressions of the place at the time.

I should think that it would be impossible to look at this picture without feeling a sense of freedom: and also a sense of Pissarro's attitude to the visible world, his affirmation of it, and his insistence on it as a source of luxury and delight.

It is a spring morning, the sunlight cool, crisp, putting a veiled glitter over the road, the bare branches of the trees, the blossom that speckles them. In places the light falls in depth over the tops of the trees in a sort of luminous fur. An endless variety of textures, rhythms, and scales are brought to equal terms on the surface of the canvas: bare branches, distant masonry, clouds, blossom, leaves, earth, blue sky, the column-like figure of the peasant woman – all these are brought to equal terms on the surface of the canvas, and all are painted with the same flat, unmodeled flakes of paint.

It is this feature, this all-over unity, more than felicities of subject matter or decorative effects of color, which gives Impressionist painting its air of freedom. (I mean by Impressionism the style practiced by Monet, Renoir, and Pissarro

between the late eighteen-sixties and the early eighties.)
The Impressionists saw the world in terms of light; and they
saw light in terms of opaque paint. Impressionism proposed
a new view of drawing, for its definitions were achieved
without the flourish, the rhythmical systems, of earlier art.
It does not wrestle with the forms as all modeled art does;
there is no show of muscle. Nor does anything escape
because it is left at a distance; everything is accessible,
touched by the eye and kept, because it is miraculously har-
monized. No other style has quite the same power to project
us into the outside world. To look at this painting of Pis-
sarro's is to refresh over and over again our experience of
outdoor space. Space is expressed in every aspect of the pic-
ture, and each stroke of paint is chosen for its resonance
against its neighbor – and also for its active contribution to
the whole. The double part played by each fragment of paint
is essential to the life of the picture, its space and light.

To understand the special qualities of impressionist
painting, consider another landscape with the same theme –
Hobbema's *Avenue*. In the seventeenth-century picture the
main relationship between the land and the sky is expressed
in a simple contrast: dark land, light sky. All the smaller
forms are worked out inside the limits of this main contrast.
But in the Pissarro the relationship is far more complex: it is
based less on a contrast than on a subtle interlocking. Pis-
sarro's sky is no backdrop, nor is the road a stage – the two
interlock in an inclusive relationship, so that, although we
are never in doubt as to how far away anything is, at the
same time we seem to be drawn into the picture as we are
drawn into the real world with our eyes. This is not simply
because of perspective; it is due more to the painter's all-
around continuous awareness of space, expressed in an end-
less series of affinities, a series of webs in which each colored
link contributes its necessary value.

18

The blue uniform of the postman on the left seems to concentrate the patch of blue sky over his head; while the white blossom and the creamy walls of the barn to the right of him do the same with the white clouds over them. A chain of these relationships stretches from the postman on the left of the picture to the blossom on the right, and it forms a sort of flattened pyramid with its apex in the eaves of a white building on the sky line; and this slow, expansive shape seems to project itself upwards into the sky as though great arms were mapping out the position of clouds overhead.

This is only one aspect of the relationship between land and sky, as it is worked out in fairly large forms; the same process continues, even down to individual strokes. A small section of the foreground of Hobbema's picture is a self-contained incident, rich in itself. In the Pissarro each fragment of paint, although it appears to mean less in itself, to be more abstract, is invested with the same luminosity as the sky. You seem to get less – and more – from each stroke: less description but a richer equivalence of space and light; less incident but a weightier content.

By 1870, the year this picture was painted, Pissarro had arrived at the position he was to occupy for the next ten years. He had modeled himself upon Corot when he had first started to paint in the countryside around Paris, and it was from Corot that Pissarro learned to see his subjects in terms of a tonal ensemble. He learned to work directly from his impressions and to allow the immediate experience in front of the scene to be the guiding factor by which all the other aspects of the picture were regulated. And it was from Corot, too, that Pissarro had his first intimations of the tradition of classical composition which he was later to bring to life in such an extraordinary way.

But there was another ingredient in Pissarro's formation as a painter, more active and more difficult to assimilate

than the purely technical example of Corot. I mean Realism. Realism is always associated with the name of Courbet – because he used the word as a personal battle cry. But it was far too wide a tendency to be defined by one man. Briefly, it was concerned with treating subjects from contemporary life rather than from history and literature – and it wanted to treat them without idealizing them, describing them just as they were, without relating them to a traditional canon of form.

Neither Courbet, nor Millet, nor Daumier painted in the open air. It was not until the eighteen-sixties that their younger followers carried Realism to its logical conclusion in this way. It is difficult for us now to appreciate the novelty of open-air painting in the history of painting as a whole, or to realize how controversial it was when it first was done. It was a program of revolt: the *plein air* painters, and I think Pissarro in particular, saw themselves moving away from the deceiving shadows of the studio into the light of day. They turned away from the snobbish play-acting implied in the official paintings of history and mythology. Instead they looked into the real world, where everything is part of a chain of cause and effect, and everything, even the most mundane thing, can be seen as having some human significance.

Open-air painting was a democratic tendency (and was recognized as such by its opponents) because the subjects it treated were available to everybody's eyes and anyone could relate the pictures to their own experience. And also it was individual to an unprecedented degree: each work represented an individual choice of view and a degree of personal improvisation. Indeed, the picture as a whole only takes on value in relation to its personal content: where a lay onlooker might ask in front of an earlier picture "What is it about?," he might ask in front of a *plein airist* picture "What has the artist seen in this subject?"

Of course one cannot talk about the realist tendencies of the eighteen-fifties and sixties as though they amounted to a single-minded, clear-cut whole. Many ideas that evolved together out of revolt against the academic tradition turned out to be difficult to reconcile as time went on. Painting from nature, for example, proved to be almost irreconcilable with the exploration of realist ideas, because, to put it roughly, the more closely a painter pursued the appearance of things, the more involved he was bound to get in his own subjective impressions of them; and the more subjective his painting became, the less room there was in it for general communication about the nature of his subject matter. In fact it was the increased subjectivity of Impressionism which really distinguished it from Realism.

MAN AND HIS ENVIRONMENT

One of the general intentions of Realism was to record contemporary man in his environment, to paint not so much the individual as the circumstances that made him. Pissarro and Degas were the only members of the Impressionist group to follow up this intention. To Monet, for example, the busiest street was interesting mainly as an optical effect in which the human element was merely one ingredient among many: we could almost imagine that he hardly reflected whether he was painting grass or pavement, parasol or trouser leg. The outward aspects of the subject have become absorbed in the seeing of them. Pissarro's peasants are painted with as clear a sense of who they are and what they are doing as Degas' washerwomen or dancers. But where Degas will concentrate upon a gesture or a posture which is expressive of habit or training or necessity, with Pissarro we are made aware of the whole landscape and its

bearing on the people who move in it and are governed by it.

Whenever our eyes roam over the surface of *A View from Louveciennes*, exploring foliage, sky, the warm expanses of the road, or the violety-gray spaces, they always return, as though to a key, to the figures. Above all, we return to the column-like back of the peasant woman. There is a certain heightening of tension round Pissarro's figures, an alertness, as though where men stood the air was just that much clearer, the ground that much more firm. Consider the quickening in the drawing round the woman's figure here, the tense, box-like interval between her and the wall on her right, occupied so exactly by the roadman. The sense of scale between the woman, the little tree, and the man, so grand and so utterly real, is one of the most perfect things in the painting of the nineteenth century.

PLEIN AIRISM

It was necessary at the time, and it has become conventional since, to talk about *plein airism* as though it was nothing else but a campaign against the time-worn clichés of the academic tradition. But it can also be seen as a campaign to reconstitute some of the traditions of painting in a new context, and to bring them back to life in front of nature. Some of the subjects painted by the Impressionists indicate the first view, and others the second. Snow, for instance, or sunlight on broken water, were clearly conditions of nature that were painted in order to claim certain unprecedented effects for the language of painting. On the other hand, a road or a street seen in perspective, a theme painted time after time by Monet, Renoir, and Sisley, as well as by Pissarro, was clearly turned to so often simply because it offered in real life some of the formal elements of classical landscape composition.

Pissarro in particular was concerned with bringing the modern anti-traditional aspect of his work into some sort of relation with the tradition of landscape painting. And for him the road-in-perspective theme was an endlessly fruitful obsession. In his many series of views looking along roads he explored every nuance, every possible permutation, of construction. Perspective was the agency by which the most mundane scene could be given a classical articulation, could be seen in terms of proportion and interval. Thus in so simple a picture as *La Route de Louveciennes* in the Louvre, the fabric of the composition is carried by the horizontal which runs from the horizon at the far end of the road through the wall on the left, and the verticals of the trees and buildings. The sloping angles of the roofs and the shadows on the road drive one's eyes into the strongest vertical of all, the two figures advancing down the road, the key point in the picture.

CONTRAST WITH POUSSIN

Although this ordinary scene is a world away from the idealized construction of, for instance, Poussin's *Gathering of the Ashes of Phocion*, yet it partakes of something of its nobility: its spaces, so different in their meaning, are carved out with a kindred austerity, a similar clarity. But among the thousand contrasts between the two pictures there is one which is essential: the standing figure in the center of the Poussin leads us into the picture with his gesture; we notice particularly how his figure seems to indicate the closed and authoritative form of the temple that stands immediately above him. We are an audience in front of a proscenium arch. In the Pissarro the vertical accent formed by the figures corresponds with the straight edge of the pavement in front of them at their feet; this is vertical procisely because the

painter is standing on it: the strongest accent in the picture, the one that determines every other feature, aligns us with the painter's own position in front of his motif.

Thus for Pissarro perspective moves outwards and inwards at the same time: it is the agency which orders the world in the onlooker's eye, which defines and at the same time overcomes distance, the very hallmark of human vision. There is nothing theoretical or doctrinaire in the way he uses it; merely an absorbed attention to the way things get bigger and smaller or line up in the eye as you move about. In the Pontoise landscapes of the late eighteen-sixties these alignments and correspondences in perspective provide the dominant theme; and later, when Pissarro's art reached its climax in the eighteen-seventies, this sense of the dual power of perspective, pointing inwards as well as outwards, is no less strong. But now color and light and perspective are seen as having an integral meaning. Distance is not seen as a nostalgic haze but precisely: nearness and farness, "here" and "right out there" are brought together exactly in the same structure.

INTERLOCKING MOVEMENTS

In *A View from Louveciennes* the painter is standing on the grassy verge at the left; he sights down it; the bush facing him seems to measure up to him. To the right he takes a great level sweep which includes the orchard below the road and much of the wooded hillside beyond it. These two movements, up and down the grass verge, left and right across the road, complement each other and provide the picture with its scale. They interlock continually: the shadows across the road on the left reach out towards the hedge opposite, defining the width of the road, locking it in to the

column of green and brown that the grass verge makes. Right across the picture the trunks of trees divide up the spaces of the orchard into compartments, each interval perfectly felt, each like a self-contained country, holding a promise. The clearest of these compartments is that between the woman and the tree trunk facing the painter. This is made into a square by the shadow on the road and the aqueduct on the sky line.

The woman's figure gives scale to the whole picture. We feel that the light that saturates the wide warm road and glitters in the orchard is concentrated on her, as though the russet of her jacket or the whiteness of her cap were the sum total of it. She dominates the square compartment ahead, where the tree not yet in leaf opens like a fan in front of her. Her size and her warm color are echoed in the trunk of the tree that faces the painter, and the arches of the aqueduct against the sky are like repetitions of her white cap.

Pissarro was never to lose his sense of commitment to what he painted, nor did his responses to it lose their poignancy. There is a wonderful generosity of vision here, an evenness; although he might ascribe a key role to one part of the picture rather than another, it was never at the expense of any aspect of his subject. Each selection was an enhancement of the whole. Each mark that he made, always so eager yet so unflourished, tense yet sober, was a claim for the real world, an affirmation.

The Listener
June 16, 1960

SICKERT, THE NEXT English painter after Turner (it is repeatedly said of him and it is true), slips through your fingers as if he were made of air; you think you know him (who could not know him?) and you stretch out your hand to touch him and he is gone.

The trouble is that, like generals or statesmen, artists who have a historic part to play, and acknowledge it, get their private faces wiped off them. This has happened to Sickert: his historical position is unassailable and it is not easy to see past it. He made and lived up to a double reputation: the friend of Whistler, Degas, Jacques-Émile Blanche, he really knew what the French were up to; his relationship with France was a genuine professional connection and not, as with most of his colleagues in the New English Art Club, a matter of good intentions and tourist make-believe. The pictures speak for themselves – they are absolutely true stylistically; alone among their contemporaries they do not compromise realism, do not soften it or rub it down against the old masters.

Then there was that other Sickert, the heir to the native tradition, to Hogarth, Ford Madox Brown, Charles Keene, the storyteller, the author of *My Awful Dad* and *That boy of mine will ruin me* and *Ennui*; the chronicler of time, character, locality. It is the side of him that is epitomized verbally in an essay in which he attacked the conventional study of the nude:

Now let us strip Tilly Pullen of her lendings and tell her
to put her own things on again. Let her leave the studio
and climb the first dirty little staircase in the first shabby
little house. Tilly Pullen becomes interesting at once ...
she becomes the stuff for a picture. Follow her into the
kitchen or better still – for the artist has the divine privi-
lege of omnipresence – into her bedroom – and Tilly Pul-
len is become the stuff of which the Parthenon is made ...

The paradoxes and disguises that he surrounded himself
with are usually thought of as a sort of personal smoke
screen laid to protect his own integrity as a painter. The fact
is that reviewing his work now one tends to see those para-
doxes as much truer to his nature than one would have sup-
posed at first. And it is Sickert the confident painter who
now begins to look like the smoke screen. But I must explain
what I mean by turning to his work.

I want to describe a picture in the exhibition at the Tate.
A woman lies naked on a bed. Daylight pours in from the
window, breaking sharply and coldly across her arms and
head and chest. A man sits at the foot of the bed, his arms
folded, his head turned towards her. He is clothed: shirt-
sleeves, waistcoat, cap on. Beyond him the details of the
room, marble-topped washstand, mirror, wallpaper. The
man is against the light; he is a dark splodge; she is a light
one. Silhouettes are decisive, but between them the paint is
inscrutable. Light is everything.

The picture I am describing is one of the Camden Town
interiors; it is called *Summer Afternoon* [Fig. 4]. Like most of
his pictures of this kind, the composition, the whole vision,
derives from Degas. But placed beside a Degas, beside *Au
Café*, for example, or *The Rape*, interiors like this with two
figures, there is a world of difference. In the Degas there is
remarkably little sense of a human situation. The man and

the woman seem detached from each other, ignorant one would say of each other's company; the artist's eye is like a stranger's, a foreigner's who specifies with stereoscopic accuracy the appearance of a society but knows nothing of the personal exchanges within it. But Sickert's figures are aware of each other – they are within a situation. Time plays loudly in his pictures: you can almost hear the tone of the man's voice in *Summer Afternoon*, foresee his gesture. Sickert had a fantastic grasp of the nuances of a pose in terms of nervous atmosphere and behavior. Think of the composition *Off to the Pub*, the woman stiff and huffish with her back to the doorpost, hubby leaning to open the door with sheepish truculence, the air between them electric. Or the gesture of the Miner, in the picture of that name done from a photograph, as he kisses his wife. No gesture that I can think of by Degas has this expressive, communicative eloquence.

But at the same time if we look for a moment at the execution of the Sickert, we find that it contrasts with the Degas in an opposite sense. In Degas every stroke of the brush has a bearing on an imagined form; every mark, one could say, is conceptualized. And the same is true of those of his descendants with whom Sickert can be closely compared – Vuillard and Bonnard. With their early work, certainly, marks do not always represent things, but if they do not, they make or contribute to a pattern, they follow an idea. With Sickert the handling is almost incredibly detached. It moves freely as though propelled by nothing but the hand and the eye: for example, in the marvelous *Mrs. Barrett*, one of the warmest pictures he ever painted, the brush, marking its way with dots and strokes across the straw hat, the face, the hair, seems to be doing nothing but passively echoing light. It is truly as though the picture were like a transparent barrier between the outside world and the artist, as far from the

surfaces of the model as from the physical responses of the painter, and keeping the two forever apart.

"A SUBTLE ATTRIBUTE"

With Sickert in fact the handling of the paint takes on an almost self-sufficient value; from the first it had been a conscious intention to control it, to develop it; an intention no doubt warmly fostered in Whistler's studio where elegance of facture was at a premium. He wrote about it as early as 1889 in his introduction to the London Impressionists' exhibition in which the advanced wing of the N.E.A.C. first showed its hand. What is it, he asks, that one gains from a modern picture when one approaches it closely? "Not new facts about the subject ..." but "a subtle attribute which painters call *quality* ... a certain beauty and fitness of expression in paint, apparently ragged perhaps, and capricious, but revealing to the connoisseur." And as time went on and he rationalized his methods, handling, this "subtle attribute" came nearer and nearer to the surface until it appeared that with each picture he was endorsing Maurice Denis's dictum of the picture being first a flat surface covered with color in a certain order.

There is undoubtedly a connection between the value that he placed on handling and his determination to free painting from the stresses and strains of search and invention. It is interesting that his later criticisms of Whistler were based on the argument that Whistler did not abstract enough in the process of painting, that he was too tied to the procedures of *plein airisme*, that he tried to complete his pictures in front of the model without a clear-cut idea of their conclusion in his mind. Once he had met Degas and

had the traditional procedures of working from drawings confirmed, he had found a method which would allow him to separate drawing and design from execution, from the play with paint. He took to squaring-up his drawings, to transposing them accurately on to the canvas, ordering his palette with pre-mixed tones, underpainting, calling on all the traditional studio procedures. Execution was to be "the singing of a song by heart, and not the painful performance in public of a meritorious feat of sight-reading."

STAKING OUT A POSITION

He was not alone among artists of his generation in wanting to break down painting into stages: there is a parallel right through post-Impressionism – in Seurat, in Van Gogh, and during the eighteen-nineties among the Nabis. But whereas in France this late flowering of academic method was in the interests of a new expressive language, a new intimacy with form and color, with Sickert it was a way of staking out a position as a professional artist. His deliberate, thoughtful method was a means of cutting himself free from the tangle of *plein airisme*: an emotional as well as a technical tangle, for to paint directly from nature was to be at the mercy of what you painted – a victim as well as a master.

Few painters can have carried off such an extrovert attitude in front of their work. (This is what separates him from post-Impressionism.) He utterly rejected the confessional, introspective side of Impressionism, the side from which Cézanne took off: if Cézanne left his canvases in ditches it was surely as most of us try to turn our backs on what is too close to us; if Sickert sold his canvases off in unopened bundles it was because he saw them as finished artifacts to be disposed of quickly according to the laws of supply and demand.

It was one of his big serious jokes to de-personalize painting – to make it the reverse of precious. It was a profession – and if English painters chose to look at it as a sort of spiritual hobby that was no recommendation for English painting. He really valued the years of comradeship with Whistler when he had painted off Whistler's palette. When a dealer asked him whether a certain picture was by him or not he telegraphed back "No, but none the worse for that." During the second half of his life he relied on assistants, photographs, prints by earlier artists: painting was a coinage, and it was in no way debased by exchange.

His admiration always went to the expert, never to the dilettante: he loved his favorite English painters because there was no art-nonsense about them:

> Turner was coloring views ... in the way of trade at the age of eleven. There was no greater mistake than to say that he survived this because he was a genius. It is the other way about.... Keene learned his trade "on the job" doing drawings for a three-penny comic paper to make his living.... It was on this diet that he became one of the master draughtsmen of the world.

But if Sickert rejected working in front of nature in favor of a more controlled method it was certainly not because he wanted to make things up. "Suppose," he told D. S. MacColl, who was much keener on what he would have called the poetry of the subject, "suppose that you paint a woman carrying a pail of water through that door, and drops were spilt on the planks. There is a natural necessary rhythm about the pattern they make, much better than anything you could invent." He put all his money on what he actually saw – he had to – he simply could not draw out of his head; indeed, he seems to have been devoid of that conceptualizing faculty

which many a lesser artist takes for granted. Those enigmatic dashes of light and shade that constitute the woman's head and arms in *Summer Afternoon*, one wonders how he could have expected them to be read: they could be bread pellets or torn-up newspaper. There is no equivalent in Degas or even in Monet for this dependence on the optical patchwork of light. Degas' treatment of light is driven along by classical drawing, even in his monotypes, surely the flattest things he ever did; light explains, orders, makes solids in space. One cannot tell what he's drawing from life and what he is inventing. But Sickert has no memory: the picture I have been describing is like a wonderfully harmonious man-made photograph, a flat spaceless map that tells its story with the most impersonal elegance in English painting.

But what kind of an illustrator is it who approaches his subjects like this? *Summer Afternoon* is one of a series he painted about a famous sex murder of the day. Others in the series are called *The Camden Town Murder* and *What Shall We Do for the Rent?*

A painter's style is defensive as well as aggressive, a mask as well as a manifesto. I cannot help feeling that perhaps the strongest factor in Sickert's development was his cosmopolitan origin. What was he, he might well have asked, born in Munich of a Danish father and an Irish mother and brought to England at the age of eight. For two years he was an actor. And being an artist was literally the performance of a lifetime. He had the energy to make many alternative readings of it and to gain a particular kind of confidence from each one. He was the traditional artist-craftsman, hard wood cut from the heart of the tree (of course as a painter he was no such thing); and he was the artist whom he met in Whistler's studio, the artist of *The Ten O'Clock Lecture* independent of place and time, a law unto himself, a man who

could turn anything into pictures. There is a tremendous pride in his words when he writes of his painter father, or when in one essay he defines his own descent:

> I am a pupil of Whistler, that is to say, at one remove, of Courbet and at two removes of Corot ... under the influence in France of Pissarro, aided in England by Lucien Pissarro and by Gore, the latter a pupil of Steer who in turn learned much from Monet, I have tried to recast my painting ... etc., etc.

There is no less pride in his exclamation:

> Anything! That's the subject of modern art!

Or in this declaration:

> He takes an armchair of American leather, and by a scribble produces something wonderful ... skill, selection may collocate a part of an ugly thing with a part of another ugly thing and produce a third which is beauty.... It is something new!

Again, it may have been his detachment from both England and France which allowed him to make the really remarkable synthesis, within which his shortcomings as well as his unique endowments could be exploited up to the hilt. I mean that in looking at French painting through anglicized eyes he was able to see Impressionism as a possible mode of dramatic rapportage – and looking at England was able to see that somehow illustration could be assimilated within modern painting. This is precisely what he is demonstrating in the Camden Town interiors, in *The Raising of Lazarus,* or the portrait of Victor Lecour; and if they are not quite the

great pictures we would like them to be, if we feel that the synthesis is brought off too neatly, that the halves of the equation cancel each other out, then this perhaps is because of the very detachment which made the synthesis possible.

34

P. Wilson Steer, 1860–1942

Catalogue introduction to an exhibition of the same name
Tate Gallery (The Arts Council), London
November 11, 1959–June 10, 1960

STEER AND SICKERT had much in common besides the coincidences of their life and death. They were the two mainstays of the London Impressionists, the advanced wing of the New English Art Club, and to the generation that followed them they were identified with Impressionism in this country. They were both the sons of painters and shared a painterly assurance that was rare in this country. Except for a few years neither professed to be exploring new ground: both carried a certain strain of defensive conservatism, hearty in Sickert's case, retiring in Steer's. If we examine this conservatism more closely we find that it is the key to the difference between them. Sickert kept up a familiar chumminess with the artists of the past ("I may say these things about Rembrandt. *Je suis très bien avec Rembrandt.*"), but he was invariably modern. Steer's relationship to his own times was equivocal. Capable of far greater originality than Sickert ever was, he looked at the old masters with nostalgia, with something of the passive devotion of the connoisseur; and he used them in a way that Sickert never did. He addressed the onlooker in the accents of their style. This difference between the two artists was fundamental and it explains how it was that Steer was, comparatively speaking, a success during his lifetime, and it explains why it is that now the slightest scribble from Sickert holds our attention

while much of Steer's work seems cut off from us by an intangible barrier of period and taste.

Sickert is an utterly whole artist; Steer a divided one. And yet it is partly this sense of dividedness, of promise and regression, of originality and banality, of life and passivity that constitutes Steer's fascination. Sickert was an exception in English painting. Steer, one has the uneasy feeling, was somehow typical of it, and we are under an obligation to look into his mirror.

From his very early youth Steer had been a collector of shells, of minerals and crystals, and of coins. His interest in numismatics, which was to last all his life, led him in his teens to think of entering the Coins and Medals department of the British Museum, but the academic demands were too much for him and he turned to painting. He worked at Gloucester School of Art under John Kemp and then, failing the entry to the R. A. Schools, left for Paris in 1882. Here he seems to have spent a respectable and sheltered two years, largely in the company of English students and making no effort to know French painters or advanced French painting. He saw the Manet retrospective exhibition shortly before he left; but his real contact with Impressionism seems to have been through pictures seen in London after his return. In Paris he worked first at the Académie Julian under Bouguereau and then for a short while at the Beaux Arts under Cabanel. His time was cut short by a rule introduced by the Beaux Arts which demanded a knowledge of French.

He settled in London. From now until the end of his working life he was to spend his winters in the studio working from models or from studies, and the summers off on long painting trips in the company of one or two of his friends. A companion of many years was Fred Brown who had been in Paris at the same time as Steer and who on his return had begun to teach at the Westminster School of Art,

making the place into a rallying point for young painters who were out of sympathy with the Academy and in sympathy with the French. Both Brown and Steer were foundation members of the New English Art Club which was founded in 1886, and both contributed to the London Impressionists' exhibition at Goupil's three years later at which the progressive painters in the New English declared their position. In 1893 Fred Brown was appointed Slade Professor at University College and he invited Steer to join him as teacher of painting. Although he does not seem to have been particularly interested in teaching, he continued at the Slade under Brown and then under Tonks until the latter's retirement in 1930.

However scanty Steer's contacts with French painting the fact remains that he was soon producing pictures of an extraordinary precocity. The Etaples pictures of the summer of 1887, although they owe a great deal to Whistler and through him to the Japanese, strike an entirely original note; indeed, the Tate *Bridge at Etaples* seems, with its extreme economy and its self-conscious and slightly mannered drawing on the flat, to anticipate *Nabi* painting of ten years later. Within a few years Steer was experimenting with daring juxtapositions of color and handling and even more striking formalizations. The summer of 1890 saw a series of direct studies in a singing Impressionist palette (e.g., *Poole Harbour*) and the climax of these seaside pictures came in 1894 with the Fitzwilliam *Children Paddling*. Here he used a kind of pointillistic touch, although, needless to say, it was entirely personal and anything but doctrinaire. His dots are decorative and expressive, but this feature, coupled with the obvious ordering of the palette gives a foretaste of what was to be a lifelong tendency in his painting, to work within a carefully controlled keyboard.

About 1895 an abrupt change comes over Steer's line of

advance. A deliberately anachronistic quality enters his work. Up to now he had, to put it crudely, been painting modern pictures, even if they were charged with a retrospective mood; but now he begins to experiment with styles drawn from the past. He turns from the fresh astringent light of the seaside to the gold and shadow of wooded landscape. He turns away sharply from the kind of composition used at Walberswick and begins to study the classical machinery of landscape composition in depth; from the shocks of unpredictable patterns to the familiar rhythms of what Sickert called the "August Site," the castles, rivers, vistas of the *Liber Studiorum*. Between 1895 and 1901 he looked at Rubens, Watteau, Gainsborough, Constable, and Turner, as well as more recent painters like Corot and Monticelli who had themselves traveled imaginatively into the past. And in the studio the transformation is even more striking, for here he moves away from the Manet–Whistler idiom in which he had been working and embraces an entirely different one in which the spaces of the picture are controlled by rhythmical handling rather than by the exact designing of flat areas. It is in the studio too that he presses his interest in the past to its furthest point with studies like the *Rape of the Sabines*, an odd compound of Tintoretto and Rubens, and the most ambitious picture of this kind, *The Toilet of Venus*.

Whatever the fascination of Steer's early work, it is by his painting of the period 1905–15 that he must finally be judged. It is here that he painted his most ambitious pictures; he had absorbed the lessons of the landscape masters and was working from within them with great personal freedom. MacColl suggests that he had abandoned working in oils in the open air by the mid-nineties but it is doubtful whether he had ever been systematic one way or the other. Many of his earlier pictures, small as well as large, have all the appearance of having been reworked away from nature, and at the same time it is

hard to believe that some of the most important later pictures were not carried a long way in front of the motif. The fact is that within the great landscape sequences, *Chepstow Castle* of 1905–06, the *Isle of Purbeck* of 1908–09, the *Severn* of 1909–10, there is a marked difference of quality that seems to correspond to his closeness or distance from the motif. In each of these groups of pictures there are some with an overbearing atmosphere of clubroom and museum and a tired, fumbled texture, as though he had worked under a compulsion to make his own private discoveries respectable, to dignify them in a worldly way. But there are others, the Tate *Chepstow* of 1905, the Walker Art Gallery *Corfe*, in which his imaginative grasp of weather and light does not slacken and the paint plays truly all through the picture. With these pictures his art reaches a unique pitch; they are among the few landscapes of this century in which the painter's intensity of vision gives an almost tragic value to the subject.

Steer's inspiration was visual; unlike Sickert's it was not based on drawing, a consciousness of shape, but upon a consciousness of the moods and movements of light. Any idea of "finish" in the sense of a formula was inimical to his inspiration, and the more he felt compelled to finish a picture in an acceptable way the further he was driven from the true sources of his feeling. It is for this reason no doubt that as he grew older he was prepared to accept the possibilities of watercolor, to see that the medium held, for him, an unlimited promise. Here he could outflank the demands towards finish that the oil medium seemed to impose, here he could accept the most daring transpositions and abbreviations under the necessity of the medium. They are slight, certainly, these hundreds of studies that he made during the last decade of his working life, but they have a sparkle, a sharpness, an authenticity that brings one closely against his true character as an artist

His life was uneventful, his character unspectacular. He lived surrounded by admiring friends who, so it appears, protected and isolated him and shored him up with their admiration. There is no doubt that there was a streak of self-indulgence, of intellectual laziness in him: it is reflected clearly in his work. And the more one admires the qualities of his work the more impatience one feels with his lack of self-criticism, his passivity. There is something mysterious about the way in which his talent was disguised, deflected. The center of the mystery is in the way in which he embraced the past. It is here that one can isolate what was perhaps the dominating characteristic of his imagination and here too, that one can most clearly see the way in which he was swayed by the contingencies of his time.

In an early sketchbook used at Walberswick in the 1880s, buried among sketches of children on the sands, there are drawings for invented compositions, friezes of dancing figures which might have been fragments of a projected *Triumph of Bacchus* or an *Homage to Venus*. This juxtaposition of observation from real life and imaginative invention is characteristic of him. Everything that he looked at was saturated with "otherness," a romanticism of other places, other times – he was, after all, an artist of the *fin de siècle*. Everything seen had its resonance and the natural course of his art led him from observation to memory and reflection and fantasy and back again. When he looked at his favorite models he saw them in an aura of poetic mystery, like faces glimpsed occasionally in passing taxicabs. And the early seasides are charged with an extraordinary weight of feeling: an ardent moment is suspended in which everything is remembered and everything is imminent.

What seems to have happened is that as time went on the wish grew to make this "poetic" feeling manifest, to give it a stylistic attachment and at the same time to ensure that

there was nothing gross left in his naturalism. It is instructive to contrast the *Toilet of Venus* with a picture that may have had some influence upon it, Manet's *Olympia*. The traditional elements in the French picture enhance rather than mask the modernity of Manet's vision. It is as though the past is used to dramatize and enrich the present; but the same could never be said of Steer. With him the historical elements are the purest masquerade, pulled on like fancy dress to blur and dissolve. The stinging present is replaced by an imaginary time, nostalgic, drifting, the eighteenth century of Beardsley's *Under the Hill* or Conder's fans.

It must be remembered that the English response to Impressionism was conditioned by two factors already existing in the English scene: Pre-Raphaelitism and Whistler. From the first the young English painter of the eighties inherited a belief in "nature" qualified by "poetry"; from the second a notion of the picture as a harmonious distillation, an aesthetic object, withdrawn to some extent from the hard edges of reality. Insulated from French painting in this way, it is doubtful if anyone recognized the revolutionary *content* of the Impressionist style: certainly there were those who recognized the value of an art of real life and others who recognized the value of a clear and luminous palette, but the style itself was superficially too near to Constable, Turner, the Pre-Raphaelites, and essentially too distant, for its meaning to be understood. *Plein airism* had been taken over by those who had modeled themselves on Holman Hunt and Bastien-Lepage rather than on Monet, and it had become discredited. From the outset it had been argued that Impressionism was "formless." Thus it was not surprising that during the course of that remarkable revulsion of taste which followed Wilde's conviction, the collapse of the aesthetes, that opinion should turn against everything which was modern and French (decadent) for purely parochial reasons.

The Impressionists were sorted through for anything which could be related to the groundwork of English painting: Degas and the illustrators of the sixties, Pissarro and Constable, Monet and Turner. And it went much further than this, for connoisseurship, which was the respectable residue of aestheticism, referred the Impressionist touch back to Gainsborough and indeed every painter whose handling had bravura and vibration. Everything which could not be forced through this mesh was rejected: hence the extraordinary myth of Constable's influence on Pissarro and Monet, of the Pre-Raphaelite influence on the Impressionist palette. George Moore, the pundit on the subject of French painting, declared that "Art has fallen in France, and the New English seems to me like a seed blown oversea from a ruined garden."

Steer was the natural victim in this situation and he was sacrificed mercilessly to a retrograde and chauvinistic notion of English art. (Others no less talented have had the same treatment since.) From the first he was discussed not so much as an advanced artist but as an heir to the past. As early as 1892 MacColl bases a review on a comparison with Romney; eight years later we find him comparing him with Constable. This was to be the constant tenor of Steer criticism: a modern Constable whose vision was true to the frank, lyrical, nature-loving unintellectual spirit of English art.

The only reason why this matters at all is that it is perfectly clear that Steer's development was affected by it. When MacColl compared him with Constable it was to the latter's disadvantage. Tonks held him to be the greatest living painter and did not hesitate to say so. Steer, who dreaded notoriety, conflict, adventure was, one imagines, very pleased to bury himself in this atmosphere. To Tonks and the rest of his friends, art was something of a sacred mystery: this was one of the reasons for their horror of Fry's theorizing. Steer, with

his thoughtless talent was the epitome of the mystery. And in playing the part of the intuitive, the heavily built holy fool of art he was doing himself an injustice at the same time as he was flattering the lean and hungry intellectuals who surrounded him.

And yet his stature remains, whatever the disappointment we might feel in his life's work as a whole. He was a better painter than his admirers knew and for reasons that they would barely have recognized.

He had two incomparable gifts: a profoundly imaginative response to light and a parallel feeling for the expressive life of paint. His approach had nothing of Sickert's cool expertise; it was a far more chancy, (and often) a more strenuous thing. His paint for all its deceptive awkward elegance, is under stress; even in his most labored pictures there seems to be an energy in his paint which is longing to burst out, to "come right" with sense and meaning. "Every time I start a new picture I feel it is like learning to swim all over again," he remarked to Collins Baker, and it is true that each picture is unpredictable in the detailed syntax of the paint. He relied heavily on the compositional conventions of picture-making but it would be a complete misreading to take him for a mere picture-maker. He valued his subjects profoundly, special places, special memories, and he could never have said with Sickert "Anything, that's the subject of modern art." Was it because the subject stimulated him so intensely that he leaned back so heavily upon the conventional forms? Sometimes the conventions look like crutches on which to support the living light, sometimes like shields for him to shelter behind. The extraordinary fact is that if the picture went right, the original stimulus could cut through any convention, any cliché, and even though he was looking at the world through gilded and varnished spectacles each picture was an experiment of which the outcome was uncertain.

Encounter
December 1960

FROM THE MID-1880s, when the English could no longer avoid measuring themselves against their contemporaries in France, until the mid-1950s, artists and critics have been looking for those among their number who seem truly to understand what French painting is about; and at the same time (it is the other side of the coin) for those who seem to stand in the clearest and most distinctive contrast to the French. It has been as though the confidence and self-respect of English art has depended upon its ability to square this circle: to demonstrate its grasp of the most important art of modern times *and* to prove its independence from it. Thus an artist like Duncan Grant or Elliot Seabrooke or Patrick Heron has been of interest as much for the interpretation he has made of Cézanne or Seurat or Braque as for the intrinsic value of his work; and similarly a Stanley Spencer, a Lowry, or a Lynn Chadwick has been estimated as much for his "Englishness" as for anything else. When an artist appears whose position can be discussed from both directions, a Graham Sutherland, a Wyndham Lewis, a Victor Pasmore, he becomes a cultural hero. Steer and Sickert are the archetypes of such heroes.

Both appeared at a time when art and art scandal were popular news, a situation made by Whistler and Wilde as much as by the distant repercussions of events in Paris. They were at the center of the scandals that greeted the early exhibitions of the New English Art Club, miniature

echoes of the Impressionist exhibitions of fifteen years before. Both contributed to the *Yellow Book*. After 1905 both had achieved their own kind of celebrity and from then until the 1930's were accepted as the central figures of English painting against whom younger artists measured themselves. From the start of his career, Steer was warmly supported by D. S. MacColl (who in 1892 compared him with Romney to Romney's disadvantage, and in 1900 placed him above Constable), George Moore who described him as "the only painter in London who could fill the blank that Manet's death had made in my life," and an influential circle of admirers. A picture by him was first acquired by the Tate in 1906, and he was the first living artist to have a retrospective exhibition there (in 1929).

Sickert's reputation, during his lifetime, was a far less public one. His authority among his contemporaries rested first on his friendship with Degas and other French painters. He went out of his way to avoid permanent bonds with the circle that surrounded Steer and did all he could to give an impression of unpredictable frivolity. Naturally he had nothing like the same official success; however from his return to England in 1905 until the middle of the war he was at the center of the art-politics of the time, as the host of all the advanced artists at his Fitzroy Street studio, as a co-founder of the Camden Town Group, the Allied Artists' Association, the London Group. And during this period he was not only writing vigorous criticism but also teaching a succession of students.... But it was not until the 1930's that his reputation began to soar to its present height. A new generation of painters, men who had grown up *since* the cubist revolution, rediscovered him and turned to him as to the source of a particular interpretation of realism. There was a retrospective exhibition at the National Gallery just before his death, and from this point onwards it has

been the more or less accepted view that he was the most important and best English painter since Turner.

The case of these two is admittedly a domestic matter. It would not be simple to defend a Steer landscape or a Sickert interior to a Frenchman, at least not on the grounds that one would wish. He no doubt would see in it only the crudest reflections of his own nineteenth century and would be embarrassed rather than entertained by the English accent. Steer and Sickert are not artists by whom we could hope to be fairly judged abroad.

And yet whatever their proper position as artists, the fact remains that their historical importance to English painting is unassailable. Their working lives stretched from the 1880s to the 1930s, that is to say they spanned the transition from the decadence of the nineteenth century into twentieth-century art. They responded in ranging degrees to this transition; at the same time, they were catalysts, as it were, of a continuous critical evolution during this time. Their work and their reputations are in themselves a history of the key problem in painting at this time. It goes without saying that modern art grows out of Impressionism, that Cubism is unthinkable without Monet. Half of the problems that English art has encountered in its interpretations of twentieth-century French art are the consequences of the fact that Impressionism was itself a foreign language; and this difficulty has been confounded further by the fact that by coincidence (the sketches of Constable and Turner, the palette of the pre-Raphaelites) the Impressionism of Monet did not look as foreign as in fact it was. This has given a characteristic slant to all subsequent developments, to Roger Fry's assessment of Cézanne, for example, or Wyndham Lewis's definition of the modern artist, or Ben Nicholson's response to abstract art. In trying to understand the evolution of our painting during the present century it is tremen-

dously important that we should understand the first English overtures towards Impressionism; for this reason, before any other, Steer and Sickert demand our attention.

The best painting done in England during the years before the foundation of the New English Art Club was distinguished by its reverential attitude towards nature. Of course this had little to do with realism in the continental sense. However searchingly Ruskin analyzed the strata of rocks or Rossetti examined the tendrils of the honeysuckle, neither was concerned with anything that would place them beside Courbet or Manet. Theirs was the reverse of a materialistic thought; it was rather a matter of ideals and sentiment.

But by the 1880s a new ingredient had transformed the scene. Whistler had been in London since 1859. His collision with Ruskin occurred in 1879. His work, which was widely known, and his ideas, publicized by himself and Wilde and others, called up a new climate, a new sense of what painting could be.

> That nature is always right is an assertion artistically as untrue as it is one whose truth is universally taken for granted.

And

> Nature contains the elements in color and form of all pictures as the keyboard contains the notes of all music. But the artist is born to pick and choose and group with science those elements that the result may be beautiful.... To say to the painter that nature is to be taken as she is is to say to the player that he may sit on the piano.

English Impressionism, such as it was, was born by *Modern Painters* out of *The Ten O'Clock Lecture.*

The young painters of the 1880s accepted Realism as the proper point of departure for modern painting. That is to say, anecdote and decorative invention were to be suppressed in favor of the thing seen. "Suppose," Sickert told D. S. MacColl, "that you paint a woman carrying a pail of water through that door, and drops were spilt on the planks. There is a natural necessary rhythm about the pattern they make, much better than anything you could invent." But this is not to say that London Impressionism, even Sickert at his most forceful, had much in common with its continental predecessors, with Monet's reckless indifference to the conventions of picture-making, or Degas's rage for actuality.

> Impressionism [Sickert again, in his introduction to the London Impressionists' exhibition at Goupils, December 1889] has no wish to record anything merely because it exists.... It accepts as the aim of the picture what Edgar Allan Poe asserts to be the sole legitimate province of the poem, beauty....
>
> It does not admit of the narrow interpretation of the word Nature which would stop short outside the four-mile radius. It is, on the contrary, strong in the belief that for those who live in the most complex city in the world, the most fruitful course of study lies in a persistent effort to render the magic and the poetry which they daily see among them, by means which ... are offered to the student ... not so much on the canvases that yearly line our shows of competitive painting, as on the walls of the National Gallery.

Art for Art's Sake, as it worked itself out during the nineties, took on a double meaning, re-drawing the distinction between art and nature and in doing so, claiming more of nature's material. Everything that life yielded, it told the

artist, was grist to his mill. So the aesthete placed objects before ideas and sensations before objects; so the painter discovered the city, shadows, tenements, London's appalling fog. After the turn of the century it became respectable, and the excitement went out of it; it degenerated into a sanction for vacuity; it bred the purposeless sketch and the figure composition and it created an emptiness of thought that the more vigorous minds tried to fill with something they called poetry. But all through the nineties Art for Art's Sake was the most live idea current and it put a strange stamp, both daring and reserved, on the work of any artist who was touched by it.

The "aesthetic critic" that Wilde described in *The Critic as Artist* turns away from the "obvious modes" that deliver their message and are then silent, and turns to embrace "such modes as suggest reserve and mood and by their imaginative beauty make all interpretations true and no interpretation final." If Wilde had been another man he might have found these modes in Sickert, in Steer's interiors, in the best of Maitland, Lavery, Starr, for here the withdrawal or the obliqueness of subject matter adds a positive quality which we cannot miss even now: they seem to be always hinting, playing on the nerves of an audience used to having its subjects explicit. Certainly there is little like this in French art. Ingres' *La Source* does not strike us as a picture in which nothing happens, nor does a Renoir nude, and even the most bizarre of the early Vuillards gains its effect not so much from the abandonment of a subject as from the abandonment of a canon. "Why not frame the sonnet?" Whistler asked Rossetti, when he was shown a poem that went with a picture. He could not see the connection between the two. His English followers could, and they took the more daring step of leaving the poem unwritten.

Although it is outside the scope of this article to discuss

English Impressionism as a whole, it is necessary to take account of some of the ideas connected with it which affected both Steer and Sickert even if they rejected them.

50 An important faction of the New English Art Club during its early years was made up of painters who had studied in Paris and learned the conventions of naturalistic tonal painting. They had come under the powerful influence of Bastien-Lepage, who had died at the height of his fame in 1884. It is not difficult to understand his appeal to the English; he was perhaps the most Victorian of French painters. His subjects were drawn from peasant life and struck a familiar note of sentimental concern for the poor and picturesque. Also he was a doctrinaire *plein airist* and this was eagerly seized upon by his English followers as the minimum platform from which the view could be maintained that nature was always right. Working in the open air ("Everything from a Kit-Kat to a seven-footer," as La Thangue told an interviewer) they produced a body of pictures of fishermen and peasants in the tonality of over-exposed photographs, extraordinary for their uniformity of manner and depressed romantic atmosphere.

The whole cast of Sickert's character was foreign to the good-earth mysticism of these painters. There was a dramatic collision between them in, of all places, the memorial volume to Bastien-Lepage which appeared in 1892. Sickert contributed an essay in which he attacked the *plein air* method, and contrasted it with that of Millet:

> Millet observed and observed again, making little in the way of studies on the spot ... and when he held his picture he knew it, and the execution was the singing of a song by heart and not the painful performance in public of a meritorious feat of sight-reading.

Sickert's training gave authority to his attack. Under Whistler, who painted his portraits from the model, he had seen too many failures to have any confidence in direct painting. He mistrusted the amateur in Whistler; his pictures were not "brought about by conscious stages each so planned as to form a steady progression to a foreseen end ... they were a series of superimpositions of the same operation." His meeting with Degas confirmed his belief in the traditional methods of painting and from then on he was able increasingly to separate drawing and design from execution. He took to squaring up his drawings, ordering his palette with premixed tones, under-painting, and calling on all the traditional studio procedures.

Thus the painter who was in the best position of all to interpret Impressionism to the English was, from the first, arguing against the experimental empirical aspects of Impressionism. The characteristic value of the Impressionist touch was for him a self-sufficient thing. What was it, he asks, that one gained from a modern picture when one approached it closely? "Not new facts about the subject ..." but "a subtle attribute which painters call 'quality' ... a certain beauty and fitness of expression in paint, apparently ragged perhaps, and capricious, but revealing to the connoisseur." In an essay published in 1892, D. S. MacColl had this to say:

> Drawing is at bottom a kind of gesture, a method of dancing upon paper. The dance may be mimetic; but it is the *verve* of the performance which impresses ... (the draughtsman) wishes to convince the imagination, not to delude the senses; and the sheer beauty of handling will do this more effectually than a death-like projection or a multitude of circumstances.

It is plain to see how this idea of drawing, which attaches itself naturally to the handling of paint, bears fruit later in the *bravura* of a John or a McEvoy. But it is important to remember its origins in the aesthetic movement, in the cult of the elliptical, of quality for its own sake. The Ruskin–Whistler action was really all about this, a division between painters in which Whistler, Albert Moore, and the rest could, and Frith and Burne Jones could not, see a picture as an aesthetic object as well as an aesthetic representation.

Sickert's love of his material and his rough yet exquisite handling of it is an entirely self-contained quality in his painting. Compared with the handling of any French painter, even Vuillard, it seems to live a life of its own, nearly indifferent to the forms it represents. We can if we choose look at one of his canvases and see nothing but energy and intelligence and sensibility in self-absorbed play with material. It is as though in each painting he was endorsing, under his breath, Maurice Denis's dictum of the picture being first a flat surface covered with colors in a certain order. And it was precisely this confidence in the play of painting that gave him his extraordinary freedom over his subject matter. He, almost alone among his contemporaries, was untouched by "poetic" ideas. Painting is illustration, he would declare, daring his friends to call him flippant. This frank admission left him free to sustain his craftsman's objectivity and provided his art with its most outstanding quality: an ironic balance between the sharp human meaning of the scene and the visual attributes he abstracted from it. Never was a famous monument gilded by the rays of the rising sun recorded so drily as St. Mark's was by Sickert, nor a sex murder reported with such elegant indifference as the Camden Town Murder.

Almost before it had begun to be wild the New English Art Club turned towards the past. Sickert's portrait of George

Moore, the *Yellow Book*, Steer's early seaside pictures had had scandalous receptions but they were on a literary level; already in 1895 Moore was writing in a review of the club's annual exhibition: "a little reef is enough to bring about a great shipwreck; a generation has wasted half its life [*i.e.*, at trying to paint in the open air] and the Old Masters are again becoming the fashion." The speedy retreat from *avant-gardism* (however mild) can be seen as a move forced upon it by pressure from the outside and also by certain tendencies inherent in the position adopted by the painters themselves. 53

As to the outside pressure, two factors are particularly important. One is the general change of climate that followed Oscar Wilde's conviction, and the other is the appointment of Fred Brown to the Slade professorship and the gradual identification of the most important art school in the country with the New English Art Club.

Wilde went to prison in 1895. During the next five years the world of the aesthetes collapsed. "I implore you to destroy *all* copies of *Lysistra* ... by all that is holy *all* obscene drawings," wrote Beardsley from his deathbed; and Yeats, looking back at 1900:

> Everybody got down off his stilts ... nobody drank absinthe with his black coffee; nobody went mad; nobody committed suicide; nobody joined the Catholic Church....

And this headlong renunciation of "decadence" that went with the Boer War, the Barrack Room Ballads, and the Diamond Jubilee was also a boom in "healthy" British sentiment (for "decadent" meant French as well as everything else: "Its fang de sieckle that does it, my dear, that and education and speaking French....").

This provided part of the impetus for the extraordinary nationalistic interpretation of Impressionism, held in varying

degrees by MacColl, Tonks, Steer, and their circle, of which the most extreme expression was given by Wynford Dewhurst:

> It cannot be too clearly understood that the Impression-istic idea is of English birth. Originated by Constable, Turner, Bonington, and some members of the Norwich school ... like most innovators they found their practice to be in advance of their age... the French artists simply developed a style which was British in its conception.

Of far greater interest than this claim, which is after all not much more quaint than Pissaro's counterclaim that Impres-sionism was descended from Clouet, was the opinion gener-ally held that French art was in the decline. Degas was spoken of as the last of the Masters; Moore spoke of the New English as a seed blown overseas from ruined France, and he encouraged English painters to believe not only that French art was dead but also that it was their duty to realize themselves as British artists. And, of course, at the time when artists in London were trying to take stock of Impres-sionism and to find out what it meant to them, the style was meeting the full flood of reaction in Paris. The New English was founded in the year of Seurat's *La Grande Jatte* and when in the late nineties the ties between London and Paris were strengthened by younger men, Rothenstein, Conder, John, the Synthesistes were in full pursuit of the primitive, the medieval, and the "permanent."

In England eyes that had learned to look at Manet and Monet now looked again at Velázquez. And before long the Impressionist mark was placed on the same level as any other painterly mark. Impressionism, it appeared, was no more than a nineteenth-century, French, and rather bour-geois application of what Velázquez and Gainsborough and

Hals had been doing all the time. Connoisseurship, the respectable residue of aestheticism, prized the art of Manet, Monet, and Pissaro away from the nineteenth century and returned it to the old masters.

The presence of Brown, Tonks, and Steer at the Slade had in itself a reactionary effect upon the New English Art Club. They were determined that drawing should be taught on a sensible academic basis. Brown had himself experienced the absurdities of art-teaching current at the South Kensington Schools. There, he wrote later, "the idea of working by construction did not exist. The word plane was never mentioned...." The problem of teaching drawing, "resolves itself into a question whether art should be taught on a basis of science, or of something vague and indefinable, varying with the bias of the teacher.... Structure, the laws of optics, the relation of the parts to the whole, etc., can be taught."

A characteristic quasi-Florentine style of drawing was developed at the Slade. It was a style that only made sense if it was related to an ideal of form, an ideal drawn from the old masters. It was certainly not impressionist in the sense of conveying an impression of a thing seen under certain circumstances. The fact is that Tonks, convinced naturalist though he was, had as little understanding of Impressionism as he had sympathy for anything after it. Rossetti was the first and profoundest influence on him and the typically pre-Raphaelite notion of "poetry" always came between him and the outside world: "What has made (painting) partly understandable to me is the idea of Poetry, by that I mean that part of us which seeks to express the spirit...."

Wilson Steer's retreat from the brink is perhaps the most revealing factor in the whole situation. His painting between 1885 and 1895 was the most advanced that was being done in England; every aspect of the Walberswick seasides was daring and unorthodox in the context of English painting

and also vis-à-vis the French pictures from which they derive. On the surface these pictures appear to be attempts to transplant the vision of Monet to the English coast and countryside. Yet one rarely feels in Steer the pressure of actual observation for its own sake. His approach was a synthetic one even when it appeared to be the opposite, and the Whistlerian artist "born to pick and choose and group ... that the result may be beautiful" is never far away. But beautiful is not to be detached from "poetry," a mood, a dreaming world. These children, mooning or possessed or running into the orange sunlight with their *art nouveau* bows flying, they are drawn from the same soil as the *Turn of the Screw* or *Dream Days*.

The detailed notation of Steer's paint is, unlike Monet's, both illusionistic and aesthetically self-conscious. For instance, in the Fitzwilliam's *Children Paddling* the shingle in the left foreground is represented by a mass of dots which is both meticulously rhythmical as a pattern and also performs a sort of paraphrase of perspective. On the right the surface of the water is defined by an arabesque of glittering white blobs. There is an extraordinary and disturbing tension between the self-conscious pattern of these highlights and the way in which the children and the boat gliding in from the right are established in space. A brilliant sense of the all-absorbing impact of sunlight is combined with the feeling of an artificial, timeless world, far removed from our own. The particular quality of the light, one feels, is valued not for its own sake but because of its resonance: it is the light of childhood holidays, sand castles, shrimping.

Although Steer never lost this grasp of light (it was his greatest gift), it was not long before his dreaming, a sort of nostalgia for a time-without-time, that in his early work was satisfied by the children on the beaches, transferred itself to

the past in art. By the mid-nineties he was already playing with style, making *pastiches* of Gainsborough, Velázquez, Corot, indeed of any example from the past which approximated to the loose handling and blurred definition of Impressionism. The first high-point of these studies was the *Toilet of Venus* (Tate) of 1896 which was painted in the grays, pinks, and lemons of Velázquez and evoked a make-believe Fragonard. After this picture his work was never quite the same. By 1900 his landscapes had lost most of the cool, crisp colors of Impressionism and had drifted off into a golden haze. He visited the famous picturesque sites, Turner's *Liber Studiorum* in his pocket (MacColl tells us). Pictures like *Chepstow Castle* and *Richmond Castle* are declarations of an entirely different set of values to the earlier seasides and bohemian interiors. The field of vision is wider, more panoramic, as though he were acknowledging a greater responsibility. Nothing could define the differences between the youngster of the *fin de siècle* and the Edwardian success more accurately than a comparison of the scatty off-center placing of the figures in the Tate's *Walberswick Beach* and the centered keep of *Richmond Castle*, rolling clouds above, hunters exercising in the middle distance.

After several years abroad, Sickert came back to London in 1905 to find a very changed situation. He and Steer were no longer in the vanguard of affairs; a new generation was dazzling the New English with its precocious brilliance and already John, Bevan, Ginner, Gore, and others had made their own contacts in Paris and were beginning to reflect the influence of Post-Impressionism, of Gauguin in particular. Cézanne was first exhibited in London in 1905 and from this point onwards his name crops up in every discussion. The issue between the London Impressionist generation and their successors reached its climax when Fry introduced

the second of his Post-Impressionist exhibitions (autumn 1912) which included not only Cézanne, Van Gogh, and Gauguin, but also Fauves and Cubists.

58 Steer and his circle turned their faces against Cézanne. So did Sickert, although less unambiguously and with less rancor. For one thing he owed it to his reputation to establish that he had known all about Cézanne for years: "now, to us, born – in parts – of the Impressionist movement, Cézanne has always been a dear, a venerated and beloved uncle. We have known him all our lives...." But the difficulty lay first and last in Cézanne's distortions.

> Cézanne, less than anyone, achieved significant form. What is the first gift needed to achieve significant form? A sense of aplomb.... Cézanne was utterly incapable of getting two eyes to tally, or a figure to sit or stand without lurching.

And MacColl echoes this more cheekily:

> ... But the figure was too difficult for him, and from difficulties of all sorts he escaped into still lifes ... flattened jugs, apples, and napkins like blue tin that would clank if they fell.

Accepting the legend of Cézanne's own dissatisfaction, they singled out those very qualities in his work which were indicating a new realm in painting and held them up as evidence of his incompetence; the internal rhythms, the interplay between the canvas and the motif, the all-over interlocking of sensation and design, these, in the eyes of Sickert and MacColl were no more than the eccentricities of a fumbling incompetent.

 Now this fantastic misunderstanding, fantastic because

it was on the part of such intelligent and gifted painters, would be of little interest unless it could be connected with their own position as painters. The fact is that it is founded in their own relationship with Impressionism, above all in their own failure to assess the content of Impressionism.

Sickert, we have seen, was more or less indifferent to that side of Impressionism which was represented by Monet; that is to say, that which is based on direct contact with the motif. Somewhere he speaks of "the kind of insensitiveness, the necessity of falling back on subjective habit and formula that the dogma of the actual presence of the model brings with it...." And he argued strongly against *plein airism* when the movement was at its height during the eighties. This is a crucial point. "The kind of insensitiveness" he speaks of is a reality when an artist is attempting to make a convincing replica of his subject or to illustrate its character from the life. There is always a conflict between the physical presence of the thing he is painting and those characteristic attributes which he wishes to extract from it. The illustrator must approach his theme through the medium of memory. But the art of Monet is the antithesis of illustration; it is a realism of sensation. That is to say, the impressionist painter's criterion is not "Will that provide a convincing description of what it was ... ?" but "Is it true or false to my present sensation of it ... ?" And Sickert's indifference to this new question led him to ridicule Cézanne for attempting to do what he took to be impossible. He speaks of the "Tragic slowness of Cézanne's method" as though Cézanne was in the same camp as Bastien-Lepage.

Steer was no more able than Sickert to grasp the unprecedented character of Impressionist content. Like Sickert he needed some sort of barrier between himself and what he was painting: without it picture-making would have been impossible. Sickert found this barrier in his rationalized,

craftsmanlike methods; Steer found it in the models that he borrowed from the old masters. Just as ritual and protocol might remove a man from the anxieties of human relationships, so the forms of traditional landscape composition removed Steer from the raw nagging of actual experience. He was able to filter off just what he wanted from actuality and no more. As Sickert was freed by his method and could take full command of a pattern of flat shapes, a telling illustrative gesture, so Steer was freed by Turner and Gainsborough to exploit the light of a particular scene and play its glitter or mellowness or serenity to its conclusion.

Their alienation from what one takes to be the heart of the modern tradition as it descends from Impressionism is exposed more clearly than anywhere else in the quality of their drawing, in the way in which they define individual forms in space in relation to the picture surface. It is rare in the work of either of them to find a passage where the brush seems to lock on to a form, or to feel that the progress of the picture constitutes a search for clarification or articulation or understanding. Sickert separated drawing from painting; his brush strokes are a filling in. It never seems to matter to him that a certain shape in pencil on a piece of paper four-inches-by-six has a character and significance which is utterly different to when it is an area of color on a canvas sixteen-inches-by-twenty-four. This is why, in spite of the marvelous quality of his drawing and his grasp of tone, there is always a certain thinness in the spaces, in the positioning of things in his pictures. Steer's sense of shape was infinitely less advanced than Sickert's; he seems rarely to have questioned the appearance of things in this way. A hand in one of his portraits is skated over as though all that mattered to him was that it should be recognized as a hand; a tree will be dashed in with incurious fluency almost as though he was relying upon the sort of pattern-formula that

used to be found in old books on landscape. It is rare that any of his pictures will continue to read consistently as one approaches them closely; it is painting at arm's length.

Any important change of style or sensibility, or one might say, any important artist, modifies the current ideas of what an artist is, what he stands for, and what can be expected of him. The character of the aesthetic movement in England owed a great deal to the fact that it was sponsored as much by writers and dilettantes as by artists. It had a strikingly self-conscious character that was sharpened by the philistinism of Victorian society. The artist became a new sort of hero. Both Steer and Sickert were affected by this self-consciousness and, in retrospect, one can see how their development as painters was restricted by it.

Steer was anything but an intellectual. What grasp he had of painting was intuitive. But the circle that surrounded him so closely consisted of intellectuals, and above all of men with strong ideas about artists. Steer became their tribal god, the great intuitive. Tonks, who clearly felt as passionately about Steer as he did about painting itself, has left an indestructible image of him, one that is confirmed by MacColl and Moore and the rest. In an *Evening at the Vale* Steer snoozes heavily, his head sunk, while Moore reads aloud and Tonks himself poses alert and critical at the mantelpiece. If Steer wakes up at all it will be to yawn a remark of such stunning simplicity that the brilliant ones will be stopped in their tracks. "The master stands in no relation to the moment at which he occurs – a monument of isolation – hinting of sadness – having no part in the progress of his fellow men." Would so much of Steer's work have fallen below his own best level, one wonders, if he had not worked in so indulgent a milieu?

The anti-intellectual prejudice of Steer's circle (as far as painting was concerned) surely affected their attitude

towards Roger Fry. They were willing to accept Cézanne as some sort of half-wit, the peasant of Vollard's imagination. What they could not stand was to see a word-man like Fry, who had consistently criticized Impressionism for its lack of intellectual content, building an elaborate and abstruse theory around Cézanne. It seems likely that the virulence with which they repudiated Fry was due in part to their knowledge that they were themselves no more holy fools than he was.

Sickert tended to see these controversies, as all painters do to some degree, as straight conflicts between those who knew what was what (the painters) and those who had to invent explanations (the pundits). In one article he talks about painters as elephants who go where they like and critics as monkeys who ride on their backs and imagine that they direct them. The position that Sickert took up in relation to the Steer–Tonks circle was that of the professional craftsman. As time went on and the Post-Impressionist snowball grew, he turned increasingly to the English artists whom he admired most, the illustrators of the sixties, the men who worked more as journeymen than as artists in a modern sense. They were the men who knew their job, the professionals. In his criticism he was more likely to quote Poynter or Keene or Sullivan than Whistler or any other art-conscious artist. He became an A. R. A. in 1924, and one sees this gesture as a shot fired not only at the theoretical gymnastics of the modern movement but also at the precious high-mindedness of the Tonks circle. There is no doubt that this attitude, this hearty shrugging-off of personal idealism, placed a limitation on his development. If he had been less happy to rely upon a well-rehearsed procedure in painting, if he had been prepared to think of his pictures as something other than as impersonal artifacts, he would perhaps more often have achieved that compelling tension which

fills his few best pictures and which places them in a class apart in English painting.

What was it that Impressionism introduced that transformed the language of painting? It was the assumption that the content of painting was subjective; that a modern painting was not so much a *view* of something as the outcome of thought and feeling and observation about something. If it was a view of anything it was a view of a relationship and it was essential to this relationship that it evolved from a painting-situation; thus painting the picture was experiencing whatever was painted, feeling about it, defining it, reconstructing it. Impressionism disposed of subject matter in the old sense, but it did so to make room for all this.

And it is exactly all this which eluded the English; neither Steer nor Sickert were modern painters in this sense. But it was a close shave; modern characteristics are immanent in their work – the George Moore portrait, the *Servant of Abraham*, certain of Steer's direct studies from the model, the Liverpool *Isle of Purbeck*. They ended up painting out of an attitude, sheltered, as it were, from the rigors of their own best work by the formulæ of craftsmanship and connoisseurship. How was it that the Impressionist attitude meant nothing to the English, even when all eyes were on Impressionist painting? The most effective answer is the simplest: such an attitude could only come out of an educated and proficient tradition, an ambitious milieu. In England there was no such thing and for this reason Painting-for-Painting's-sake was a literary conception, not a real land towards which the painters' paths naturally converged. English painting during the second half of the nineteenth century was incorrigibly amateur (despite the fortunes made at the game) and the painter whose talent and education was matched by his seriousness and intensity was an isolated

exception. The Impressionist attitude called for too great a renunciation, in the English context; to jettison what one valued but had never really possessed was unbearable. It was natural that Sickert should, among other things, try to *recover* an illustrator's expertise, that Steer should try to recover the language of romantic landscape, just as later it was natural that a Wyndham Lewis should see Cubism as a recovery of Quattro Cento disciplines or that a Matthew Smith should use *Fauvisme* to recover the Venetians or that a Graham Sutherland should use Picasso as a divining rod for the English romantic tradition.

The Listener
November 11, 1965

WHEN *The Mud Bath* [Fig. 5] was first seen by the public at the Chenil Gallery in 1914 it might have seemed two different pictures to two different visitors. To the ordinary visitor it must have looked a folly, a meaningless piece of modernism. To the painter's friends and colleagues it must have seemed a major victory, a manifesto of the new art. Neither observer would, I suspect, have tried very hard to discern its subject matter; the one because the picture would have been indecipherable, the other because the subject would have seemed irrelevant. But now, looking at the picture after half a century of abstract art, the subject appears not only clear but also important to the sense of the picture.

We are looking down on a rectangular bath; this is the red area. The ochrey yellow is the pavement round it. A dark pillar juts up from the near edge of the bath, cutting the top of the canvas. Now the animated blue and white strips resolve themselves into figures, some in the bath, others disposed round its edge. The small study for the picture gives a clue to their animation: it is a kind of sauna; maybe they are whipping each other. As figures they are far-fetched, and it is not always possible to see where one ends and another begins, but we can see that some are sitting, others reclining, others standing.

It is a highly original picture, but like any work of art it has roots. It is absolutely of its time: all the enthusiasms of

those last pre-war years are contained in it at boiling point. But we do not get very far if we think of it simply as an English example of Cubism. We have first to remember the circumstances in which Cubism came to be known in London.

England had been comparatively isolated from Continental art for several decades. Only a few individuals, notably Sickert, had been in touch with the later stages of French Impressionism. Then from about 1909 the situation broke. Roger Fry's first anthology of French painting, which introduced Post-Impressionism to London, was in 1910; but Kandinsky had already been seen the previous year. Brancusi was shown in London in 1912; there was a Futurist exhibition the same year, with Marinetti giving a Futurist lecture; and Fry put on his second and even more demanding anthology of Post-Impressionism. The point about all these events, and there were several more, crowding on top of each other like a succession of thunder claps, is that they presented English painters more or less simultaneously with the results of thirty years' development on the Continent. Fry's first exhibition had dozens of Cézannes and Gauguins – it also had Matisse and Picasso. And Futurism, the very latest thing, was being propounded simultaneously.

Painters had to make what sense out of this they could. There was no background, no leading up to it. In such a situation "making sense" can only mean one thing: that is relating the new, undigested material to what is already known – even if this does not have any necessary bearing on the new material.

Put simply, what existed in London were the following camps: The Royal Academy, still prestigious, still plunged in Victorian complacency. Then there were two factions which had grown up out of the New English Art Club painters, such as Steer, Sargent, Augustus John, who had related Impressionism to the Old Masters, and those who had related it to

more specifically realist intentions – Sickert and his younger colleagues like Gilman and Gore. There was Roger Fry whose influence as an interpreter of French art was becoming more and more important; and there was Wyndham Lewis, at the center of a group of painters, sculptors, and poets who were concerned with the most radical aspects of the new art. It was to this group that Bomberg belonged.

Fry and the Lewis circle were naturally enough concerned with establishing some unifying principle in the new art. What this search led them to was in effect a series of redefinitions of the word "classical." Fry used it to characterize the disinterested autonomous elements in art which depend on formal values alone and not on the enlistment of the onlookers' memories or emotions. This distinction was taken up and given a different twist by the philosopher T. E. Hulme, the friend of Wyndham Lewis, Epstein, Ezra Pound, and the first critic to write about Bomberg. Hulme knew the work of the German art historian Worringer, whose book *Abstraction and Empathy*, one of the basic texts for modern art in Germany, had appeared in 1908. Hulme pressed Worringer's thesis that the whole of the history of art can be seen in terms of two contrasting principles: vital art, that is naturalistic art which involves the spectator in associated emotions (this included all art since the Renaissance), and, on the other hand, geometric art like Egyptian or Byzantine art where everything is hard and angular and detached.

These theoretical systems, which today seem so absurdly over-simple, did at least provide some sort of framework with which to handle Cubism and abstraction. And we must also remember that Fry and Hulme, like all the livelier minds of the time, were trying desperately to cut themselves clear from the tangle of Victorian romanticism which still lay heavily over English culture. It is perhaps their discomfort, their ennui, their claustrophobia which makes modern

art so attractive to them. Their support for it is polemical: modern art seems to be saying something for the possibilities of the modern world – and something against the past.

68 This spirit shows itself particularly in the way in which the imagery of machines is discussed by Hulme or Wyndham Lewis. They return to this matter over and over again. For them it was not so much the glamour of machines that mattered, as it did for the Futurists in Italy; it was rather that machines were hard, cold, unnaturally ordered organisms which were precisely "classical" in the sense they gave to that word. Here, as nowhere else, we can see their modernism joined up with criticism of the recent past and with their endorsement of earlier, anti-naturalistic forms of art.

We can see all these ideas reflected in *The Mud Bath*. Bare, stripped-down, there is something both archaic and machine-like in its flat impersonal surface and the cranking, levering movements of the figures. But it is the picture as a whole which most prompts comparison with a machine. It is a single structure, meticulously thought out, functional in a special sense. This is a quality which Bomberg was to develop even further in the pictures which followed this one, above all in the great canvas called *In the Hold*, his most extreme work.

It is interesting to compare the machine aspect of the Bomberg with a drawing of the same period by Wyndham Lewis. Lewis applies the machine image literally by pretending that the figures he is drawing are a kind of machine. The two mechanics in his drawing of that name are really just traditional life-room models transformed into robots. But the Bomberg figures are not like this at all. Curiously, for all that they are as sharp-edged as a pile of girders, they have a kind of spring about them, a muscularity which is entirely human.

I want now to look at the picture against a more tradi-
tional background. Bomberg had studied for several years
in evening classes under Sickert, and then he had gone on
to the Slade. There is no evidence that anything of Sickert's
powerful teaching rubbed off on him. He seems to have had
an inborn sense of the monumental – the earliest surviving
drawings testify to it. This put him in a different world from
Sickert, for whom the visual impression was everything.
For Bomberg the eye was a stupid organ, almost helpless
when unsupported by other senses. He was a natural anti-
Impressionist: it is hard to imagine him even considering
the possibility that a drawing could be to do with fleeting
impressions, or that design could have anything to do with
accident.

In this he was being true to a much older tradition in art
than Sickert's. Sickert knew this, and it is interesting that
Sickert and his circle recognized this link with the past in a
good deal of modern painting. More than once they had
criticized Post-Impressionism on the grounds that under its
novel surface there lay an "academic" skeleton.

In a certain sense this epithet "academic" can be applied
to *The Mud Bath*. It is in an academic tradition, a real and
valuable tradition which has nothing at all to do with the
modern Royal Academy. For one thing, the theme of a large-
scale figure composition is at the top of the list of the tradi-
tional hierarchy of subjects in painting. For another, his
method, based as it is on studies, carefully considered draw-
ings, suppressing every spontaneous move in the interest of a
disciplined position – all this is true to the grand tradition.

It is rewarding to compare *The Mud Bath* with another
young man's "masterpiece" (I am using the word "master-
piece" in its original sense – as a test of a young painter's
professional skill). Bomberg would have known Augustus

John's *Brazen Serpent* when he was at the Slade. One can imagine that he would have looked at it with mixed feelings: with admiration for its bravura perhaps, but also disgust for the way in which it seems to parody the Old Masters that it draws upon. But, all the same, the two pictures have quite a lot in common. The proportion of figures to the canvas area is similar: in both, fairly violent action is braced against a dark vertical; in both pictures the corners are cut off diagonally, leaving a brighter lozenge-shaped central area.

This is absolutely as far as the comparisons can be pressed, because beyond this point, for everything that is true of the John, its opposite is true of the Bomberg. For all its naturalism the John is unreal, ghostly: for all its abstraction the Bomberg is an immediate experience. The John is eclectic, drawing its style from many sources: the style of the Bomberg is consistent, singular. The John is an invented scene; the Bomberg is about a real place, Schevzik's steam baths in Brick Lane, Whitechapel. The John has a centralized action, every figure is reacting, however winsomely, to the figure of Moses in the middle; but in the Bomberg there is no central action, each figure seems absorbed in its own pose; the relationship between the figures is formal, not dramatic. The John is in deep perspective which parallels the dramatic action. In the Bomberg the flattened space is also in accord with the action, but it has no central focus and is bled off out of the edges of the canvas.

Each one of these differences in the Bomberg represents a question asked, a cliché challenged in the interests of a new kind of pictorial reality. Look, for instance, at the background shapes in the Bomberg, the red fragments between the figures. They are as real, as lively, as the figures themselves. In the John the background shapes are like lost parts of the canvas. In the John you can see how the modeling of the forms weakens the shapes of them, and also how, as the

surfaces recede into the depths of the picture, both drawing and color become blurred and degraded.

Look for a moment at the way in which Bomberg han- dles space in *The Mud Bath*. Obviously he does not deploy perspective in a traditional way; but he is tremendously concerned with the way in which things are in front or behind each other, the way they overlap. He uses this as a way of controlling both the position in depth and the flatness of every form. For instance, at the foot of the column no fewer than four forms coincide exactly along its left-hand edge. There are several beautifully controlled coincidences of this kind elsewhere. In passages like this he is seeing to it that however fully he loads the space in the picture it is not at the expense of the picture plane: its taut flatness is preserved. Elsewhere, with equal finesse, he sees to it that the incidences of this kind just do not happen. The heels of the standing figure on the right are examples – they project in tiny sharp nicks over the edge of the pavement, giving a terrific added punch to the figure on the right which is cut off by the pavement and the one on the left which cuts it.

The question of space and volume is tightly bound up with the color also. At first the figures look quite flat, like cut-outs, then as one gets used to reading the white and blue as light and shade (notice how consistent this light is, flowing steadily from the top left) one begins to notice how subtly he controls forms with it – the long elegant twist in the arm of the seated figure on the left, or the way lit planes cross other lit planes but are distinguished from them so that nothing melts formlessly into anything else.

I have already remarked on the originality of this picture. Cubism was there, across the Channel, a spur, a massive and tantalizing example. Even so it is impossible to guess at the effort of the imagination which was involved in assimilating the new art into the context of English painting. Bomberg

transforms the academic figure composition – he blows it wide open at every point – and in the process he charges it, he restores to it an astonishing vitality.

72 Looking at the painting over a period of time I find I am more and more impressed by its vitality. It is so real and so filled with energy; but these qualities do not derive from the representation of a real and energetic subject – they are carried right over into the fabric of the picture so that it is the picture itself which is real and energetic, not what it depicts.

Bomberg never lost contact with the subjects of the outside world – when he turned to an abstract idiom it was not to evade reality, not to evade the particularity of the outside world. It was rather to approach it more closely, to find a more direct access to it. For the decadent naturalism of the nineteenth century had laid a sort of dead skin over appearances. This is what *The Mud Bath* is trying to broach, to penetrate, and to strip off; and when after the war Bomberg returned to what, in some respects, looked nearer to a naturalistic style and began to allow himself a freer and more plastic involvement with the subject he painted, he did not once forget the lessons of his youthful campaign.

Catalogue introduction to an exhibition of the same name
Marlborough Fine Arts, London
February 1968

YOU CAME OFF the street up a dark staircase and straight into the upstairs gallery. It was like entering an attic. The first things you saw were floorboards and a floor-level view of the pictures. The floorboards creaked, and the place always smelt of the paraffin stoves that were standing around (there was some inadequacy in the wiring). Through the top gallery you came to a balcony hanging out over the large gallery below, just as it might over the squash court which the lower space resembled. On the balcony to the right was Helen Lessore's desk, and she was almost always there, pale, beaked, a melancholy bird. To your left, a precipitous iron staircase took you down into the large gallery. A door opened straight onto the pavement of Bruton Place. Mrs. Lessore's shoes would watch you go. More than anything else it was like a studio, an *atelier de peintre* spruced up for visitors and it was this – that the gallery itself seemed nearer to the painting end of pictures than to the merchandising end – that gave it its inimitable, irreplaceable quality. The fact was that Helen Lessore had never intended to become involved with dealing. She had found a job at the Beaux Arts Gallery during the thirties after she had left the Slade where she trained as a painter. Sometime later she had married Major Lessore, the proprietor. After his death she had found herself landed with the gallery as the only means of

meeting her family responsibilities. She was a dealer out of necessity. But she never accepted the name happily, and with good reason. Her performance, judged as a dealer, was amateurish in the extreme.

It had been a long time since the Beaux Arts Gallery had played a positive role in contemporary painting. Helen Lessore, knowing little of the business, having no international connections and even less interest in the kind of exhibitions which were typical of the average gallery at that time, determined that whatever else happened the gallery was now going to accept a responsibility towards the present. For twelve years she showed only what she herself believed in. Not once in that time did she put on a show to pay the rent. Year after year she introduced new and untried artists, and although many proved to be flops, many more were the real thing. At least fifteen artists established justifiable reputations under her sign – including several who for one reason or another are not represented in this exhibition. And the important thing is that few of them could have done so anywhere else. Who else would have seen the point, as she did, of Michael Andrews, Frank Auerbach, Euan Uglow, Raymond Mason? She looked on her artists with that mixture of pride and critical hypersensitivity that a painter-teacher might feel towards his best pupils. The ructions, and there were some, were as far as I know all because she refused to countenance something that she believed to be harmful to a particular talent.

Self-sacrificing, jealous, reckless, she was in some respects an ideal dealer. In others she was a failure. In the end the gallery went under, flags flying.

Sickert's *Servant of Abraham* used to hang for years in Mrs. Lessore's flat under the gallery. It is a reminder of her connections: Thérèse Lessore, Sickert's wife, was her sister-in-law. It also serves to remind us of certain things that the

gallery stood for: it is figurative, painterly, the opposite of suave. It has all the qualities, a provisional, unpolished facture, a material frankness, that go with work in progress rather than with the rounded finished product. We can see in this Sickert both the methodical loving observation that we find so much later in Euan Uglow or Michael Andrews, and the grandeur, the tragic sense that seems mysteriously to find expression in a particular attitude to paint, and which both Francis Bacon and Frank Auerbach have explored with so much energy. One can well imagine that the *Servant of Abraham* was like a touchstone to Mrs. Lessore. She has spoken of how more than once a new artist's work was put to the test of the great Sickert head, hung alongside it in her flat while she made up her mind.

She took the gallery over at the end of 1951. It isn't easy to recapture the atmosphere of that time. The galleries were full of the last dregs of neo-romanticism, decorative painting that exploited the nature imagery of Sutherland, and every imaginable variant of a decadent synthetic cubism. As yet American painting meant nothing much but Ben Shahn: Pollock was a rumor.

By far the most important features on the English horizon (apart from the new metal sculpture of Butler, Paolozzi, *et al.*) were the conversion of Victor Pasmore to abstract art and the re-emergence of Francis Bacon, both of which had happened in the late forties.

Pasmore and the Martins were at the center of a great deal of polemical activity. They indicated a direction as nothing else did then, a masterful interpretation of the modern movement. And yet in spite of the momentum that was gathering round them it was by no means clear that the main stream of the time was flowing in their direction. The whole issue of abstract art was surrounded with huge and often unsupported generalizations. A young painter looking

for his bearings at that time would have had only the shallowest experience of abstract art. There had been no opportunity to see, for example, Mondrian as a totality, still less to experience the depth and humanism of a Pollock or a Rothko. Much that was being done seemed cold and doctrinaire. And when Victor Pasmore showed his first reliefs in the summer of 1952 these seemed to announce an even more extreme passage towards the anti-personal.

The same year saw two important Bacon exhibitions, as well as a thematic exhibition arranged at the ICA by Peter Watson, Robert Melville, and David Sylvester called *Recent Trends in Realist Painting*, in which Bacon was the central figure. Bacon was Delacroix to Pasmore's Ingres: everything seemed to conspire towards a polarization of the issues of abstraction versus figuration. If this seems a naïve irrelevance today this may be because it is no longer possible to imagine figurative painting as an alternative modern tradition. Pasmore had come to abstract painting via Turner, Whistler, the Euston Road. The logic of his position seemed impeccable, the terminal point of a line that Maurice Denis and Roger Fry had ruled into the interpretation of nineteenth-century art. Why bother with a warhorse or a nude if the point lay with the "flat surface covered with colors in a certain order"? But on the other hand, if the point was that the warhorse *was* a warhorse and the nude a nude, would this not place one in an entirely fresh position in relation to the flat surface covered with colors? This thought indicated a re-examination of realism; a rejection of the still-life tradition with its equality of emphasis, its detachment; and by the same token, an investigation of all those aspects of figurative painting which had escaped the seemingly inexorable process of formalization inherent in the tradition of Paris: Munch, Kokoschka, Soutine, Expressionism as a whole, of which England was still largely ignorant, and whatever

alternative example existed in Paris itself, Gruber, Balthus, Giacometti, Minaux, Rebeyrolle, and so on. And just as in the thirties Coldstream and his colleagues had re-examined nineteenth-century painting for clues which would help them to break out from the impasse of Parisian avant-gard-ism, so in the early fifties there was among many younger painters a lively interest in Goya, Manet, Degas, Courbet, Van Gogh, as well, of course, as Cézanne. This interest was stimulated and informed by the writings of two critics in particular, both of whom were concerned with the interpre-tation of realism although from opposing points of view. These were David Sylvester, whose unswerving commit-ment to Giacometti and Francis Bacon was one of the fea-tures of the decade, and John Berger.

Reviewing an early mixed exhibition at the Beaux Arts Gallery, John Berger described the horrible alternatives that faced the young painter: "On the one hand the triviality of the Old Academy; on the other the New Academy's tired abstraction or apocalyptic mumbo jumbo Together the two seem to lay claim to and corrupt every possible contem-porary tradition The young painter feels that he must start quite by himself from scratch Never before has the truly promising work of a new generation been so graceless, so dogmatic in its uneasy refusal to accept help from suc-cessful example."

Berger's was an immensely attractive voice both to stu-dents and to the general public. His ardent and forceful writing undoubtedly built up an atmosphere of expectation surrounding the idea of realist painting which considerably exceeded the facts. He made great efforts to put the realist/abstract controversy on the same level that it occupied in Europe where the realism of a Rebeyrolle or a Guttuso was specifically left wing. One such effort was a large exhibition of realist painting at Whitechapel called *Looking Forward* in

the winter of 1952/53 in which Berger gathered together a wide variety of work that could be related to social realism. "One might wish" he goes on in the article already quoted "that these young painters could see the possibilities of a more socially relevant art But because of a lack of leadership, this has not yet happened, and so their art remains gruff, eccentric, obstinate, clumsy, naïve, but at the same time passionate, urgent, and springing ... from the only source they feel they can trust – their everyday, almost banal experiences."

The artists Berger was discussing collectively were the group of students who had just emerged, prolific and confident, from the Royal College: Jack Smith, Edward Middleditch, John Bratby, Derrick Greaves. They had first made their presence known at the Young Contemporaries. Now they were showing at the Beaux Arts Gallery. Berger gave them unstinted support. So did a number of other observers who thought they saw in these painters – still after all students – a positive answer to "modernism" and all that it implied. "As the thunder of the great revolution rumbles away into history and many of its aims are seen to have been chimerical ..." – thus Michael Middleton in a review of Derrick Greaves's first exhibition.

What they had in common was that they all painted on an unfamiliar and ambitious scale and in a graphic and monochromatic style and that their subjects were often of domestic or kitchen scenes composed rather as the camera might compose. There was no political program behind this; at most an exalted relish for the grind of daily life. It was rather, as David Sylvester pointed out in a hostile article which gave the name that was hung on these artists for years (and was later transferred to the theater), that in painting the kitchen sink they were simply looking for the most ordinary subjects that they could find, the most banal, the least artistic. It was a repetition of Courbet's search for a

subject matter outside the familiar bounds of art. And in Bratby in particular there was revealed a positive love for the most ordinary and garish product design – cereal packets, detergents, plastic toys, board games, and so on – that anticipated the material of the Pop artists who were to follow them from the Royal College in a few years' time.

Smith, Middleditch, Bratby and Greaves represented English painting at the Venice Biennale of 1956. This was the end of it all. They had been under a searchlight for several years, cast in a role that was not of their choosing and an intolerable strain had been put on their free development. Smith was soon to move off in a quite different direction, and he parted company with the Beaux Arts. Bratby also left, on a wave of popular success resulting from his work as the author of Gully Jimson's paintings in the film of *The Horse's Mouth*. Greaves too withdrew from the gallery as his work became increasingly abstract. Middleditch remained, slowly developing an almost oriental decorative gift.

Berger also was to disassociate himself from the "Kitchen Sink movement" and indeed to recant much that he had written about the social task of modern painting in the West. In an article written in 1959, virtually his farewell to regular criticism, he declared that he had been wrong in his assessment of the intentions of these particular artists, and he went on to question whether any painter could take up the kind of position he advocated. "I assumed that painting and sculpture could develop in as broad a way as the other arts. I now doubt, whether, in our historical situation they can." But what he was looking for was there now, he said, in the new theater and the new generation of film makers.

The "Kitchen Sink movement" was really a vast misunderstanding – Berger's support (and the popular response to it) had unwittingly saddled these painters with a cliché, and they had no defence against it.

There was no mistaking the painters who were subsequently to become identified with the Beaux Arts Gallery for a group or a movement. Auerbach, Kossoff, Andrews, Aitchison were nothing if not individuals. In this sense they owed their allegiance to Francis Bacon, the exemplar not of a putative new tradition of figurative painting but of its actual solitude. "Bacon paints crime ... as though he were an accomplice" Berger wrote of him when he showed at the Beaux Arts in 1953.

One thing that emerged with absolute certainty during the mid-fifties was that if a painter was to work with any vitality and independence in a figurative way he would have to accept that he was swimming against the tide and that he was in a real sense an exception and that his will, his conviction, and his attachment to his subject must be correspondingly exceptional. He must learn to work unprotected in any way by the general milieu. What was typical of the painters who came to be identified with the Beaux Arts Gallery during the second half of its life was their acceptance of this state of affairs and their corresponding acceptance of the ethical content of painting. One can see this reflected in the minimal production of Michael Andrews and in the way in which he seems to have used tonal naturalism as a kind of neutral language, an absolutely transparent style-less medium through which to arrest his subjects. One can see it in the work of another student of Coldstream's, Euan Uglow, whose timeless indifference to the dialectic of style is as radical and challenging in its way as the obsessive reiterations of a Kossoff or an Auerbach. One can see it in the self-contained, subjective world of Craigie Aitchison, a world where every nuance speaks of a private response, an infinitely extended communion with the canvas. One can see it in the enthralled attachment of certain of these artists to a particular model or a particular place, more fruitful, more suggestive, more consol-

80

ing than anyone or anywhere else: Auerbach's E.O.W., Jeffery Camp's Lowestoft, Sheila Fell's Aspatria.

What they had in common – one speaks of them in the past only because their relation to the gallery belongs to the past – was not a shared style or view of what painting should look like, but rather an ethic. When Michael Andrews spoke, in a statement that was published in *X Review* of painting as "the most marvelous, elaborate, complex way of making up my mind ..." he could have been speaking for them all. "I've made alteration" he says elsewhere in the same piece "and I've said to myself 'this is the way to do things' or 'you shouldn't do things like that' and so it has seemed to be that it was a mode of behavior that I was correcting. That's been the reality rather than anything objective." And Frank Auerbach: "The thing that gives me a thrill about other people's paintings – paintings that I'd cross the road to see – is a vision pushed to its extreme. One doesn't care at all about idiom – manner. Personality consists in this thing about conscience ... being true to oneself, which means finding unique forms ..." And later: "All important discoveries are made in the course of autobiographies." To all of them the picture was provisional, a shifting surface, the upshot of numberless decisions each one of which was made under pressure. Whatever happened to any part had a crucial bearing on the whole. Paint, the very matter with which painting actions were made, was identified with the image, was in a sense, its source. There was little leeway between conception and execution, idea and its embodiment. Hence the atmosphere of doubt and stress in which the difference between revelation and blind failure seemed a matter of a hair's breadth. The picture, it seems in the work of Auerbach or Andrews, Uglow or Aitchison, is hardly the goal, the end product of the painting process, but rather the sum of all its episodes.

Almost all the young artists who were shown at the Beaux

Arts were either from the Royal College of Art or the Slade. During the early fifties the two establishments followed roughly parallel courses and in spite of their traditional rivalry were in fairly close contact. Rodrigo Moynihan, the professor of painting at the RCA, and Coldstream at the Slade were old colleagues. David Sylvester was in close touch with both establishments and presided over joint discussions on more than one occasion. In retrospect there are striking differences. Invariably the RCA produced prolific artists, the Slade the reverse. Extreme instances are those of Bratby who at one point was pressing the gallery for two exhibitions a year, and Michael Andrews who was the first artist Mrs. Lessore chose to show but who took from 1951 to 1958 to produce the pictures. Again, those from the Royal College tended, for some reason, to show more outward solidarity, to hunt in pairs. This was the case with Middleditch and Greaves, with Auerbach and Kossoff. In the case of the last two the relationship went particularly deep: before the RCA they had been at St. Martins together (along with Michael Fussell and Sheila Fell), and also had studied under David Bomberg. Those from the Slade, on the other hand, tended towards a more solitary stance, so that although both Uglow and Andrews had learned a great deal from Coldstream at the Slade, their interpretation of his teaching ran in opposite directions. And nothing could be deduced from their work, put beside Aitchison's or Diana Cumming's or Margaret Evans's, which would lead one to suppose a common origin.

Timothy Behrens, also from the Slade, belonged to a later period there when other students of Bomberg, Dorothy Mead, and Dennis Creffield had passed through and considerably affected the climate. Very active at both the Slade and the Young Contemporaries, their influence was added to that of Auerbach and Kossoff and attracted many imita-

tors. It looked for a year or two on either side of 1960 as though a new figurative "movement" was afoot; it was a short-lived student affair that did little to illuminate the work of the few artists who had been seriously exploring this direction for years.

Another more positive event was brought about by the peregrinations of Bomberg's students, namely the appearance at the Beaux Arts of the distinguished Swedish painter Evert Lundquist, up till then unknown here. Back in 1953 Mead, Creffield, Peter Richmond, and Cliff Holden had shown work in Sweden and Lundquist had seen the exhibition. Surprised at certain parallels with his own work, he had sought them out. Now in 1959 Holden introduced Lundquist's work to Helen Lessore who showed him twice.

There were several occasions when she presented older artists who for some reason or other were almost unknown. The most memorable was perhaps John Dodgson's exhibition in 1959 when this extraordinary and magical painter showed what was practically a lifetime's work. It was in the nick of time: a few years later his studio was burnt down and most of his work lost. Less fortunate was a plan to show Bomberg, then completely neglected in the galleries. His death came too soon.

There are two quite distinct views of an artist's relations to his time. On the one hand there is the idea of him riding the *zeitgeist* like a surfer, absorbing everything that is in the air, working with the currency of the time as though it were his raw material; and on the other hand there is the idea that whatever he does is meaningful only in relation to his own internal experiences, his search for consciousness, and that the *zeitgeist* is created out of his achievement. To oppose these two views like this, exclusively, is an obvious vulgarization. It is a feature of the present state of art that it encourages and even insists on such an alternative. The

much-vaunted renaissance of painting and sculpture in England in the early sixties consisted not only of the emergence of a new and highly talented generation of artists, but also of a vast increase in the popular consumption of art. New galleries, new promotions, a new and much publicized smartness for the role of artist were all part of the deal. Perhaps the most spectacular feature of the new English art "scene" was and still is the speed with which new concepts are absorbed, not the originality or depth of those concepts; permissiveness rather than discrimination. The stylistic oppositions of the early fifties seem to have given way to equally exclusive and far more sterile distinctions between those who are in the swim and those who are not. There is no doubt where the Beaux Arts Gallery stood in this, and looking back over Helen Lessore's twelve years there, it is her unambiguous stand outside fashion that one values and regrets most. When she was invited not so long ago to lecture at an art school on her experiences as a gallery proprietor, she turned the offer down. "Reading the letters of Van Gogh, or the novels of Zola" she wrote in answer "one might think that the behavior of art dealers, and of official bodies, has not changed much; and yet it has – not only the pace has quickened, but the idea of fashion has become more powerful – the whole art world has become like a *maison de haute couture* – it has become more grossly commercial than it used to be even thirty years ago – even fifteen years ago – more superficial, more vulgar, more greedy

"I cannot stand up and tell the students what they must do to be 'successful'; nor have I the heart ... to stand there and exhort these hopeful young things to take the martyr's road."

The Townsend Journals:
An Artist's Record of His Times 1928–51

Introduction to a book of the same name
Tate Gallery
1976

WILLIAM TOWNSEND died suddenly in Canada in the summer of 1973. Besides a considerable body of painting, he left behind him a vast quantity of writing, most of which had never been seen by anyone but himself.

An entry in one of his journals from the early fifties records how, while helping his parents move house, he had discovered boxes and boxes of old papers and notebooks from his childhood. Even he is astonished at their quantity and variety: illustrated descriptions of parish churches, notes on the geology of East Kent, notes on place names, on comparative philology, on Russian Grammar, on bird songs, painting-by-painting reviews of the Royal Academy Summer Show. "What a diligent boy I was!" he exclaims. This diligent and omnivorous interest persisted remarkably, for the journal in which the discovery is recorded was part of a daily record that he kept with few interruptions from his school days until the end of his life. One can only wonder at the self-discipline and the inner pressure which took him to his desk night after night, whatever the exertions of the day, whether in the studio, or teaching, or in a full social life. Some years ago he had realized that this journal was beginning to assume a historic character. He deposited the existing volumes in the Library of University College, London, with

instructions that it was not to be made generally available until twenty years after his death. At the same time, he asked the present writer to be responsible for a first reading and to make recommendations to Charlotte Townsend, his daughter and heir, about publication from it. This was made possible by a generous grant from the Leverhulme Foundation.

In total the journal runs to nearly fifty volumes of manuscript, mostly in hard-covered notebooks of 8 × 5 in. There must be well over two-and-a-half million words. The earliest entries tend to be a combination of boyish accounts of school life and achievement with highly detailed descriptions of things seen. His two passions are nature and architecture, and in these he is evidently much encouraged by his father Lewis Townsend, a dentist and a man of letters *manqué,* a poet and the author of a successful biography of Oliver Wendell Holmes. In much of the early writing one has the sense of a task undertaken to gratify certain stringent parental demands.

Father and eldest son, with or without the rest of the family, were inveterate walkers, birdwatchers, antiquarians, botanists, tireless at the highest reaches of sightseeing. There were long weekend walks through the countryside of East Kent in which not a nest goes unidentified nor a cottage undated. There were also meticulously planned holidays in Normandy, Wales, Ireland, Brighton, Bath, during which, it seems, every quarter of an hour is accounted for. The first volumes are almost entirely given to descriptions of places seen. The discipline of this kind of writing must have helped to shape his formidable visual memory. It is as though he can play the day over to himself like a film. The painter's immediacy of apprehension combines with the antiquarian's sense of a layered past. And at his best his descriptive writing is distinguished not only in its clarity and intelligence but by a certain dry vividness from which marvelous images

suddenly flash out, as when he recalls his first impression of Milan Cathedral as "a hillside of dead pines," or tells himself that provincial England is "like a sleepy pear."

He went to the Slade in the autumn of 1926, his time there coinciding with the last years of Professor Tonks's regime. It was here that he made the essential friendships of his life; with Claude Rogers, William Coldstream, Geoffrey Tibble, Edgar Hubert, Elinor Bellingham-Smith, Anthony Devas, Rodrigo Moynihan, Gabriel Lopez, and many others. Two experiences occur during this time which were to have a lasting effect on him. One was nearly nine months of travel abroad, first in Egypt where he was the guest of a fellow Slade student called Yousef, and almost immediately afterwards in France, Italy, and Tunisia in the company of a retired naval commander who was an amateur painter. His record of these travels stands as a whole, and there seemed to be no point in breaking into it in making the present selection. The second crucial experience was the death by suicide of one of his closest friends, the Colombian Gabriel Lopez. Townsend profoundly admired his painting and his poetry, diametrically different from his own. He had been with him a great deal during the last months of his life and his death affected him deeply. The diaries come to an abrupt stop a few days after Lopez's death. When they start again two years later, we find him back in Canterbury, helping his father keep the accounts for his practice.

Through literary friends of his father's, particularly Eleanor Farjeon, Townsend had built up several connections with publishers and he had begun to find work illustrating books and designing jackets. He had hoped to be able to survive on this in London but it was never a regular living. His life in Canterbury has the qualities of an exile, broken only by occasional visits to London to chase publishers, see exhibitions, and keep up with his friends. These are melancholy

years. He sees himself being slowly brought down by provincial life, losing contact with the people that mean most to him, unable to free himself from the demands of his father, on whom he is, in any case, dependent. He develops a passion for the ballet, blowing his savings and paying a balletomane's court to Danilova and Toumanova in their prime. And as the decade advances, he becomes increasingly drawn into left-wing politics, the local Labour Party, the League of Nations Union, the W. E. A., Arms For Spain. Both the Abyssinian conflict and the Spanish Civil War are recorded almost daily, as are the Munich Crisis and the events leading to September 1939. He watches his friends somewhat at a distance, recording with intense feeling each visit and each nuance of aesthetic and political opinion. He is a witness from the wings of their first successes: Devas's rise as a fashionable portrait painter, the short-lived and daring experiments in informal abstraction of Tibble and Moynihan, the founding of the Euston Road School by Rogers and Coldstream, and their swift *reclâme* along with Pasmore and Graham Bell in the years immediately before the war.

He joins the army in 1941 and is demobilized five years later, having become a staff captain with the Army School of Education. This period is not recorded in the journals. When he picks up civilian life and returns to writing, he is married, Charlotte is born, and he is a teacher at Camberwell School of Art, where William Johnstone was reassembling the people who had been connected with the Euston Road School before the war. From this point on his life is centered on art schools, at Camberwell and then at the Slade where he goes with Coldstream in the autumn of 1949. From 1951 onwards he makes regular visits to Canada where he also teaches.

Read as a whole the journals yield an extraordinary pic-

ture of a life in both its private and its public dimensions. It is not possible yet to do complete justice to this picture in publication, for to do this would mean to observe a balance between the inner and the outer chronicle. Scores of people are mentioned in these pages, and although I do not think that he would have minded the publication of his professional acidities, I know that he would not have wanted confidences abused nor feelings needlessly hurt. So any selection now can only give a partial impression of the scope of the journals and of their final importance – that importance stemming, as I have suggested, from their inclusiveness. The document as a whole is many things: a profoundly honest confession; an acute and sophisticated account of a professional career, with all the gossip and inside talk that implies; it is a succession of passionately detailed and feeling accounts of places and above all buildings seen; it is the critique of an intelligent and humane man upon his times. In selecting these extracts, which amount to the merest tip of an iceberg, I have concentrated on three periods which seem to me to be of the greatest historical interest: his student years, the late 'thirties and the first year of the war, and the years 1946 to 1951. I have not included anything after these for a variety of reasons. Later entries tend increasingly to be about day-to-day matters at the Slade – conversations with students, college politics, the somewhat repetitive appointments of academic life. All this is fascinating to anyone involved in this world but of limited general interest. These are also the years of his Canadian visits.

He was first invited there to teach at the summer session of the Banff School of Fine Art. It was the first time that he had crossed the Atlantic and all his skills as an observer are brought out to the full. He is learning a new landscape with its own fauna and flora, all of which have to be worked up

and recorded. He is learning a new culture, new kinds of cities, new styles of reference. And of course, he is meeting scores of new people and looking at a lot of unfamiliar art.

90 As visit follows visit he begins to understand Canadian life in greater depth and finally even to become a part of it. All his life he had been fascinated by the special problems posed by the relationship of English art to the Continent. Now in Canada he was to encounter similar problems in new terms. He became something of a spokesman for Canadian art and culture and, as the journals go on from the first visit to the end, a remarkably rounded picture emerges of a crucial period. But the effect stands as a whole. There seemed to be no point in extracting sections whose real interest lies in their contribution to an organic account, separate to a large extent, from his preoccupations at home.

Finally, during the last few years there is a change in the nature of the entries themselves. The style becomes more elliptical, less reflective, and private and public matters are more sharply intercut. When the time is right for more inclusive publication, such changes of style will fall meaningfully into place. I cannot see that they would here.

One strand which is never dropped in the entire text is his commentary upon his own painting. Whatever else he was involved in, however multifarious his interests, the central concern was always his studio. And yet, like so many artists in this country, there is something tentative in his relationship to it. Perhaps in the end, too much time was spent thinking about it at a distance from a productive *milieu,* his time broken by insecurity, war, too much teaching, his hold on it weakened by lack of recognition. He had committed himself early to a quiet position. Any form of extremism was foreign to his judicious observer's temperament, and he was not an innovator. However, the best of his

painting reflects those qualities of balance, sensitivity, and acute economical observation which were essential to him, and in some of the Kentish hop garden series and the cityscapes of Edmonton, these qualities are refined to a pitch which approaches perfection.

Part II

On Matisse and Likeness

Essay from a student sourcebook
International School of Painting,
Drawing, and Sculpture, Umbria
2002

PROLOGUE

THERE ARE several objections to focusing on Matisse's por-
traits. Numerically, they were not an important part of his
output. They are easily outnumbered by still lifes, interiors,
figures that are not portraits; and of course they are overshad-
owed in grandeur by the large decorative compositions.

And there is a general objection, an external objection
that stems from the orthodoxy of modernism. For most of
this century it has been held that portraiture is impossible
within the terms of modern art – both for obvious social rea-
sons, and for stylistic reasons. Qualities such as likeness,
psychology in the dramatic sense, characterization, respon-
siveness to the sitter, and so forth simply have no part to
play in the modernist painter's adventure – and anyway, the
camera can take care of all that so much better. The few art-
ists of the twentieth century who have persisted in making
portraits – Kokoshka, Otto Dix, Balthus, Francis Bacon,
Lucien Freud – have tended to be seen as marginal cases,
somewhere off the main line. It is to the point that in his
great hymn of praise to modern art and "pure painting," it
was a portrait that André Malraux (*The Voices of Silence*)
took as the cardinal example of what he was talking about.

It was Manet's painting of Clemenceau, and Malraux dismissed it as a portrait: "From now on the subject was *nothing,* the artist was *everything ...* "

96 In J.-P. Sartre's novel *Le Nausée* the central character Roquentin finds himself one Sunday afternoon in the museum in the provincial city he is living in. He wanders by rows of portraits of the local dignitaries of his grandfather's generation, mayors, industrialists, and stopping in front of one of these he reflects: "When one is confronted with a face sparkling with righteousness, after a moment this sparkle dies away and only an ashy residue remains.... Parrottin put up a good fight. But suddenly his look burned out, the picture grew dim. What was left? Blind eyes, the thin mouth of a dead snake ... "

I was struck when I first read this because it seemed to describe exactly an experience I had had, not just in front of third-rate paintings. Portraits do burn out. It's as though one's recognition of the individual human presence has a limited life. It runs out. The picture dies, leaving one with an empty effigy with a grimace frozen on its face. One could argue that these qualities of life-likeness are inimical to whatever else it is we go to pictures for. But why should we circumscribe what we ask of a picture, particularly since there are such strong counter-examples, portraits where the longer you look the more strikingly alive the sitter becomes – all of El Greco's portraits, most of Rembrandt's, Goya's, David's – and, to an extent that I find continually astonishing – those of Matisse.

Consider the famous drawing of Sarah Stein, made in the winter of 1915/16 when Matisse was going through a period of extreme reduction. It is one of the most austere images he ever made. You can see traces of a lot of searching. His conclusion is a bare structure of about seventeen lines – and yet, what are we to make of its power as a representa-

tion? The drawing smolders with life. It seems to be more than a likeness, but rather to be itself alive, generating irresistibly a living, individual human presence, alert, sensate, responsive, with her own inner life. And this feeling does not go away. Look at this drawing for as long as you like. You cannot catch it resting.

I am enthralled by this mystery. What follows is a pursuit of this mystery, but in no sense an explanation of it.

REPRESENTATION

I turn first to Matisse's representations of himself. Self-portraits belong to the painter in a special way. Every other genre points outwards, finding attachments in the world outside the studio. But the mirror closes out such attachments; it closes the gap between observer and observed: the eye that is being described is the same eye that is directing the description. It looks at its look out there – and here on the canvas. The mirror equals the field of the picture. What it contains is the picture.

Inevitably, self-portraits are pictures about painting. They draw us in to the painter's introspection and his unstable questions – unstable because "What do I look like?" glides ineluctably into another question, "What am I doing?" Not that Matisse plays parts in front of the mirror – he is no Rembrandt in oriental drag, no Courbet swaggering with his thumbs stuck in his belt. It's rather that he turns to the mirror to face his anxiety, the anxiety that was famous among his friends, the anxiety that was the painful tariff that he paid for the driving force of his art, the tension between his deep conservatism and his longing for the new, between his reserve and his sensuality, between his extreme self-consciousness and his wordless intuitions

He paints himself as a painter, and his self-portraits are reflections on painting as well as reflections of himself. In the great nude called *Carmelina* in Boston, the painter makes his appearance crouched in the corner of the mirror behind her, a tiny oblique presence compared to the model's commanding frontality. But there is more to it: her symmetry is due to the fact that she is facing us straight on. We assume the painter's place in front of her, face to face. We look, and we are aware of ourselves looking. The picture brings this about.

Ever since Velázquez, this situation, this entrée into the studio has been a possible subject. It reappears again and again in the nineteenth century, in Manet, in Degas, in Seurat. Matisse evokes it playfully in many of the Nice interiors, and at a more profound level in the very fabric of the picture itself in his brush marks, his erasures and corrections that involve the onlooker not only in the act of painting, or drawing, as a series of tactile and motor experiences but as a mental process, of search, of trial, of the unfolding of possibility, of recognition, of judgment.

That Matisse recognized this and valued it in spite of the contrary impulse to conceal the hard work, to turn effort into effortlessness – is clear from his later impulse to record the stages of work and to show in the clearest possible way how changes had been made as he went along. Consider, for example, the first drawing he made after his return home from the hospital where he had nearly died, significantly, a page filled with a sequence of self-portraits.

Among Matisse's first paintings there are two intimiste interiors in which self-portraits feature as pictures. They are like secret messages. The *Woman Reading* is turned away from us, calm and silent in the subdued light, but she is facing the self-portrait drawing which hangs on the left wall. Between the two of them there is a clutter of still-life objects,

a plaster cast, a propped up portfolio, all emblems of the life he is embarking on, the life of the studio. Over the woman's head, taking the light so that we can't make out what it is "of," a picture, a luminous rectangle of pure possibility. This faces us squarely. It is the only form that does so.

In the *Top Hat* still life the self-portrait drawing faces us, and between us and it is the desk with its jumble of papers and objects that don't look as if they had been arranged but rather of having accumulated there as other more important things happened in the room. Standing out from all this is the top hat, emblem of the respectable legal career that Matisse had recently walked away from. The desk is surrounded with canvases, pictures, frames. The self-portrait drawing is crossed by an empty frame. Notice a curious point: although the self-portrait in its frame is drawn in perspective as its place on the wall demands, the empty frame faces us squarely. Either it must have been carefully adjusted on the wall to do this, or its orientation deliberately distorted.

Richard Wollheim in his *Painting as an Art* has drawn attention to the importance of a fact about painters at work that is so obvious that one doesn't think about it. Whatever changes that have come about in the history of painting – in materials, subject matter, scale, convention, social use – he says, "there has been one noteworthy constancy, and that has been the posture, the bodily stance that the painter adopts in the act of painting ..." (*i.e.*, addressing the canvas, eyes open and fixed upon it). She or he faces it.

It's a commonplace of film technique that we experience the spaces of the world from four distinct aspects: *behind* us we can only see in mirrors; *upwards*, where we look for glory and heroes; *downwards*, where we look in dejection, or to find things, or not to step in something disgusting; and *levelly*, straight ahead. It is levelly that we talk to people, recognize faces. The crucial characteristic of a face, its symmetry,

the feature that makes it different from a head, is only seen at eye level. This is where recognition begins.

It's also at eye level that we approach pictures – literally when we see them in a gallery or museum, ideally when we consider them in our mind's eye or think about their meaning. Like faces, they too are all front.

I am arguing that there is some sort of general affinity between pictures and faces; it's clear that this can be put to use as a metaphor. Picture as face would be one among several – picture as window is another that Matisse worked with all his life. Others might be picture as wall, picture as body, and so on, each offering a trope that might yield ways of saying things about pictures that could not otherwise be said, throwing workable if fragile bridges between words and the silence of painting. But in accepting this possibility, I would not want to surrender my earlier and perhaps more primitive affinity. We look at pictures face to face. Both face and picture are expressive. Both are representations.

In the two early pictures we were looking at, the canvases and empty frames have a clear autobiographic importance. They stand for Matisse's tentative view of himself as a painter. There is nothing tentative about the four great decorative interiors of 1911 – *The Pink Studio, The Painter's Family, Interior with Aubergines*, and *The Red Studio*. There is something triumphant about these pictures in which he declares where he stands and what he has done. In the two studios, pictures play an important and complex role. But what I want to draw your attention to is the way the center of each of these canvases is held by a rectangular form – not a picture – which faces us, square on, and which dominates the action throughout the painting. In *The Pink Studio* it is a folding screen draped with patterned fabrics. In *The Painter's Family* it is the fireplace and mantelpiece. I have no doubt that these paint-

ings are truly self-portraits, nor that these squarish, picture-like forms on which they are centered stand in for himself.

Finally, I show you the portrait of Pellerin, where the symmetrical pose confronts us with intimidating severity. The dome of his bald head occludes the frame of the picture behind him. The two, sitter and picture, are bound together by an apparently arbitrary arc of paint. The two stare back at us. Pellerin was a rich industrialist. He was also the owner of the largest collection in France of Matisse's ultimate master, *Cézanne*.

EXPRESSION

How can this affinity between picture and face be brought to bear on the matter that I started with – the sense of living likeness that haunts Matisse's portraits? I turn first to his own words. Painter's statements usually need to be taken with a grain of salt, but Matisse's *Notes of a Painter* of 1908 are different. He was 39 when he wrote them. He was confident of the ground he had covered in the last ten years. He had just opened a school. He really wanted to explain, to make himself clear. These are carefully formulated statements, written with integrity.

> What I am after above all is expression.... The thought of a painter must not be considered as separate from his pictorial means.... I am unable to distinguish between the feeling I have about life and my way of translating it.

He asserts the identity, the inextricable link between ends and means. This is where he dissociates himself once and for all from the academic tradition. Now he goes on to specify how this identity can be brought about.

> Expression, for me, does not reside in the passions glowing in a human face or manifested by violent movement. The entire arrangement of my picture is expressive: the place occupied by the figures, the empty spaces around them, the proportions.... In a picture every part will be visible and will play its appointed role.... Everything that is not useful in the picture is, it follows, harmful. A work of art must be harmonious in its entirety.

You will notice how he presents the two key ideas – Expression and Wholeness – as though they are linked, or rather, different ways of looking at the same thing, the recto and verso of the same coin.

Expression is a strange word. It means first to press or squeeze out, only later to represent, to state, to convey. In this sense it seems to point both ways, inwards and outwards, to hover somewhere in that shadowy zone between subject and object. We sweat over how to express ourselves; we sweat over how to interpret another's expression.

When Matisse begins to draw his model, her expression is, if you like, what her features mean; how she represents herself. Understanding the constellation of her features is to understand *her* expression; but his search for that constellation consists exactly of his search for expression – *his,* Matisse's, expression. I think no artist has ever understood this reciprocity as clearly as he did. The sitter's face was a mirror, not in the vulgar sense that could be applied to all those portrait painters who always end up painting the same face. With him, the particular, the idiosyncratic and elusive was the sharpest stimulus to his own expression.

Expression, he tells us, is indistinguishable from his means. What does this signify? It does *not* mean that he has some sort of held idea about what he wants the drawing or

painting to express – and then shapes and judges the painting as the vehicle for that idea. He looks to the painting to guide his expression, to make himself clear to himself. His moment-to-moment response to how the canvas looks back at him constitutes the unfolding of his expression. Now he describes the painting process (he's talking in general here, not about portraits):

> I must precisely define the character of the object or of the body that I wish to paint. To do so, I study my method closely. If I put a black dot on a sheet of white paper, the dot will be visible no matter how far away I hold it: it is a clear notation. But beside this dot I place another one, and then a third, and already there is confusion. In order for the first dot to maintain its value I must enlarge it as I put other marks on the paper.

His marks must hold their own, must stand on their own terms. The relations between them, their organization, must have their own coherence and in the achievement of that coherence, he discovers his expression.

What is assumed here, it goes without saying, is the vitality of the canvas or the sheet in front of him. It looks back, and the fantasy that absorbs him is that as he marks it he is modulating its expression.

Look, for example, at one of the few portrait drawings done in the Fauvist years, the portrait of Jeanne Manguin of 1906. The drawing develops symmetrically. The linked hands, the fold of her shawl, the centered brooch, the collar, all join in a series of upward-spreading triangles that support her head. This structure spreads out from a vertical axis, the axis that supports her features and is closed only by the swoop of the brim of her hat that literally caps it off. The

whole drawing looks back at us. The marks that denote her eyes, nose, mouth are in lively accord with the marks that denote her shawl, the veil, lacey cuffs.

The canvas or the sheet of paper has its own specifics of size, proportion, and area: it's not just a piece of something neutral. It is a whole thing. He devotes a paragraph to this point in the *Notes of a Painter*:

> If I take a sheet of paper of a given size, my drawing will have a necessary relationship to its format. I would not repeat this drawing on another sheet of different proportions, for example, rectangular instead of square. Nor should I be satisfied with a mere enlargement had I to transfer the drawing to a sheet the same shape, but ten times larger.

At the height of his most severely modernist period (1915) Matisse made some drawings of the violinist Eva Mudocci. One of these is on a tall narrow sheet – I think it is a Japanese paper that he used for prints. The image is worked out to the edge. You can see from the erased marks how he has progressively assimilated the image to the page, bringing the collar and the long upraised hand into a parallel relation to the edges, redrawing the features so that they lock into the shape of the paper, the paper that he pushes back on either side of the head with charcoal rubbing that is not so much like shading as like a kind of cutting or carving as though the paper were a plank, something solid.

In the famous drawing of the same sitter (in MOMA) we can see the same process working in an opposite direction. The drawing started at about two-thirds its present size. The head was further to the right and much more naturalistic in its rendering. The additions appear to be sequential – first the strip on the left, making the whole wider than it is

tall, allowing him to develop the great buttress of her sup-
porting arm; then the two strips on the bottom which
restore the proportions of the original sheet but change the
subject, introducing the arm of the chair and the movement
of the other arm across her lap. I can't think of another work
that brings the experience of time more poignantly into
play. There is a forward momentum, a drive in which one
view of the whole is supplanted by another and another; at
each stage, the parts root themselves in the different rect-
angles, giving a distinct quality to her presence, a different
balance to her splendid pose. We take in this forward momen-
tum by reading it backward, working back to the original
drawing as though working through layers of memory. We
find her present head locked in to the top of the page, the
contour of the hair left open on both sides so that the back-
ground shapes flow in, as if to an armature, to enclose and
delicately support the head. Earlier markings have left their
traces. Through them we can feel her gradual shift to the left,
drawing herself together, drawing herself up with greater and
greater authority, and pulling away from, although not leav-
ing the ravishingly beautiful face that once was and is now
erased, that hangs there, a memory. But it was in that veiled,
dreaming face that the drawing began. Somewhere within
those first moves were the seeds of the impulses that drove
the drawing forward to its present state.

In drawings like this we can feel how sometimes the
paper becomes so real in its dimensions that he is able to
work on it as concretely as a sculptor working on a piece of
stone. It is given, and the image is carved out of what is
there as best it may be. His erasures are like a stripping
down. There are several reported remarks where Matisse
says things like "Drawing is nearer to sculpture than to
painting." Elderfield quotes him as saying "A drawing is a
sculpture," and of course, at the end, with the cut outs, when

he felt that he had at last got somewhere in his lifelong bat-
tle to have drawing and color speaking as one, he says it
again, in triumph: "Cutting directly into color reminds me
of a sculptor's carving into stone."

There is a little self-portrait drawing where we have no
choice but to see the sheet itself as the artist's head. The
boundaries of the head are left open. The drawing is all fea-
tures, but they don't float around. I am reminded of a solid
object that has had a face inscribed on it and becomes a
head. And also of that astonishing object, the fifth version
of the head of Jeanine in which the features, the massive
nose, the craggy eyes, have become the head, finding their
own version of the skull, a more compelling presence by far
than the earlier versions where the head was realized in a
more normative form.

In the painting of Sarah Stein, which is associated with
the drawing that I first showed you, the head emerges from
a gray wedge that is both background to her head and
pushes forward to become her shoulders and chest in one
continuous plane. The head and long neck seem to grow out
of that gray plane, to be both part of it and an exotic flower-
ing above its surface. The picture as rectangle, the picture as
fabric, the picture as face: the haunting affinity between the
face and the fabric that supports it evokes that legendary
picture, the True Image, the Vera Ikon, the Veronica, the veil
onto which Christ's features were miraculously imprinted
on the road to Calvary. I have no idea how much Matisse
had thought about this legend before he made the Stations
of the Cross designs for the Chapel at Vence, but there the
Veronica is, dominating the whole wall, facing us more
openly even than the figure on the cross and with greater
force than anything else – because it is a picture.

PORTRAITS

Matisse's portraits are almost always of family, or of friends –
people in his circle, painters, painters' wives, musicians,
actresses, collectors who had become friends. There are very
few commissioned portraits. And as to his models, it is only
occasionally that he made portraits of them.

The family, Mme. Matisse and Marguerite in particular,
are like hard-driven laboratory assistants. During the cru-
cial years 1905/6 his wife is the model for the paintings in
which he summarized the Fauve style, *The Hat* and the
Green Line. And it is she again who sits through endless sit-
tings for the great portrait that is his major response to cub-
ism. These paintings mark radical turning points. She had
supported him through thick and thin. These sittings which
stretched her nerves to breaking point, and the results of
which brought down storms of ridicule from conservative
critics and the ardent support of critics like Apollinaire,
were strenuous tests of her support and understanding.

Matisse's last published words were in the introduction
to a folio that was published in 1954, the year he died, called
Portraits. It is one of his more beautiful texts. All through it
he stresses the search for likeness: "True portraits, that is to
say, those in which the feelings as well as the features seem
to come from the model, are rather rare.... " He goes on,
"The driving force which leads me throughout ... depends
on the initial shock of contemplating a face."

The painter must empty his mind of all preoccupations,
Matisse says, thinking only of the face in front of him:

> The art of portraiture ... demands especial gifts of the
> artist, and the possibility of an almost total identifica-
> tion of the painter with his model.

Likeness, he associated with "asymmetry," by which he means the way an individual face deviates from a type.

108 I believe, however, that the essential expression of a work depends almost entirely on the projection of the feeling of the artist in relation to his model rather than in organic accuracy ...

But wait a minute! He is saying two things here: the expression must come from the model; the expression must come from the painter. Which does he mean? I leave the question hanging for a while.

An extreme instance of the painter's "projection of feeling" would be the Yvonne Landsberg portrait, with its baffling outburst of scratched lines that leap out from the motionless sitter. There have been many attempts at interpreting them. Matisse refused to explain them. Yvonne Landsberg was an extremely shy girl in her teens. Matisse was touched by her shyness. When she and her brother arrived at his studio for the first sitting, they found Matisse drawing the buds of magnolias, which, he told them, reminded him of her. The painting took many sittings and was entirely re-painted at each one. Her brother was to comment that with each sitting it seemed to resemble her less – but, in a quite different sense, became more and more like her. The scratched lines were whipped in at the last minute and, according to Landsberg, Matisse was as astonished by them as everyone else.

In describing his search for likeness, Matisse stresses the interaction between himself and his model as though it comes about on a level over which he has no control, far removed from ordinary social intercourse. He stresses the almost commonplace conventionality of the sittings. There is no Kokoshkarish nonsense about X-ray eyes "penetrating the sitter to her innermost being." At first it is a matter of

learning her appearance. At the end of the first session, he tells us, he will have a "more or less precise image ..."

> This image is revealed to me as though each stroke of 109 charcoal (had) erased from the glass (between us) some of the mist which until then had prevented me from seeing it.

After this first session, he wants to leave it for a day or two. "During this interval there occurs a kind of unconscious mental fermentation ..." When he takes a second look at the drawings he made on the first day they are likely to look weak: "But beyond the haze of this uncertainty I can sense a structure of solid lines." This structure touches his imagination which, as time goes on, is fired equally by the structures revealed in the first sitting and by the renewed presence of the model. "The sittings continue in the same spirit, probably without these two people becoming ... much more informed about each other than on the first day."

> But "something has come into being ... an interaction of feeling.... After prolonged work in charcoal, made up of studies which more or less interrelate, flashes of insight arise, which while appearing more or less rough, are the expression of the intimate exchange between the artist and his model."

In contrast to the cool and somewhat detached tone of his description here, there is a mass of evidence to indicate that he approached his portrait sitters in a state of heightened emotion, as though the success or failure of the work was in their hands, as though everything hung by a thread over which they had control. This comes over even in letters he wrote to a colleague when he was working on portrait draw-

ings of the Baltimore collectors, Claribel and Etta Cone, working from photographs: and one of them was dead! He approached his sitters wide open to the "shock" of contemplating their faces, with awe and wonder. Sometimes he speaks of them like a man in love.

110

In 1913, the year of the great cubist portrait of his wife, he was introduced to an American woman, Mrs. Warren, who sat for him. It seems that Matisse was unusually pleased by the final drawing, which had evidently been hard-won.

"For some time," he told Matthew Prichard, who had introduced Mrs. Warren, "I thought it too difficult and that I should have to abandon the attempt. There was a constant movement of her will forwards and backwards, giving and withdrawing, opening and closing; my first drawing was nothing, but when, after hesitating, her being agreed to lend itself, I was able to work. There was no change in the features unless in the light of her eyes, but there was a constant vibration (here Matisse fluttered his hand back and forth) – it was like a rippling lake, like sunshine on water, there was nothing whatever to seize and there was no point where it seemed possible for me to begin."

He was so proud of the final drawing, Prichard tells us. He thought it had a vitality that no photograph could match. Something had happened, something had been released in him – or, something had come over to him from the sitter:

"It was a miracle," he told Prichard later, "She is a flowing stream. She is just a flame, she hangs by a thread, no point is indicated where you can grasp her. In spite of that, the drawing is a complete realization of my vision."

"Beyond the haze of this uncertain image I can sense a structure, solid lines..." In all Matisse's work there is a sense of momentum, a forward pressing movement in which the painting is opened up again and again, change is courted, the standing of the whole painting is put at risk when moves and alterations are made. His blunt, uningratiating corrections are made without any regard for closure. When the still-open picture has looked back at him and its look has matured – not into timelessness, but into a steady, enduring regard – when this has come about, he is ready to walk away from it.

The momentum of his work always involves a certain stripping away, the shedding of irrelevance. In the modernist drawings like the studies for the portrait of Greta Prozor which are among the most aggressively reductive of all, one infers a whole history of search and discovery among the ghosts of lines that hover behind the final ones. This last minimal structure does not feel like something imposed – although it is clearly invented, having no literal correspondence with things seen. These few lines feel less like summaries of past observations than like new statements in an entirely new language – a language in which the terms are not abstracted from the head in front of him and transcribed onto a neutral surface, but rather that the head is made over again, invented, given new life from the unique terms of this particular page and its history.

Later Matisse was to find a different rhythm for this forward-moving process, a process that we can compare to the cycles of compression and release, of indrawn tension and outward flow that are inseparable from our physical and mental awareness. The anxiety that produces the first drawings, with all their trials and corrections, is discharged now in a torrent of line drawings in which the terms that have been laboriously assembled into a tight-knit whole are

spent prodigally in a kind of play that looks as if it feels as if it could go on forever.

Drawings along these lines were exhibited in the late thirties under the title *Themes and Variations*. But notice that with these heads, the variations that he plays out are not exactly formal variations in which the theme can be exactly specified or to which the variations can be exactly returned. The theme is flexible, a continuity of intangibles, as mobile as running water. The point is that Matisse's reductions must not be mistaken for some latter-day version of that Renaissance tradition that recommended the artist to strip away the particular and the contingent in order to reveal the Idea, the timeless essentials that lie beyond the particular case. Matisse is not working towards an ideal generalization: he is living something out in real time, the presence of his sitter – this person – and the presence of his drawing – this drawing. And it is the unfolding of understanding that took place in real time that is finally summarized.

His reductions bring the issue of likeness to the fore, as a problem. The question of likeness fascinated him and puzzled him. He wrote about it in connection with a sheet of self-portrait drawings that were in a major exhibition in Philadelphia in 1947. How can it be, he asks, that these drawings, none of which matches another, are all so obviously of the same person? He lists their differences; then he points out that there is some consistency in the way the parts are articulated: "The way the nose is rooted in the face – the ear screwed into the skull – the lower jaw hung." What preserves the sense of identity, Matisse writes, is the "organic make-up" of the four heads.

Likeness is preserved through all these transformations: "It is quite clear," he says, letting his self-portrait spill into words, "that all four drawings describe the same man, as to his character and personality, his way of looking at things and

his reaction to life, as to the reserve with which he faces it and which keeps him from an uncontrolled surrender to it."

This was the face he presented to the world – dry, clear-eyed, logical, controlled. It was one side – the day-lit side – of an argument that had raged inside him all his life. The other, the dark side, spoke for intuition, the unpremeditated impulse, the surrender of will. It wasn't his argument alone. French painting had defined itself in parallel terms for a hundred years and more, hence the mythic power of the rivalry between Ingres and Delacroix, the persuasiveness of Baudelaire's opposition of *le naïf et le pontiff.* The terms change – line versus color, Florence versus Venice, Poussin versus Rubens, studio versus *plein-air* – and of course, Post-Impressionism, *Cézanne* above all, had permanently transformed the terms of the argument. But the tension remains, finding new positions in the mind of any artist struggling to understand where they are and what they must do. For this argument is nothing less than painting's specialized way of talking about issues that are as old and as universal as human consciousness itself.

CONCLUSION

There is a drawing that is published by Lydia Delectorskaya – Matisse's model and companion for the last two decades of his life – and on the back of it Matisse has scribbled that day's version of the argument. There are two lists, under the titles *Reason* and *Inspiration. Reason* has *Method, Color* (crossed out), *Drawing* (the translator has Sketch, but as far as I can see the word is *Dessin),* then *Color* is written in again, and finally *Valeur.* This is translated as Meaning; which is, of course, one of the word's primary meanings. But in studio jargon, valeur means the weight and temperature

of a tone – and elsewhere Matisse will tell us that the particular emotion that his model evokes is expressed by the distribution of *valeurs* – values – across the whole canvas "forming their orchestration, their architecture." So in the ambiguity of this word we are brought back to his original formulation – Expression is indistinguishable from Means.

The other list, under the heading *Inspiration*, starts with the word *Rapture*. Then: *The devil* – or a *double substituting for a rational man.*

Then: *Comparison to a woman being courted – who is another's.*

It is an enigmatic list. What thoughts were going through his head when he wrote *color* on the Reason side, then crossed it out, then wrote it in again? And who is it *who* is compared to a woman being courted and belongs to another? The model? The picture? Or the painter himself?

Some years later, the year he died, he wrote in the *Portraits* essay the now famous account of the "revelation in the post office." Here he tells us that he first became interested in portraits at a precise moment in his youth. He was waiting in a post office for a phone call. He was thinking about his mother – the implication is that it was her call that he was expecting.

"To pass the time I picked up a telegraph form ... and using the post office pen, began to draw on it.... I drew without thinking what I was doing, my pen going by itself, and I was surprised to see my mother's face, with all its subtleties...." He goes on: "I was struck by the revelations of my pen, and saw that the mind which is composing should keep a sort of virginity ... and reject what is offered by reasoning."

Perhaps one reason why Matisse so valued the particular relation that the portrait required, the painter, the sitter, the canvas somewhere between them – was that it brought into

the foreground the very nature of painting itself. It gave reasonable circumstances for the release of fantasy, and in turn, fantasy, desire, delirium spun an atmosphere in which reason could focus its sharp point. The canvas, the paper, faced him. It was face-like. It returned his look. In moving across it, in marking it, he was forming its features, finding its expression. The presence of the sitter – whom he never placed more than two meters away, usually closer – the presence of his sitter opened channels of feeling that flowed as if from outside, from the sitter, from the mysterious portals of that face whose expression was her own, autonomous, Other – and yet, as it flowed through him, was his.

"At a certain moment," he told one writer, "there is a sort of revelation, I am no longer in control. At such times there is a real split in me. I no longer know what I am doing. I identify with my model."

An ancient myth of inspiration is being enacted here, only now the Muse, who alone understands the mysteries of inside and outside, of here and there – and knows all about the terms of modern painting – relinquishes her muse position at the artist's elbow and crosses the room and sits for him, expressionless, not more than two meters away – face to face.

Claude Monet

Catalogue introduction to an exhibition of the same name
Aquavella Galleries, New York
October 10–November 27, 1976

THE MAGNITUDE OF an artist can be gauged by the richness of his resurrections. Thirty years ago most painters would have agreed that Monet's reputation had long since been put to bed. To eyes educated by Cézanne's formulation of reworking Poussin from nature, Monet was formless. To those steeped in the metaphysical waters that nourished European abstraction, Monet was a kind of pagan prophet whose involuntary contribution had been the dissolution of subject matter, and by some fallacious but furiously argued association of ideas, it seemed that his preoccupation with ephemeral effect rendered his own art ephemeral. To the Surrealists he was anathema, a materialist concerned only with things as they are.

No generation can see a big artist whole. We put part-truths that are available to us to the service of our special needs. *That* Monet, the painter of light alone who turned his mechanical eye indifferently in any direction, that stupid painting machine, was in a sense a necessary anti-hero who, if he had not apparently existed, would have had to have been invented by Kandinsky, Klee, Malevich, and Mondrian. The rediscovery during the early fifties of another Monet is well known, the Monet of the late *Nymphéas* who suddenly became topical at a time when issues of very large scale, open and *enveloping* format and painterly attack were

being urgently explored. It seems that new urgencies are working now. We want to look at the whole of Monet. He helps us to ask questions which we are only beginning to be able to formulate.

One reason for the over-simple view of Monet which was held by earlier generations is that the whole story of advanced art in the nineteenth century was oversimplified. The fight which Monet and his contemporaries fought against the Salon and the Academy was treated as a black and white conflict in which the right wing had no existence except as enemy. The psychology of the avant-garde made it impossible to acknowledge either the force of the academic (except as repression) or of the dialogue which existed in a painter like Monet between past patterns and future freedoms. By blocking out the force and actuality of Monet's antagonists much of the depth of his achievement is also lost. A great deal of work has still to be done in this area.

Not that experiments such as that tried at the Metropolitan recently, when Salon paintings were hung alongside Impressionists, cause us to admire what we had hitherto disliked. It is rather that we need to be reminded again and again of the polemical aspects of nineteenth-century painting and of the fact that originality is not simply a matter of invention but of finding a context for invention, and that this context is itself hollowed out of the conventions, the clichés, and the honorable precedents given at any time.

Sometime in his late teens, then, Monet is persuaded by an older painter, Eugène Boudin, to paint out of doors. Monet commits himself to this practice completely. The rest of his long and remarkable energetic life is spent exploring the implications of this commitment.

This is not to say that he always worked from observation, nor that his life's work followed a single, unbroken line from this point. Indeed his researches — and no painter was

ever less complacent than Monet – take him a very long way from simple landscape sketching.

In looking at those academic paintings at the Metropolitan and at the Impressionist paintings in the next room, one was struck by the liveliness of the surface of the Impressionists all the way across. Each inch of the picture could be seen as frankly painted, made out of strokes or dabs of live color in which no color change seemed to be subservient or secondary. In the others, each feature seemed to be made out at the expense of something else. In all traditional painting the underlying descriptive logic is based on the contrast of one form with another or with the bringing out of a form against its background. Such a form will be centered the way a figure is centered on its spine, its mass turned in on itself or flung outwards with a kind of choreographic energy which nonetheless stems from its center. This will happen with high energy in a decent painting, flabbily in a weak one, but the principle is the same. There is something hierarchic about such drawing, inevitably. The important is emphasized, the unimportant *suppressed*. We are *shown*. But if we look at a Monet of the sixties or seventies we are struck by the absence of this kind of hierarchy. Everything seems to be alongside everything else (which is not to say that the pictures are flat), nothing is turned in on itself or rhythmically linked with its neighbors, but stands equally beside them. It is as though everything had appeared at the same moment. *L'Embarcadère* is arguably an exception which proves this rule: the woman in black on the right is so foreign in scale and tone to the rest of the picture that it is hard not to conclude that she was put in under different circumstances from the rest of the picture, in which evenness and unity are so striking.

Looked at as a composition, *L'Embarcadère* is quite conventional. It belongs to that ancient landscape scheme in

which the *stage* of the picture is divided into an L of nearer forms and the eye is led out through the opening of the L toward distance and sky. But Monet does not use this scheme to direct the eye to one incident or another, to conduct us rhythmically. Is the *hero* of the painting the cream-colored sail, the white dress, the pink parasol? None of these obviously, for none has either point or moment except as equal participants in an ensemble that includes everything in the picture, the ripples on the water as much as the figures, the vibrating leaves as much as the boats. Each item in the picture seems to have met with the same degree of transformation, to be equally painted. Drawing is an all-over process in which the meaning of edges is in no way downgraded but rather given new values based on whatever laps it around.

Of course, this view of drawing had long been implied in the language of the landscape sketch. It is at work in Constable sketches but not in the academy paintings; in Corot's sketches but not in any of his set-piece compositions. Long before the furor of the Impressionist exhibitions in the seventies, academic teaching had recommended that the landscape painter begin with studies (*pochades*) made directly from nature. These should be painted quickly, aimed at effects of light and *l'impression*. The word *impression* meant the look of the motif in its first impact as a pattern of light and shade. It had a secondary, more subjective meaning, perhaps best understood as a new idea for a picture, or an inspiration. But neither observation nor inspiration had any validity until they had been brought back into the studio where they could be organized, given shape according to the painter's knowledge. The originality of the precursors of Impressionism – Daubigny, Boudin, Jongkind – lay not in the fact that they worked directly from nature but in the novel value that they attributed to this way of working, a value that Monet and his colleagues were to take up as their

battle position. The aesthetics of the sketch are made public. The public is challenged to look at paintings the way painters did; and also to look at any subject as though it was a landscape. This was not easy, for it is of the essence of the sketch that it is elliptical, condensed, and that its impact is an immediate one under the force of doubt and recognition. We "make out" such a sketch, we read it, calling upon all that we know of a painter's eye and hand to reconstitute his subject matter. Such energetic challenges as this were in a different world from the more passive picture reading to which the Salon-going public was used.

The first Impressionist paintings have an air of vivid adventure. It is as though a new world is being opened up, a world with limitless horizons. Although on the face of it, the program was a modest one, the further it was pursued, the more mysterious its challenge turned out to be. The problem was to establish, under the conditions of open air painting, those circumstances of reflection and organization under which art can be made. How was the transition to be made from mere information to aesthetic form? *Plein-airisme* is inevitably iconoclastic in its opposition between the world seen (out-of-doors) and the world of pictures (the studio). There is a great force in that contrast, a force which Monet did not surrender lightly. Although the pursuit of light had become a driving intention in him, he did not abandon more orthodox ambitions. During the sixties he had several shots at assimilating his new material into grand set-piece compositions. Only one was completed, the *Femmes au jardin* of 1866. An even more ambitious painting of the previous year, a *Déjeuner sur l'herbe* had been seized by a landlord, damaged by damp, and was finally cut into pieces. There was a major composition planned of *La Grenouillère* for which *L'Embarcadère* in the present exhibition may have been a study. Monet told his friend Bazille about

this in a letter (September 25, 1869) and refers to "*quelques mauvaises pochades*" – paintings that now seem like the most daring and magical statements of Impressionism to date – but he adds "it is only a dream." The reason was simply that he could not afford the materials or find stable conditions needed for such an undertaking. By the time his affairs had settled down in the mid-seventies his ambitions had changed.

We do not know, and it is idle to guess, what course Monet's art would have taken if, like Cézanne, he had had some private security during this period. Would the argument between the demands of outdoor painting and large-scale composition have been developed in greater depth? Would the radical aspects of his work have developed more slowly and reflectively? Certainly one is tempted to see a correspondence between his plight as a harried outsider and his defiant commitment to his roving sharpshooting exercises, working from boats, from the front rooms of inns, his studio on his back in all weathers.

By 1873 Monet had been back from his war-time exile in London for a couple of years and was established with his family at Argenteuil. His affairs were just beginning to improve. That summer he painted a remarkable work, now in the Louvre, which carries his reflections about outdoor painting on to a new stage. *Dans le jardin, le déjeuner* is a large canvas 160 × 200 cm, and obviously conceived as a set-piece although it is painted in his full Impressionist manner. In style it is close to *Le jardin du peintre à Argenteuil* and *Le jardin de Monet à Argenteuil* which must have been done at about the same time. When *Dans le jardin* was first exhibited at the 2nd Impressionist Exhibition of 1876, it was catalogued as "*panneau décoratif.*"

There is a great deal going on in this painting. The immediate foreground is occupied by a basket on a stand

filled with fruit. Beyond this is a table covered with a white cloth and with china and more fruit. To the right is a wooden garden bench running in perspective toward the center of the canvas. To the left of the table, the artist's son is on the ground in a patch of dappled shadow. Beyond, the sun blazes on the garden path, and there are great banks of geranium and other vivid flowers on either side. Beyond them and running up to the top of the picture is a further zone of shadow in which can be seen the wall of the house with windows, and entering from the right, the sunlight breaking across their pale dresses, are the figures of two women. In an abstract sense the structure of the picture is not distant from the traditional landscape and figure composition with its zones of light and shade, its stage-like enclosure and the controlling diagonal. But it is as though all these elements have been dissolved and merged into a completely new amalgam. There is no single point of dramatic tension, no rhythmic direction, no *choreography*. Instead there are broad areas of involvement which seem not to be separated from each other in space but rather to hang side by side with each other. In front of the painting, one is inclined to move about rather than to look at it from a fixed point of view, and in doing so one is drawn closer and closer into its tangled varieties of color and vibration. The table with its crisp cornucopia richness is one center; Jean Monet in his slot of space on the left is another; the staccato blaze of the flowers another. The eye is not directed on its way between these centers but rather wanders among them, dazzled, cooled, caught up so closely in the look of them and in their special, ungeneralized identity that it is content only when close enough to a particular area that its neighboring areas are not altogether clear in their focus. Paradoxically it is only then that they are completely clear in their orientation. Then, there is a sense of being at the heart of the picture, wrapped around

by it rather than reading it at a distance. And out of this, the feeling of being at one with things seen is achieved.

It used to be said of Monet – Cézanne no doubt started it with his "*Il n'est qu'un œil!*" – that he was a purely *retinal* painter. It is not an idea that one can get very far with. Like any painter of consequence, he is addressing himself to the culture of pictures, even if it is to remonstrate. Even as he and his colleagues turned their backs on the museums they were rediscovering the schemata of earlier traditions. The problem, and it is built into the very foundations of the Impressionist adventure, was how to reconstitute those schemata so as to bring the sparkle and bite of their vision most vividly to life. Looked at another way, the problem was how to structure pictorially the shapelessness of experience, how to anchor vision without bringing it to a standstill.

All through the seventies and eighties Monet is experimenting with new ways of structuring and articulating. Color which he has now learned to use with an unprecedented purity offers an infinitely subtle and flexible alternative to the traditional massings of light and shade. Systems of interlocking blues and oranges, for example, or lilacs and lemons will carry the eye across the whole surface of the canvas and these color structures, each marvelously tuned to particulars of light, will be augmented by a vast range of accent, of comma, slash, dot, flake, each attuned so economically to its object that the eye is continually at work in its reading. This wonderful language, so sensitive to nuances of light, to place, time, weather, yet so robust and driving, allows him to annex for painting, territories that had, until then, been literally invisible to it.

With the painting of the Gare Saint-Lazare, we realize how completely old definitions are changed by his vision. His attention takes in the station buildings, the tracks and locomotives, the swirling steam and smoke, and out of each

conjunction he finds something unpredictable and poignant, this moment in the indifferent city humanized by his responsive attention to it.

124 During the eighties he paints ice flows and floods on the Seine, coast scenes in the full sunlight of the Mediterranean, the storm-wracked cliffs of Brittany, the barren valley of the Creuse. By the end of the decade he has begun the series of poplars on the banks of the Epte near his new home at Giverny, and the haystacks there. During this period, he seems to be drawn to subjects of extraordinary shapelessness – fogs and mists, the *Débâcles* of the winter of 1880 in which the whole picture seems given over to leaden flux, or on the southern coast where the all-over incandescence of light seems to burn features away. But at other times his attention is drawn in the opposite direction and he seeks out motifs which are extremely well defined and even hackneyed as though deliberately to challenge expectation. The much-painted cliffs at Etretat are an example of this, and later the series of Rouen Cathedral or the Houses of Parliament or Venice. Often in front of these sites he will adopt a presentation which is as frontal and symmetrical as may be, the motif emblazoned on the canvas with an almost heraldic simplicity, as though by solving all questions of placement at one stroke he is claiming the maximum autonomy for his pall of color. These extraordinary solutions cannot be isolated from the innovation of the series.

Monet's search for the structure was qualified always by his relation to time. The contrast between a painting in front of the motif and a composition made traditionally in the studio is parallel to the contrast between experience of here and now and the experience of memory, with its layering, its resonances, and its revisions. We cannot fail to read Monet's paintings of the sixties and seventies in his time, correlating their facture, their overlappings and corrections,

with observations and decisions made there and then. The motif and the painting *happen* simultaneously. Yet anyone who has taken a photograph out of doors, let alone painted, knows that the more one tries to keep up with things, the more obvious it is that instantaneity is not a feasible project but an aspiration.

The dialogue between Monet's practice out-of-doors and the culture of pictures is, in a sense, an argument about time – or an ideological level between the *now* of modern life and the motionless *then* of the museums, and on a practical and psychological level between the simultaneity of motif and painting act, and the layered, reflective experience away from it. As he grew older, the contrast between one mode and the other decreased until we can hardly tell where one leaves off and the other begins. Many of the Rouen façades and the London scenes are not painted on the site at all, and it is not obvious which these are. He had a prodigious skill by now, but more significant perhaps, he had the experience of middle age in which the present loses some of its rawness, is irradiated by memory, and becomes less intractably unique. By the end of the eighties, when he started on the *Poplars* and the *Haystack* series, it seems that he felt that he had reached the limits of his exploration of the instant through the *pochade*. Ostensibly the program was to capture shorter and shorter moments on each canvas. "When I began," he told de Trévise in 1920, recalling the beginnings of the *Haystack* series thirty years earlier, "I was like the others; I believed that two canvases would suffice, one for gray weather and one for sun." It is a self-travesty. Obviously the Monet of 1890 thought no such thing. At the time he complained horribly of his difficulties, above all of his slowness and his dissatisfaction at "the easy things which come at one stroke." What he was up against now was not so much the speed at which the light changed in the motif but the speed at which his own judgments changed,

and the gap between that and his practice. Doubt, dissatisfaction, the nameless emotions of self-criticism move at their own speed and create their own disjunctures between the time of the motif and the time of painting it.

The special power of the series paintings is that the form of the series itself takes over and symbolically resolves the argument between structure and instantaneity. It allows for infinite revision for tactile solidity and a kind of stillness which is resolved by the *movement* into the next picture; it allows for extreme informality too, for repetition imposes formality of another kind. These paintings are like a kind of recapitulation of everything that he had tried to do up to now. But they are also completely new, for no paintings before had done what they were doing: creating a span of time in which each segment is isolated, free standing and still, a moment extended into pure duration.

The Listener
November 5, 1959

IT IS A COMMONPLACE that the evolution of twentieth-century painting has proceeded from a systematic destruction. Picasso, the first instance, has attacked the art of the past with a sledge-hammer. But in the long run a destructiveness like Picasso's has turned out to be in the interest of a new kind of beauty; the ugly fractures and deformations of the other day are today's arabesques.

The case of Marcel Duchamp is different. He, with none of Picasso's navvy-like energy, proceeded coldly and eloquently to destroy beauty. This enterprise was not undertaken for a lark – it was in fact the consequence of his most serious reflections upon art. Considering his life and work, one is immediately reminded of two notions put forward by Baudelaire concerning the modern artist. In the first paragraph of his monograph M. Lebel mentions Baudelaire's concept of the artist as a dandy; one can hardly avoid the comparison, for Duchamp's independence and anonymity, his comparative seclusion, his amateurish virtuosity as a chess player, as a mathematician, his own description of himself as "an unfrocked artist," make this the obvious approach.

But equally one is reminded of Baudelaire's remark that the modern artist is by definition also a critic; every one of Duchamp's works after 1911 can be seen as aimed critically at one (or more often several) of the salient problems raised by modern art. Nothing that he has signed has been done for

the sake of production; one feels that it is not creative fury that lies behind his rare utterances, but critical deliberation. The works have been like the outcome of long conspiracies, infernal machines. One cannot exaggerate their complexity. On this point I think it is important to remember his personal background: being the younger brother of Jacques Villon and Raymond Duchamp-Villon, both highly professional and productive artists and well up if not in the front rank of the *avant-garde* of pre-war Paris, his early attitude to art must have been conditioned by their dominance. No doubt this has a bearing upon his extreme sensitivity to the problems of art, as well as his fastidious indifference to the mystique of production; his competitiveness has been that of the youngest brother who shows off, who is brilliant, who gambles recklessly, and who at the crucial moment disrupts the game and does not compete at all.

Reviewing his work, as one is now able to do in Robert Lebel's well-illustrated book, one is able to follow out a variety of themes. All of them seem to bring one in the end to the problem of communication.

Duchamp's first advanced paintings were done in 1911. They are portraits which combine several aspects of the sitters. Although they use cubist devices, unfolded forms, and multiple perspectives, they differ from cubist paintings in that they deal with the movement of the subject within the picture rather than that of the painter round the subject. Later in the same year Duchamp painted two of the most astonishing pictures of the period, the *Coffee Mill* and the *Nude Descending a Staircase*. The *Coffee Mill* is an intimate portrait; the structure of the machine is shown in section, much simplified. The grinding wheel is also shown in plan, making a toothed circle that dominates the center of the picture. Coffee beans flow downwards and emerge in a soft

pile at the bottom. But the movement and wit of the whole construction centers in the crank at the top whose handle flails out in a bunch of snaky lines, its orbit indicated with an arrow. It is impossible adequately to describe the vitality of this work. It looks at you with a terrific mechanical animation; it grinds and turns under your eye: you have the impression that you are using it.

The much more ambitious *Nude Descending* has the same sort of mechanical vitality, the same clarity. The forms of the figure have been treated as though they belonged to a walking-downstairs machine; they have been spread out and multiplied so that they encompass many stages of the action yet at the same time they are completely unified. A number of shapes in the picture, although they are no less concrete than the rest, indicate nothing but the range or sweep of a particular movement.

Both these works are hard and distinct images of movement. What do their forms actually represent? They are inventions which have to be reconstructed dynamically, in time, by the onlooker, studies of time which are "solved," so to speak, in the real time during which the onlooker examines them.

The first of Duchamp's famous "ready-mades" carries the spectator's participation a stage further. This was a bicycle wheel which he mounted upside-down on a stool: the spectator is expected to join in, first by recognizing it as an art-object, and second by giving it a spin. Duchamp's studies of movement and mechanical relationships have always reflected back to his thoughts about the concept of art, about the relationships between the artist, the work, and the spectator, between the "reality" of the art-object and the "reality" of the outside world.

MOST AMBITIONS WORK

From 1915 to 1923 Duchamp was engaged on his most ambitious work, a painting on glass called *The Bride Stripped Bare by her Bachelors, Even*. This was to be the culmination of a series of studies that had started in 1911. The program of the work is complicated to a degree; I want at the moment to point to two aspects of it which reflect the preoccupation that I have mentioned. The imagery deals with the imagined interaction of pretended machines which are, as it were, caught in a moment of stillness. (These machines, I should say, are identified as characters, the bride, the bachelors, their physical and emotional mechanisms, and so on). In defining the forms of these machines Duchamp turned repeatedly to the chance effects of actual phenomena: color is obtained in some parts by the settling of dust, shapes by the imprint of gauze blown by the wind or the chance fall of string. But one could hardly guess that chance was present here, for the whole work is meticulous.

Ten years after completing the *Large Glass*, Duchamp published the inside story of it in the form of a green box which contained large numbers of notes and drawings reproduced in facsimile from the scraps of paper on which he had made his calculations. These were assembled in a random order. An important section of these notes is reproduced in an article on the *Green Box* by Richard Hamilton in a recent number of the magazine *Upper Case*. This is a page headed *Preface*, and in this Duchamp declares his aim as being to find what he calls "the sign of accordance" between a state of rest arrived at by various groups of objects reacting on each other and the choice of future possibilities open to them. The "state of rest" is the point at which the forms have been stopped; they are hanging, as it were, between the

past and the future, between what has been forced upon them by various laws and by chance – and what is possible for them next.

OBSERVERS CONTRIBUTE TO THE MEANING

If I have understood his statement correctly it would appear that he is inviting us to contemplate the work as though it were a chessboard with the game in full progress, the "sign of accordance" being precisely our grasp of the situation when it is our move. In fact, just as factors from outside have been called in (gravity, wind, dust, and so on) in the making of the work, now observers from the outside are called in to make their reading of the work, to contribute to its meaning. This, I need hardly say, is the extreme opposite of the "timelessness" of traditional art and of the impersonal aesthetic idealism of established Cubism.

One of Duchamp's most telling remarks is: "I have forced myself to contradict myself in order to avoid conforming with my own taste." Already, at the time when he was painting the *Coffee Mill* (1911) painters like Gleizes, Metzinger, and Le Fauconnier were busy taming the cubist images of Braque and Picasso and forcing them to lie down in the green pastures of *la bonne peinture* – Duchamp's reaction, like that of Picabia and the Dadaists a year or two later, was aimed at the whole institution of aesthetics, of forms and rules of good form which blunt and falsify experience. At the point at which innovation hardens into style and becomes a familiar language, it also becomes cliché; style intervenes between the spectator and the object. To keep ahead of this process, the artist breaks his heart in an exhausting and degrading steeplechase. Duchamp's solution was to step

132

sharply to one side. The *Coffee Mill* is more than an unorthodox painting of a coffee mill: we think of it as a coffee mill. Already it has something of the phenomenal quality of a ready-made. And it is important to remember the way in which the *Nude Descending a Staircase* was received in 1911: Duchamp had to withdraw it from the *Salon des Indépendants* owing to the shocked opposition of the cubists, and John Golding tells us in his study of Cubism that "even Apollinaire, for all his thirst for novelty, found it disquieting."

Soon Duchamp was to decide that a painting could not exist uniquely, any more than words used in a sensible context could exist uniquely. Hence the Mona Lisa with Moustaches [*L.H.O.O.Q.*]; hence his endless punning, his word games, hence his solemn gambling with gravity, the wind, dust, toy cannon; hence the "readymades" as he called the objects, the bottle rack, the urinal, the comb that he selected and signed as art-objects. With them, all the observer had to do was to recognize them as works; he did not have to compare them or judge them any more than the artist had had to form them within the established terms of art-cliché. Accident, chance, gave finality; it freed the object once and for all from style.

But where there is no language there is no communication. Whichever way you look at his work you are left with this bitter conclusion. The irony which informs Duchamp's work is a reflection upon the artist's position, the idiotic position of one who is prevented from communicating by his very intention to communicate.

JOINING IN THE GAME

His monumental pseudo-studies are in themselves sarcastic statements of this position. His publication of the *Green Box* purported to give the background of the *Large Glass*, to

explain it, but it is a pseudo-explanation and simply elaborates the mystery. You are allowed to join in the game but not allowed to suppose that the rules make sense. 'If he proposes', writes Robert Lebel, "to strain the laws of physics and chemistry *just a little*, it is because he wants us to think them unstable to a degree." And in this way, one might add, to give the artist the prestige of one who is taken at his own word in a way that no one else is, and at the same time ironically to dismiss him.

Twentieth-century art has often enough been called anti-humanist. I do not think that the description applies in the long run to any major artist except Marcel Duchamp. Gabrielle Buffet speaks of "the pitiless pessimism of his mind"; nowhere did he act more clearly on this pessimism than when he sent a present to his sister, a geometry book which she was to hang up in the porch exposed to wind and sun and rain. In this way, its leaves flapping and bleached, Duchamp commented: "The treatise seriously got the facts of life."

Communication is impossible. Culture, ideas, in so far as they are common property, are cliché. The artist steps outside them in order to tangle directly with "the facts of life," gambling, calling himself a woman, punning, talking nonsense, consciously subjecting or opposing himself to these facts in order to declare a sort of freedom. The more clearly the contradiction is stated, the more impossible it becomes to do anything about it. The answer is silence: Duchamp has done almost nothing since finishing the *Large Glass* thirty years ago. This is not tragic because a talented artist stopped producing but because the factors that he is responding to and criticizing are really there.

Jackson Breaks the Ice

A review of Jackson Pollock: An American Saga *by Steven
Naifeh and Gregory White Smith* (Barrie and Jenkins: 1990);
Abstract Expressionism *by David Anfam* (Thames and
Hudson: 1990); Night Studio: A Memoir of Philip Guston
by Musa Mayer (Thames and Hudson: 1991)

London Review of Books
April 4, 1991

IT WAS A SMALL world that New York artists shared in the
Thirties, defined by philistine hostility or Francophile indif-
ference. The Great Depression that had made so much use-
less made the uselessness of art irrefutable and absurd. Then
came the miracle of the WPA. Painters were paid just to paint.

Talk, all accounts agree, was the thing. It was as if a cen-
tury of brooding about America and Europe, the past and
the future, art and society, influence and self-reliance, was
coming to a head in a gush of discussion. The issues raised
by the Regionalists, the Mexican muralists, by the question
of abstract art, or by Surrealism, were all pointing in the
same direction – towards the definition of a truly American
avant-garde. The critical moment was November 1943,
Jackson Pollock's exhibition at Peggy Guggenheim's Art of
This Century. It was widely reviewed. It was supported by
people who until now had only been interested in European
art. A few pictures sold. The power of pictures like *She Wolf*
and *Guardians of the Gate* was recognized even by people
who found them baffling and chaotic.

"Jackson broke the ice." The phrase attributed to de Kooning has been repeated so many times that it has come to sound like the title of a historic event like the Boston Tea Party or the Relief of Mafeking. Within a short time, the breach had become a flood. The phenomenon of Abstract Expressionism, New York Painting – whatever one wants to call it – gathered momentum at an extraordinary speed and within ten years the old stockade existed only as a sentimental memory, its atmosphere, its solidarity and angst to be recreated over a thousand beers by survivors now vastly outnumbered by recruits from the provinces.

Jackson Pollock is subtitled "An American Saga." As a saga should be, it is based on oral tradition: the authors have spent years interviewing more than eight hundred people, recording ten million words. They show a remarkable command of scale, moving adroitly between the broad outlines of social history and the daily detail of Pollock's life. They take the view that Pollock's mother destroyed his father and that Jackson was under her spell for the whole of his life. He never relinquished the privileged dependence of infancy and the storms of anger and envy that go with it. Nor, they tell us, was he able to come to terms with his own sexuality. There are villains: Dr. Henderson, Pollock's Jungian analyst, Robert Motherwell, Clement Greenberg; and heroes and heroines: the sad, remote father, the brothers, particularly Sande, and his wife Arloie, Reuben Kadish, Roger Wilcox, Rita Benton. They write with respect about Lee Krasner and without *parti pris*. My impression is that the book is written with justice. Many of their witnesses are still very much alive. The book – which in certain passages could be mistaken for a compendium of old gossip – has aroused controversy of the I-was-there variety and some dusting-off of ancient weapons.

There are two stories here – of the Pollock family and of

the New York art world, set on collision course a continent apart, *Titanic* and iceberg. We know how it will end. "They put you up so they can cut you down," hero Pollock said, his greatness and his doom indistinguishable. It reads more like art than life, but then as Paul Delany reminded us in a recent article in this journal (January 24), life "too is 'written' – shaped, selected, mythologized – by the same rules that govern the creation of literary texts." Here, each of the countless fragments of memory out of which the epic is built has been shaped, selected, and mythologized. Such is the polishing action of fame.

Jackson Pollock was born in Cody, Wyoming, in 1912, the youngest of five boys. Both his parents were of Irish stock, farm people from Iowa. His father LeRoy McCoy had been adopted by farmers called Pollock. He seems to have been a silent, introverted man, a hard worker, and a secret drinker. For a few years during Jackson's early childhood he had a small farm outside Phoenix but it did not prosper. The center of the family was Stella Pollock. She was a prodigious housekeeper, cooking vast meals, canning, bottling, making shirts for the boys out of the best material, but also extravagant, a big spender, and obsessed with ideas of gentility and betterment that were fueled by women's magazines. This craving for a more genteel existence translated into an insatiable restlessness. Once she had achieved the uprooting from the Phoenix farm, she was to move the family no less than seven times in the next six years.

At a certain point the father pulled out, finding work in surveying camps and road construction, faithful with his cheques home. Charles, the eldest of the five brothers, had shown an aptitude for drawing. Encouraged by Stella, he left to study painting in Los Angeles. From Los Angeles he would send home copies of the *Dial* which would have been Jackson's very first intimation of modern art. He and Sande,

the brother next to him in age, decided to become artists when they grew up. Sande had ability, like Charles. Jackson had none. For all his extreme sensitivity, he seems to have been incorrigibly clumsy. Charles was his adored idol, and bitterest rival. His pugnacious ambition was aimed directly at him.

137

By the time Jackson was at high school the family had moved to Los Angeles. At his school, by one of those common but always surprising coincidences, was another famous painter-to-be, Philip Guston. It was a reactionary time and place, with red-baiting, strike-breaking, and an active Klan. Both Guston and Pollock ran afoul of the authorities. Pollock had already started to drink seriously. He dropped in and out of school. He was attracted to Theosophy and visited the meeting-ground at Ojai where Krishnamurti preached his gospel of personal fulfilment. He refused to play football, grew his hair long, and was roughed up by jocks.

Charles moved to New York to study under the Regionalist Thomas Hart Benton at the Art Students' League. He became one of Benton's favorite students and an intimate of the Benton family. On a trip back to California he persuaded Jackson, at a loose end, to come to New York and study at the League. Jackson, too, fell under Benton's spell. He proceeded to displace Charles. The authors now digress in order to consolidate one of the major themes of the book.

Benton was the son and grandson of Congressmen from Missouri. Theodore Roosevelt had written his grandfather's biography. In spite of the social differences, there were parallels between Benton's upbringing and Pollock's. In both families the mothers were the centers of emotional power and the guardians of culture. The province of the father was defined by hard work and the assertion of manhood. Beauty was feminine, work masculine. How to be a painter and a Man at the same time? Benton, who was as fixated on his

138

mother as Pollock, had found his answer in drinking, swearing, whoring, boasting, and fag-bashing his way towards a public stance as the defender of a healthy, popular American art and the scourge of sick European Modernism – the aestheticism of the "curving wrist and the outthrust hip," in his horrible phrase. Benton gave Pollock the permission he needed. But his imagination seethed with far ghastlier monsters than Benton ever dreamed of. The he-man pose was an essential camouflage but no life solution. His orientation remained in doubt. He was hopeless with women, tongue-tied sober, abusive drunk, utterly distrusted by his brothers' wives, who saw nothing but techniques of manipulation in his alternations of charm, morose depression, and boorish violence. Rumors of shadowy homosexuality abound. "Jackson always left you with a feeling of emptiness," the painter George MacNeil commented, "as if he was living in an abyss."

The brothers assumed that under Charles's protection Jackson would find his feet. There was no sign of this happening and reluctantly they came to admit that he was a problem that was not going to go away. At this point Sande arrived from the West to take over from Charles. Sande was next to Jackson in age, a swaggering cocky fighter dressed in cowboy gear – and something of a saint. His destiny, it seemed, was to look after his baby brother. He had done it when they were children. It was a dirtier business now. "There was something ... provocative in Sande's solicitude, a license to screw up that Jackson understood only too well." For the next six years, until Lee Krasner appeared, Sande was Jackson's minder, rescuing him from police, bouncers, the gutter, or laying him out cold when there was no other way of calming him down. It was Sande who initiated the encounters with psychotherapy, of which there were many besides the famous Dr. Henderson who was later to make so much of Pollock's "Jungian" drawings. Nothing worked, of

course. Pollock never showed the slightest interest in cure, even after a major breakdown that put him in hospital for several months.

Both brothers signed on when the Federal Government started to support artists in 1935. By now, Pollock was beginning to attract the attention of other painters; Jack Tworkov remembered hearing him spoken of by the head of the mural division of the WPA as a great hope for American painting. When Siqueiros came to New York in 1936, with his intoxicating mixture of political activism and technical experiment, the Pollock brothers joined his May Day workshop.

Pollock was distancing himself from Benton. Sometime in the late thirties he began to frequent John Graham, that most mysterious of all the gurus of European Modernism. Graham took him up, reinforcing his faith in unconscious imagery. From now on, Pollock transferred his admiration and his envy to Picasso, enlarging his ambition to a world scale. *Guernica* arrived in New York in the winter of 1939, and Pollock saw it many times.

It was Graham, indirectly, who brought Lee Krasner to Pollock's studio. He had invited both of them to take part in an exhibition in which there were also European big names. Having decided that Pollock was to be her cause, Krasner moved into Sande's shoes as his main defense against the world. For the next few years her ambitions as a painter were to take second place.

Now everything speeds up. Krasner had many more connections than Pollock, and a strong social sense. James Johnson Sweeney became interested in Pollock and recommended him to Peggy Guggenheim who, in the throes of a break with the émigré Surrealists, was planning a juried show for young artists. Mondrian was one of the jurors. The story of Mondrian's Nod is that Guggenheim had sorted through the entries herself, segregating the duds, among

them Pollock's *Stenographic Figure*. On the day of the jury Mondrian showed up before the others, and Guggenheim found him looking intently at the Pollock. "Awful, isn't it?... This young man has serious problems ..." To which Mondrian is said to have replied that it was the most interesting painting he had seen in America, and then, in response to Guggenheim's incredulous reaction: "The way I paint and the way I think are two different things." The most respected abstract painter in the world had given a lesson in open-minded judgment to the wife of Max Ernst. "For American artists," the authors observe, "the story came to signify the passing of the true flame ..." Not long after this happened, Guggenheim made a contract with Pollock, an unheard of thing, giving him a monthly salary against his work, and the promise of an exhibition.

Krasner and Pollock moved to Springs on Long Island in the winter of 1945. It was here that Pollock began to work with his canvas flat on the floor. Clement Greenberg, already a strong supporter, gave his blessing to the "allover" compositions which fitted his critical scheme for the evolution of Modernist painting. The drip paintings, in which all vestiges of imagery had disappeared, were shown in 1948, '49, and '50. Fame arrived: the claims that Greenberg had been making on Pollock's behalf to the readers of the *Nation* and *Horizon* were picked up by *Life* with a long article and the headline "Is he the greatest living painter in the United States?" Pollock was shown with several others at the Venice Biennale of 1950 and at the same time Peggy Guggenheim put her Pollocks on exhibition in the Museo Correr. Bruno Alfieri introduced him as "the painter who sits at the extreme apex of the most advanced and unprejudiced avant-garde," and concluded, as if with a special message to Pollock, by claiming that, beside him, Picasso "becomes a conformist, a painter of the past."

From this extreme apex it was steadily downhill. He had stopped drinking during the two years from 1948 to 1950. He started again after finishing the film that Hans Namuth made of him working – perhaps, the authors suggest, in defense against the inauthenticity of what he had been doing in front of the camera. Krasner had excommunicated his drinking partners, and the old community of painters had largely closed ranks against his success. Greenberg withdrew his support. The barren periods when he could not paint grew longer, and when he did paint it was with waning conviction. When at last his car hit a tree and killed him it was as if he had been rushing towards his death for a long time.

Talking about watching Pollock work, Herbert Matter said: "The way he stood, the way he looked at the canvas, the way he worked it, always made me think of a farmer." For Pollock the identification was precise. He spoke of memories that would come to him as he worked of standing by his father and watching him pissing on a flat rock. Pissing features a good deal in these pages. It was often the coda to an evening, in bars, on carpets, into fireplaces, and countless beds. "I can piss on the whole world!" someone heard him shouting as he sprayed a snow bank in a New York street.

Pollock's name will always be associated with the drip paintings. They were his release from the burden of images. They are the only works in which his vitality and elegance show clearly on the surface, the only works where one does not feel the weight of concealment and anxiety. In discovering this way of working it seems that he was able, for a short time, to place distance between his fantasy and the fact of the canvas. He could draw in the air, omnipotently. "Empty of imagery," David Anfam writes in a beautiful description of the drip paintings, "they feel intensely full; lacking overt reference to nature, the organic patterns of growth nevertheless engulf us; rather monochromatic overall, strong and metallic hues

shimmer through their interstices; heavy with the quiddity of paint, their space floats and dances in front of our eyes."

It is hard to think of another artist whose life more completely fulfilled public expectations. Everything about him was right, in his casting as Hemingway-painter: not Ivy League, not out of Ellis Island, but really American from beyond the Mississippi – like "some guy who works at a service station pumping gas," de Kooning said of the famous *Life* photograph. The expansiveness, recklessness, unbounded energy, materiality, the fact that there was no *culture* to mediate between the act of making and what you saw – all this corresponded to a state of mind. It was recognized.

At the same time another, older myth was invoked, that of the *peintre maudit*. Pollock's misery was public. Simply by asserting his high ambition he was claiming a certain license and a certain intimacy with unresolved suffering. His path was well-worn, as old as Romanticism. This is where private suffering and public myth rub together. "A man's life *is* his work; his work *is* his life," he told someone towards the end, and as he said it he laced together the fingers of both hands to show what he meant. It was the same gesture that Gasquet describes Cézanne making as he explained the connection between his canvas and his motif. Was the echo in the action, or in the telling of it?

David Anfam's book, warm towards the paintings, is refreshingly cool towards the myths and dogmas that have grown up around Abstract Expressionism. He is good at exploding the notion of the sudden miraculous breakthrough, and at bringing out the continuities in each painter's work. He rejects the usual distinction between the "action" painters – de Kooning, Kline – and the "color" painters – Newman, Rothko, Still – pointing out that what mattered for all of them was the creation of a field "which melds figure and ground into a totality" and confronts the onlooker in such a

142

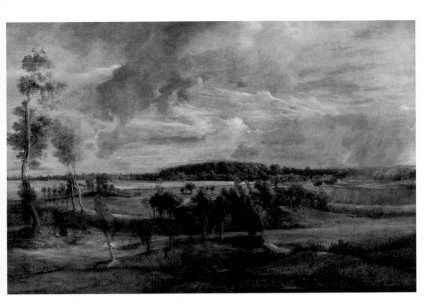

1. Peter Paul Rubens, *Landscape near Malines (Landscape in Flanders)* (1635–40), Oil on panel.

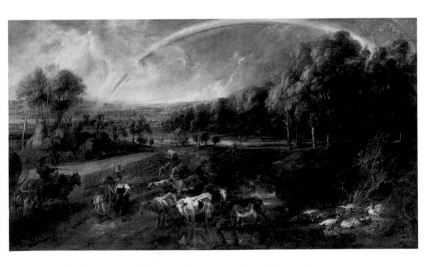

2. Peter Paul Rubens, *The Rainbow Landscape* (*ca.* 1636), Oil on oak panel.

3. Camille Pissarro, *View from Louveciennes* (1869–70), Oil on canvas.
The National Gallery, London.

4. Walter Richard Sickert, *Summer Afternoon or What Shall We Do for the Rent?*
(*ca.* 1907–09), Oil on canvas.
Fife Council Libraries & Museums: Kirkcaldy Museum & Art Gallery.
© Estate of Walter R. Sickert / DACS. Photo © Antonia Reeve.

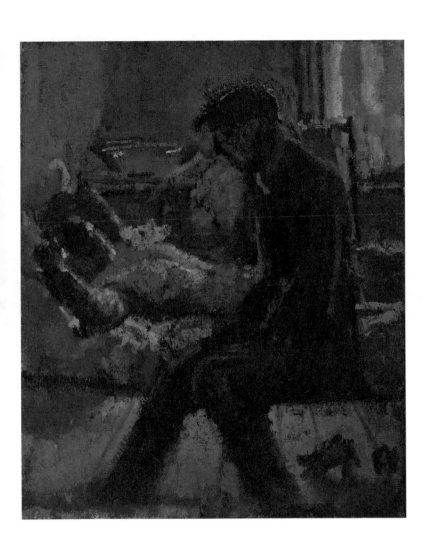

5. David Bomberg, *The Mud Bath* (1914), Oil on canvas
The Tate, London.

OPPOSITE:

6. Franz Kline, *Chief* (1950), Oil on canvas.
Gift of Mr. and Mrs. David M. Solinger, The Museum of Modern Art.
© 2018 The Franz Kline Estate / Artists Rights Society (ARS), New York.
Digital Image © The Museum of Modern Art/Licensed by SCALA/ Art Resource, NY.

7. Al Held, Installation view, "Al Held: New Paintings"
at the André Emmerich Gallery, New York (April 29–May 17, 1978).
Photo © André Emmerich Estate.

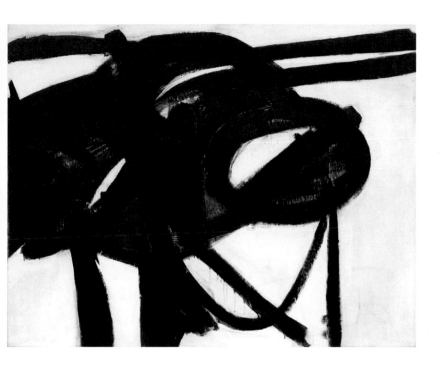

8. Naum Gabo, *Construction in Space (Crystal)* (1937–39), Cellulose acetate.
© Tate, London 2018.

OPPOSITE:

9. Jake Berthot, *Meadow's Edge* (2001), Oil on panel.
Courtesy of the Estate of Jake Berthot and Betty Cuningham Gallery.

10. Jake Berthot, *Approaching Night (For Ryder)* (2001), Oil on panel.
Courtesy of the Estate of Jake Berthot and Betty Cuningham Gallery.

11. Graham Nickson, *Georgica Bathers* (1986–96), Oil on canvas.
The William Louis-Dreyfus Foundation, Westchester, New York.
Courtesy of The William Louis-Dreyfus Foundation Inc.

way that his perceptual efforts become one with the content of the painting. This is as true of Still as it is of de Kooning. It was the underlying enterprise, far more important to our understanding of Abstract Expressionism than surface differences. He develops this argument with great subtlety. His lines on certain pictures of Barnett Newman and Clifford Still are the best things I have read about these painters.

"There is nohing to do now but paint my life," Philip Guston told himself in a studio note (the words are quoted by Musa Mayer): "My dreams, surroundings, predicaments, desperation, Musa, love, need. Keep destroying any attempt to paint pictures ..." The tone is that of a man with his back to the wall. The words were written in 1970, when he had renounced abstract art, near the time when he first showed his late works, the KKK men in hoods riding around in funny cars. Among his peers, the show was a scandal. Many saw it as a betrayal, not only of abstract art but of high culture. Hilton Kramer in *The New York Times* doubted the authenticity of Guston's clunky comic-strip images – "A mandarin pretending to be a stumblebum" was the notorious title of his review. Guston was no stranger to doubts of this kind himself. Obsessed with questions of identity, hagridden by that anxiety that is specific to introspection, the twin impulses to reveal and to conceal gnawed at each other constantly.

The son of first-generation immigrants from Odessa, he had been Phillip Goldstein when Pollock knew him at high school. His father, an unhappy junk-man, had killed himself. Phillip, ten, found the hanging body. When, at Pollock's urging, he left Los Angeles for New York, he left his family and his name for good. Later, he was to go to some lengths to conceal the change. His daughter was grownup before she knew of it.

Guston was precociously talented and had already done a good deal before he arrived in New York. He had painted

several very large murals in public places, including one, with Reuben Kadish, of over a thousand square feet in Mexico City, an achievement that had been noticed by *Time*, which scolded them for its left-wing subject matter. In New York he gained important mural commissions through the WPA. Jobs, prizes, publicity, honors, and museum sales, all came his way during the Forties. The most important painting of this time was a scene of children's games, composed with the grandeur and intricacy of an old master. The children are disguised and masked. The title is *If This Be Not I*.

He had left New York to teach in the Midwest in 1941, and it was nine years before he came back. He was on the fringe during the crucial years, an infuriatingly successful semi-outsider. To Pollock, in particular, Guston's work was a red rag to a bull. His transition to abstract painting in the Fifties was that of a late recruit, some said. But no external hostility could match his own doubts about his work. He lived on a rack of anxiety. He was bookish, and his reading gave shapes to his terror. The canvas, he was fond of saying, is a courtroom in which the painter is judge, prosecutor, prisoner, and jury. The thirty years from 1950 to his death in 1980 are like a long penance, a lurching descent from elegance and scrupulous adjustment to crudity, from enchantment to the squalor of the last great images, the bulging eye and stubble chin stranded among piles of hobnailed boots, cigarette butts, alarm clocks, and French fries.

To adult eyes, Guston in his middle years was larger than life, tall, massive, his film-star good looks buried under the jowls of a ruined emperor, a brilliant talker, insatiably smoking, eating, drinking, his troubles forever on his sleeve. He was in love, somebody said, with anyone who would listen to him. What can it have been like to be his child? Musa Mayer's wonderful memoir of her father is most convincing because of its autobiographical honesty. He gave her far less

than she wanted, resenting the slightest distraction from his work, shutting her out. Her beautiful mother, Musa McKim, a gifted painter who had put down her brushes years before, had shaped herself into a silent handmaiden. There is a lot of anger in Mayer's indignant description of the omissions and abuses they both took from their sacred monster, but anger qualified by the appetites of love. It is a story of jealousy of a very complicated kind, and of its resolution. She was up against more than just adult selfishness. What makes her experience different from that of any only child of a famous workaholic is the presence of the Romantic Muse. His demand for solitude was underwritten by the compelling and mysterious authority of art. And of the great artist, her father, she was intensely proud. Yet, was that authority truly an absolute one? The question shows up like a tiny fissure in her description of her father's stage fright before an opening, and of her memory of herself as she witnessed it:

> Pale and distracted on the trip uptown. Philip would unfold himself with difficulty from the taxi, then stop on the sidewalk outside the gallery rooted as if he couldn't move. My mother fluttered ineffectually around him, patting him, trying to calm him down, urging him to go in, telling him that everything would be fine.... Embarrassed, I was aware of passers-by looking at us. Who was this raving, wild-eyed man? Ah, an artist. That explained it. His fears would rise to a crescendo. The whole thing was a mistake, a terrible mistake, he'd cry. He should be in Woodstock, working.

"I took all of my father's fears quite seriously," she comments, "rather as if he had a painful, but not mortal illness. It never occurred to me that I might view his torments as pitiable, or unnecessary, or even within his control."

On Franz Kline: Black Traffic

New Statesman
May 22, 1964

FRANZ KLINE DIED two years ago this month. He was 52. Five of his major canvases are hanging in the Guggenheim exhibition at the Tate, and at Whitechapel there are over 60 works. Kline occupies a unique position among the pioneers of the New York school. His development was simpler than that of his more formidable colleagues, so was his contribution to action painting. When we were making our belated discovery of the new American painting in this country, Kline's *Chief* [Fig. 6] seemed bald and violent in its American-ness, yet friendly. Rightly or wrongly, it appeared that much of the new American contained a fundamental criticism of European values, of "our" art. De Kooning's *Woman* was an aggressor. But for all Kline's toughness, one sensed a live-and-let-live independence, a self-sufficient joy in painting that was innocent of stylistic, let alone cultural, polemics.

He was 39 when he painted the first of the black and white pictures. He had had 10 active years before that during which he had been painting somewhat expressionistic representational pictures which explored a wide range of traditional styles. None of the earlier work is shown here. The point about it is that it is the work of a professional painter of pictures, not of an artist tortured by doubts about the proper course for modern art in America. Unlike Gorky or de Kooning or Pollock he does not seem to have speculated on the overwhelming influence of Picasso, nor does

Surrealism seem to have been important to him. His eclecticism was that of a pro. During the Forties he painted commercial murals, portraits, commissions of all sorts (he once painted a "Laurencin" for a patron), as well as the landscapes and cityscapes and interiors of his own choice. Although he made experimental abstracts, they were, in Elaine de Kooning's words, "eclectic to the point of anonymity and lacked the conviction of the representational pictures he was making at the same time."

Meanwhile he kept up an intense parallel effort in the form of tiny drawings in pen or brush or pencil on scraps of paper. These were like the most abbreviated compositional notes, and scrappy though they were, he would sometimes work on them over a period of time.

The turning-point came in 1949 and the story, as it is told, has all the hallmarks of art legend. Kline was visiting a friend who happened to be projecting some of his drawings through an epidiascope. Kline put in one of his own and saw it "magnified bodilessly against the wall," the Indian ink looming "in gigantic black strokes which eradicated any image, the strokes as entities in themselves, unrelated to any reality but that of their own existence." The way Elaine de Kooning tells it, it was a revelation, a total and instantaneous conversion. All his previous work was superseded at a stroke. He goes off to buy household paints and decorator's brushes.

Whatever really happened, there is a certain symbolic truth about the story: Kline's mature style is like a single intuition rather than a complex conclusion about style. And it is its unique effect that it confronts us with certain specialized elements and isolates them from their usual context and enlarges them and invests them with a total importance. The energy of a sketch is writ large in the slashing, gutty paint strokes; the whittled-down spare quality of drawing

itself is paraded dramatically; so is the purely compositional content of a certain kind of drawing, that which is concerned with exploring pictorial ideas, forces, forms, dynamic divisions between one area and another, rather than with representing something.

The result was a tremendous release: having split drawing off from its descriptive content Kline finds himself able to bring all his force to bear on what is the most exciting part of painting, the first groping for an idea, and to prolong this moment without sacrificing anything of its fire or its bald simplicity. At its simplest, the intuition was just to see drawing as black *and* white rather than black *on* white, to see it, not as the vehicle of a not yet realized idea, but as a fact.

As soon as he tried to move away from the purely graphic limits of the black and whites, everything was in the melting-pot again. By the mid-Fifties he was breaking the pure black of his positive forms into grays, opening their edges, and elsewhere introducing powerful color. There is a change of mood: the inimitable jazzy fire doesn't come through any more and the afflatus of the black and whites gives way to an almost oppressive sense of effort. Black and white contains a promise of color. This was the difficulty, perhaps. It seems to me that when he puts a great slab of orange alongside two white areas, the orange is setting the terms for a more complex and also more precise space than the black and white armature is ready for. There is a loss of intensity, and also a paradoxical loss of richness.

In the late works he was right up against the limits of action painting. How long can a painter go on rehearsing his excitement in front of a canvas without sickening himself or parodying himself? The nearer the creative process comes to the painter the more dangerous it gets: ultimately a loss of distance equals a loss of identity. A famous remark

of Kline's is quoted in the catalogue: "Hell, half the world wants to be like Thoreau at Walden worrying about the noise of traffic on the way to Boston; the other half use up their lives being part of that noise. I like the second half. Right?" The greatness of Kline's work is precisely in that commitment to the "second half"; also its limit.

149

Giacometti

New Statesman
July 23, 1965

THE GIACOMETTI RETROSPECTIVE at St James's Square
10 years ago, the first occasion for many of us to see his work
in depth, seems now to have been the merest curtain-raiser.
David Sylvester, for whom the present Tate exhibition must
be the climax of years of passionate advocacy, has seen to it
that it gives as near as possible a complete account. He has
arranged it simply and without atmosphere, yet with a firm
and instructive grouping. The categories of Giacometti's
work stand freely beside each other, and comparisons
within each category are readily made. It is a major occasion
and it comes within an ace of doing full justice to the artist.
One can hardly say more.

Giacometti is an avatar of certain qualities in modern
art – its obsessive specialization, its extremism, its loneliness.
It is easy to pigeonhole him – in terms of what he stands for.
The Giacometti myth comes so pat that it would have had to
be invented, Giacometti or no. But the œuvre is another
thing. There is nothing pat here. It is the most original, mov-
ing, and beautiful work to have been produced during the
last 20 years by any artist now alive. But it is baffling, impos-
sible to pin down. The issues it raises are as complex and
elusive as the emotions one experiences in front of it. And
just as one might say that the myth comes easy because it is
over and done with, so the work comes hard: it is everything
and everything's opposite – because it is completely live.

Part of the Giacometti legend has to do with his dissatisfaction with his work, his distrust of his talent, his insistence on the impossibility of ever realizing even the simplest project. But against this we must set a vast output (there is another retrospective on a similar scale running in New York) and, when the occasion is right, an awe-inspiring facility. At the moments when he makes a piece entirely out of his head, the *Leg*, for example, or the *Dog*, works which were made very quickly, in a single rush, he reveals the masterly technique of a conjurer. The tension and doubt that surround his efforts, then, are to do with understanding rather than with execution, and with his relationship to his model rather than with his plaster or clay.

A very early painting, an Impressionist still-life done when he was twelve, reminds one of the artistic milieu he grew up in. It is without a trace of childishness. It is in an adult painting language. Clearly his father's example has been a lasting ingredient in his work. *DU* published a drawing of a tabletop some years ago by Giovanni, the father, and it stands in comparison with later drawings by Alberto point by point. There are the same scribbling lines, the same emphasis on open directions rather than closed shapes, the same stable pyramidal structure under all the vibration. Recognizing this continuity, one is led to recognize a continuity in Giacometti's whole œuvre which spans the Cubist and Surrealist experiments of the late Twenties and Thirties. In the earliest drawings, the *Skull* of 1923, or in the two bronzes of his parents made in 1927, one recognizes certain qualities of his later vision, the uneasy search for scale, a certain flickering, scanning movement in his attention, revealed for example in the way in which the mother's features are boxed in by lines scored across the broad surface of the head, as though the face itself had a scale of its own distinct from the mass of the head, or as though to look at the

face was to receive one kind of tropism, while to look at the mass of the head was to receive another, and each forced him in a different direction.

152 Was his return in the mid-thirties to working from nature – the great change of direction which removed him from the avant-garde and put him in a strange limbo all of his own – simply an obsessive re-enactment of his own previous enthusiasms, and those of his father before him? It could be strongly argued this way. But such an argument would have to cope with the extraordinary originality of the sculpture he produced in his efforts to realize the appearance of things. What he did was to explore the kind of thinking that painting had evolved (his drawings are like meditations on Cézanne's watercolors) and then, relating it to sculpture, boldly tear up sculpture's contract with mass. No figurative sculptor before him had dared to try to get along without some monumental ideal within reach. More precisely, no sculptor had been prepared to make sculpture 'of' the human figure, in the sense that a painting can be 'of' something. Looking at a Monet our attention can alternate freely between the picture-as-paint-and-canvas and the picture-as-landscape: we can see it just as well in either sense. But looking at a Rodin torso we do not have the same choice: we must *see* it as bronze, or *fancy* it as flesh. As for as our eyes are concerned, it is always a torso, a bronze torso. This is the contract with mass that Giacometti freed himself from. With him the tyranny of the muscular, all-around volume, the definitive lump, gives way to, and is replaced by, frontality and silhouette, a precedence of direction over surface, and a redisposition of proportion based on relationships in space between the artist and his model. Everything is relationship – hers to the floor, his in space to her. The work is "of" the process of apprehending her, and making the work is in itself a factor in this process.

This is why he never seems to lose intensity or freshness in front of his perennial themes, and why one has the feeling that similar works are not so much a number of stages between the beginning of an idea and its conclusion as a 153 multiplicity of simultaneous expressions which overlap or interleave in time rather than stretch out in series. He is continually in touch with experience and he cannot bring himself to break contact, take time off, which is what turning inwards onto the work itself would mean. The *Femmes de Venise* of 1956, which represent for many the highest point of his studies of the standing nude, are simply ten states extracted from his workings on a single armature.

It is no help to look at Giacometti as though he were some sort of Left Bank Euston Roader, although the paintings sometimes tempt us to do so. These bronzes, pointing at you like shoes, topping you like fountains, are works of extreme and terrifying fantasy. The achievement of the Forties and Fifties is unthinkable without the Surrealist experience at the back of it – without the notion, that is, of the work of art as an infernal machine. The fantastic and bizarre proportions of many of the bronzes are not distortions of a familiar, Expressionist kind, forced outwards onto the subject. They are functions of his search for likeness. The word begs a hundred questions. Likeness of what, and for whom? One could say that at a certain point he had refused to continue with the traditional divisions of subject and object, and had placed himself at a tangent both from those artists for whom reality is denatured by their dreams and from those whose dreams are blocked by reality. Vision is hallucination; hallucination, vision. With him, as with no other artist, the act of looking is charged, the most demanding route by which fantasy can be driven and mastered.

At the Tate there hangs inside a metal space-frame an extreme invention, *The Nose*. A small head on a neck like a

handle has a nose several feet long, driving out into space like the spike on some giant Caribbean fish. When you sight down it, it suddenly becomes as real and natural as the nose of the person you are with; except that the least movement on your part causes it to sweep back and forth in your eye, to declare its exaggerated relief, to isolate the single fact that on this head the nose really does stick out. A few yards away there hangs a row of paintings, later in date, clearly labored in front of the model. In each the point of departure and the point of return in the drawing is the nose, as it is in certain self-portraits of Rembrandt. The nose is the nearest tip of the form, a finger pointing back at him (you) just as his (your) finger-nose points at it. The form of the head is built out of the nose; the space hollowed out by the head seems to be keyed into the nose as if it were the plug through which the solid of the head had been cast. Seen in relation to the paintings, *The Nose* no longer seems wanton and bizarre but a serious optical statement; at the same time, it confirms the hallucinatory elements in the paintings, and one returns to them with an overwhelming sense of the tension which they hold.

As time has gone on his attention has continued to narrow. The paintings of the Forties look remarkably complete and pictorial compared with the latest. In canvas after canvas the sitter was contained within a frame that mediated between the flat surface and the corridor that was opened up within it, and the studio wall closed like a door at the end. Now the sitter's surroundings are the merest shadows. All attention is given to the head, the eyes, the tip of the nose; more and more of the canvas is left open. In this way his painting has certainly drawn nearer to his sculpture, and the canvas has seemed to take on more of the function of his sculptor's stand. In the sculpture, too, he has shown less concern with the total relationship between himself and the

figure and has concentrated more intensely on the head. This shift shows itself negatively in the four giant figures of 1960, which seem to me irrelevant to his work as a whole. But the new heads are as fine as anything he has done, and are so live and so complex that it seems one could never come to the end of looking at them. They represent, in fact, something of a mystery, because, although they are more fully modeled, more tactile, than anything before, they still preserve the power to distance themselves. They remind me of those occasions at a concert or in a crowd when one's attention is caught so forcibly by a beautiful or animated head that in one's efforts to grasp its exact expression one's eye seems to annihilate everything that lies between. It is like a special kind of closeness, more sharp, more stinging than actual closeness, in which by sheer force of looking one holds distance at bay.

Studio International
December 1968

De Kooning's mess is salutary. He is in eternal opposi-
tion to all prescriptive views of painting, and whatever he
has done, good or bad, is a witness to the fact that content in
painting is somehow related to an art that refuses to draw
boundaries round itself.

He paints in the first person; he is within his work, sur-
rounded by it, and although his position is as reflective and
as humorous as any painter's, there is no mocking of what
he is doing, no ironic reservation.

"Actually," he said of Renaissance painting in an article
published in 1951, "there was no subject matter. What we
call subject matter now was then painting itself." It is an
idea that can be applied directly to his own painting. He
covers a vast range of material, from match boxes to empty
oceans, from numerals to brassières, from pastoral land-
scapes and lovers to city streets and old newspapers. And
this is paralleled by a gamut of language which runs between
the most precise illusionism and allusions which are so ten-
uous as to be almost invisible within the paint that supports
them. But wherever one picks up the thread one is aware
that to split off one attribute of his painting at the expense
of another is to miss what the picture is about.

The figures in his pictures are active presences which
appear to be living by their own energy. They are not lay-
figures, propped up in limbo, nor posing models. Neither

are they masterful personifications, nor the butts of expressionist passion. They seem to have unlimited independence, and yet to be close upon us, to exist at the picture's brink.

Up to about 1942 his figures are almost exclusively men; after that they are women. As a matter of fact, the division now appears to be sharper than one had supposed because Thomas B. Hess has revised some of the dates in his present catalogue, putting the first group of women into the years 1943–46, whereas in his book on de Kooning published nearly a decade ago he had made them overlap by three years with the male subjects.

The men stand or sit, singly or in pairs, in dim rooms. Usually there is a single object at their side, a vase, or a picture on the wall, nothing else. They wear overalls, working shirts, or the kind of long coats that storemen wear, and the folds and creases in the clothes are treated with peculiar emphasis, a clear-cut classical attention that seems to lift the garments outside the blunt, mundane circumstance of the pose. This localized intensity recurs in the features where, although the faces seem often to be hardly there at all, so tentatively are they painted, the eyes are forced in tone, highly defined. This gives them an intent, concentrated look quite unlike the moody gaze of the figures in Blue Period Picasso with which they invite comparison.

Hess records that de Kooning did in fact use a lay-figure at this time, dressed in overalls; but it is easier to see these figures as self-portraits. They have that dry look, and the poses, particularly in the important *Seated Man* of 1939 and *The Glazier* of 1940 suggest an artist working with two mirrors. Drawings relating to these pictures are obviously of the artist.

"I used to get so involved in drawing elusive things like noses," he told an interviewer. "Imagine how the shadow falls on the fleshy part of the nose, and how are you going to

render it with a hard pencil? These are the drawing problems that can drive you nuts, that you have to give up."

The women are members of a different race. They enter with fanfares. To date there are four main groups: the ones that look like Bette Davis of 1943–46, the ones that look like wolves in grandmother's clothing of 1950–55, the fragmented series on paper of 1961, and the girls like laughing cow-pats which have occupied him since 1964. The anxious containment of the early interiors is dispersed once and for all by them. Where almost all the men give the impression of having been at some stage worked from observation, the women do not. It is as though their jostling presence, regal, shrill, and bedecked, puts an end to contemplation and stillness. The need is not so much to coax something on to the canvas as to keep abreast there with their chattering ebullience.

What kind of women are they? Hess and de Kooning himself have made a good deal of their archaic origins, but this seems to be true only in a psychological sense, not a stylistic one. They are very real, very modern. Some are mere presences, grinning wolf-like from the matted surface of the canvas, others are fully characterized with consistent detail like the great seven-foot *Woman with Bicycle* of 1953 who is of a piece from her vast looming bust to her slender well-preserved ankles. They are all sexually aggressive. What varies is the spirit with which they threaten. Some seem all gathered up into their breasts, like strutting birds, furies, the breasts swollen to absorb the whole torso. Others, less formidable, seem caught in positions of ludicrous embarrassment, knock-kneed in nothing but their knickers, side by side like children. But it is not really they who are embarrassed. A room full of the most recent figures can induce real genital panic. At the same time, these are the most jolly, like those formidable and wonderful girls who laugh off the shaming aspects of sex and make everything all right.

Somebody once told me of how at the height of an impossible love affair he had seen the *Massacre at Chios* in the Louvre and how for days he had haunted it; it had been the only way he could find to assuage his unhappiness, a place to put it all. I can imagine a hag-ridden man regaining his wits in front of de Kooning's hilarious troupers.

The furor that greeted the *Women* at the time of the 1953 exhibition seems extraordinary at this distance. The issue of whether he was an abstract or a figurative painter seems quite stupid. Everything that he has ever painted can be seen "as" something, can be read. And in any case, only about four years lay between that batch of women and the ones that preceded them. One reason for the uproar was probably that during those years he had become some sort of *chef d'école* and was the victim of other people's expectations. Now, with hindsight, one sees only the continuity and consistency of his figures.

The Glazier of 1940 has all the ingredients of the later work, yet bound together into a thin, fragile surface as if by an effort of extreme will. In particular, what draws one's attention is the precarious and problematic way with which the figure is related to its surroundings. Parts of the figure are painted quite flatly, the dun green-gray of the wall seeming to invade or flow into it. Elsewhere certain features – the trousers, the nose – are split off from the surface, raised from it by sharp modeling. A decanter or flask at his side is a negative shape in fact, made out of rubbed-down mottled paint belonging to an earlier stage of the picture, is profile drawn by the flat green of the background. This practice, which he would have known all about from his sign-painting days, is one that he has exploited ever since.

With the seated women of 1943–44, the battle of figure and field takes place in a freer context, and parts of the figures get loosened from the main forms and find new articulations

and new scales. These pictures owe a great deal to the seated figures of Matisse and of Picasso – they are *école de Paris* pictures. An idiom which in the hands of thousands of painters all over the world was simply the formula for faceless, subjectless painting is here the generator of unique images. With *Pink Lady* of 1944, the corrections and adjustments which accompany the drawing are left uncanceled and are progressively built up into the final image. At first glance the multiple view point of the head, the neck, and the arms seems to place it closer to Picasso than any. But this is not confirmed when one tries to work out how it got like that. Hess says somewhere that de Kooning's motto could have been an inversion of Picasso's famous remark (*i.e.*, "I do not find, I search"), and in no other picture is the thought more to the point. The pink flesh, the apple green dress, the yellow ground are like three shifting substances in constant movement against each other. Their flow, accented at points of maximum tension by thin black lines, carves out bays, inlets, promontories, and leaves, like sandbanks and oxbow lakes, lively remnants of earlier states. The image of the woman is like some underlying geological fact which determines, after all, the limits of aggregation or erosion. What is particularly important in view of what happens later is the way in which old markings, split off from their original anchorage, are allowed a floating life of their own. There is a row of nipples like buttons; a previous definition of the neck line is now a capital L, a pair of blue calipers separates the head from the supporting hand. During the next few years in works like *Pink Angels* and *The Marshes*, figures are suddenly all over the place, swooping, elegant, linear shapes whose anatomy grows out of the drawing of parts, transformed in scale and relationship.

These and the works following, the black-and-whites like *Light In August* and the great all-over pictures of 1949–50,

160

Asheville, Attic, Excavation, are presumably what his reputation as an abstract painter was based upon. Whatever the pictures looked like then, they certainly do not now look like pictures which are not "of" anything. They teem with images, and their spaces more often than not work consistently out of overlapping shapes. Things in them have many lives and many scales. One chooses how one looks and how one takes them up. A drawing for *Attic* is plainly based on furniture stored under dust sheets. It is still legible as such in the large painting; it is also a conglomeration of figures, torsos, breasts, nipples, limbs. Fishes swim through it. Mouths open and shut, teeth grin.

When he returned to the single figures, "it did one thing for me," he told David Sylvester. "It eliminated composition, arrangement, relationships, light – all this silly talk about line, color, and form … I put it in the center of the canvas because there was no reason to put it a bit on the side."

The underlying "geological" fact of the frontal image had now to stand up to a far fiercer battering than before. In a sense there is a reversal of the process that made *Pink Lady*. Instead of the picture generating itself out of the battle for the feature, now the feature seems to be generated out of the battle for the picture. The arms in *Woman I* are *almost* interchangeable with the arms of the chair hacked out of the viridian background; her breasts, like trodden balloons, are only lightly anchored and could be exchanged with the window or with the space between her feet. Hence perhaps the energy of her wolfish glare: only by such ferocity does she hold her own.

The genesis of *Woman I* is illustrated in Hess with six photographs taken at various stages in the painting. It is an extraordinary story. At first the figure is set quite clearly into a room- or porch-like space (we do not know whether she is indoors or out), and behind her is a wall and a fully

described window. The figure appears to be stretching herself in a wide-winged arm chair. She is far more violently fragmented than her environment, thrown together out of an assortment of jagged triangles, bows, loops which might have been picked up off the floor of *Attic*. These are smashed into the center of the picture; it is the head with its glaring eyes and lopsided, illustrator's mouth that triggers the reading of the parts of the figure. The figure is very much within the picture, set back by long trailing diagonals, and with a marked change of scale between it and the surroundings. As the picture advances, going through storms of destruction and revision that one can only guess at, the figure is invaded by and in turn invades the wall behind. It is during the course of this process that his handling changes its character and becomes more ample, less a matter of "drawing" and "painting" but of a vigorous, inclusive gesturing, until in the end each accent, each shape can be interpreted directly as a movement of arm or wrist in paint. The shapes that bound the right breast, for instance, are transparently related to a particular looping movement and the line crossing the top of the two breasts is from a fast whip-cracking change of direction; the herring-shaped fingers are also there-and-back strokes, and so on. All this is carried out at the full scale of the canvas, so that in the end everything you see is both image and the painter at work, on this canvas, at this distance. The earlier multiple references and choices are still available, but they are now underwritten by the dominating physical fact of the paint-covered canvas ploughed and harrowed by a man's arm.

The works that occupied him between 1955 and '57, pictures like *Gotham News*, *Easter Monday*, *The Time of the Fire*, represent his painting at its highest point of energy. They have lost none of their original fire or mystery. They stand in the same relation to the Women of '50–'55 as *Attic* and

Excavation stand to *Pink Lady*. They too exploit the campaigns won over the figure in wider, more diffused terrain. Only now the fragmented imagery of beaks and mouths and flying letters has given way to something more realistic, more sober. These are street scenes, crowded urban landscapes, and as one explores their white towering blocks – newspapers, walls – or fiery openings – red traffic, windows, lights – one is aware that it is paint structure itself that challenges one's fantasies, something as immediate and material as the fabric of the places that the pictures evoke.

This correspondence between the physical fabric of the picture and the imagined world that constructs itself around it becomes more and more critical towards the end of the 1950s when he starts on the larger, more loosely painted landscapes, such as *Parc Rosenberg* and *Suburb in Havana*. Here the landscape sensations are very literal; they are also very unstable, for as one presses the picture more closely they have a trick of returning to nothing but paint. They are constructed out of much larger, more daring strokes than before. The standard canvas size is 80 inches by 70. ("Notice ... how 70 inches, given a landscape sensation, exactly fits the arms-spread gesture of a man," Hess wrote in the catalogue of the 1962 exhibition.) It was these reckless and flattering pictures that seduced half the painters in the world, or so it seemed about eight years ago. Here, wielding a two-inch brush at full stretch of his arm, the painter was really on his athletic mettle. The whole ethos of spontaneity, the picture-as-the-act was on test and only a painter of de Kooning's courage and Protean virtuosity could have sustained it for so long.

Action Painting in the literal sense that is given by these pictures, is a red herring. *Suburb in Havana* looks as meretricious as any painting which exploits illusionistic devices too literally. De Kooning's doubts and adventures are too

near the surface. There is an element of fighting talk: how can we (or he) believe simultaneously in the soul-searching question posed by the improvisatory method *and* in the cashing conclusions of these gut-bucket strokes? The kind of spaces that are hacked out here with massive repoussoirs, crossings and spatters are literal and without resonance; the initial excitement of tearing into the painting, as if down a curtained corridor, has a short life. I see these pictures like projects for unrealized stage sets, or as sculptor's drawings, that is to say, as provisional. They are the opposite from that search for the definitive and the unique which was Action Painting's central claim: they need not be how they are – they could be otherwise.

The recent figures, it seems to me, are far from being the relaxed repetitions that some have seen them as. He has withdrawn from the fruitless exposure of Action Painting. They are tougher in a way, although at first sight their trembling bagginess would suggest the opposite. They reintroduce the kind of drawing that finds an edge between an imagined form and its field; that is to say, space is transformed in them and is not tied simply to the exigencies of paint. Lovers melt into the grass. A woman bathes alone, and if she is both moving and horrifying, squatting and snapping with her spread legs, this inclusive ambiguity of mood is faithful to the disheveled and generous tradition that he has established over forty years.

All along he has alternated between batches of figures when his attention is focused on a central image that returns his glance, and dispersed paintings – landscapes, interiors, "abstracts" – where there is no focal grimace. Either mode has supported his preoccupation with the mystery of figure and field, the question "what is it?" And either has supported in widely differing ways his drive towards self-revelation, expressed earlier in the introspective melancholy of

the male subjects, later in the fantasies of the late forties, and in the athletic extensions of Action Painting. Throughout, the women have provided something essential. Who knows what knot was broken when they first made their appearance? Something happened then, some prohibition was lifted and an energy was released, both joyful and violent, which could absorb wider and wider swathes of the outside world. The women are both condensed and rigid anatomies, and spread-out, embracing landscapes. Sometimes it is a matter of dominance; they appropriate everything. Sometimes it is a matter of how much they can take and still come up laughing. Either way, it seems they hold a key to the renewal of his search.

On Adrian Stokes's Carving and Modeling

New Statesman
January 22, 1965

ADRIAN STOKES'S NEWEST BOOK is in a direct line with everything else that he has written, although it contains much that is completely original. His persistence is staggering. There has been no shift in his grip over thirty years, but rather a continual enlargement of application and more accurate ways of handling his ideas. At his retrospective exhibition at the Marlborough Galleries, you don't find yourself scanning the sixty-odd paintings for changes of mind. A series of nearly thirty still-lifes, twenty years' work, is so consistent that he is able successfully to show the pictures joined edge to edge.

The new book is the latest and, so it is said, the last of the series which started with *Inside Out* (1945). In this series he has used the terminology of Kleinian psychoanalysis with which to present his elusive and difficult ideas. Putting it like this will, I know, look like putting the cart before the horse, to people with specialized knowledge. I don't mean to demote the technical aspects of his writing – I am in no position to do so. But I would stress that there is no need for first-hand knowledge of psychoanalytical theory in order to follow critically his view of art.

Indeed I have sometimes wondered whether it is not an advantage, for once, to have to grapple with jargon. For with Stokes, the obscurity for which he has so often been reproached seems to have a positive value. He condenses and compresses, packs one sentence into another while all

the time drawing in more and more idiosyncratic qualifications, until sometimes the page seems heaped up and dense like a frosty earthwork. But his sentences always have a sound, an inimitable timbre, and reading him is like both digging away at a resistant mass and also listening to something, a kind of unbidden singing. An inner quality persists. I have repeatedly had the feeling that I am not so much reading his argument off a page as having it happen inside my head. Also that his meaning is "my" meaning, sharp, unique, the opposite of common currency – just as one might feel about the meaning of a poem that one had got one's fingers round, but never from a more transparent prose. This is valuable because it corresponds exactly with the way in which one receives the aesthetic experience itself. There is nothing exclusive or recherché about this: no limit can be drawn to the number of people to whom art might be available – but whatever their millions, the experience will never be common currency, but always, as it were, theirs alone.

Stokes does the opposite of limit art's field. One reason why he is such a good writer on art is the broad connections he makes between art and life at large. He makes these not by bullying art into a shape it cannot hold, as so many socially oriented critics have done, but by taking his starting-point in aesthetic experience of the outside world, of which he sees art as the condensation.

Rage lies behind his writing, for all its civilized tone and its refusal to simplify. His first major book, *The Quattro Cento,* was dedicated as if to comrades in the field to "knowing lovers of art, in any dispute with still more knowing haters of art." He seems to be fighting for art, not as a cultural embellishment, nor as a generalized therapy, nor as an exclusive institution in its own right, but as an epitome of inner processes, in which quality represents a tremendous humane victory. And he attacks:

I cannot forgive the affliction of endless purlieus and mapless terraces, the rips in the cloud, the studs in the road, the beaten, beaten thoroughfares and the ill complacency of glazed apertures reflecting garish light but not the reverberation nor impact of the traffic. This ever-sinking ship rides no sea.

His starting-point was in the look of things, in the way in which they mirror the state of mind of the beholder – or, to put it another way, the element of fantasy which informs vision, the traffic between the inner and the outer world. This traffic involves distinct ways of seeing, and these ways have distinct values. I can project my own half-finished business onto the world, see it as an extension of myself, attribute to it the conflicts, the pains and pleasures of my own body. This way I exercise a sense of power over it and to some extent deny it its real character. Or I can see it as something quite other than myself with its own freestanding qualities, which I can yet use as representations of something which lies within me. Art, Stokes says, is concerned with the relationships defined by these modes of seeing. If we can accept painting as the making of a symbolic world, then the handling of pictorial form can be seen as an analogy to the way in which we grasp the world. The same fantasies are at work, only they are now ambitious and demanding. Hence his original distinction between what he called "the modeling approach" and "the carving approach."

Modeling is an expression of form and space which involves us in a tactile appreciation of surfaces, of all-embracing undulations of solid and void, and in the plastic processes of paint. Its qualities, its modes, partake of the sense of touch, and just as touch is bipolar (we feel at one and the same time the surface we touch and the skin that touches it), so modeled form seems to involve us in sensa-

tions which are both part of us and part of something out there. Its bipolarity cannot be broken: we are carried out into the flickering folds of a Frans Hals cloak or a passage in de Kooning but we are also enveloped by it. The modes of carving, on the other hand, work primarily through the eye. Now, whatever functional relationship there may exist between the sense organs, it is undeniable that sight uniquely affirms outwardness and the independent existence of things. Carving stresses this outwardness. Pictorially it takes the given character of the canvas as its starting-point; it works with the attributes of color rather than with the tonal values that can be wrested from them. It is concerned with the mutuality of one surface beside another, with exchanges within the work itself which faces us as an independent entity.

This, approximately, was the intuition on which all Stokes's work has been based. He came upon it in the first place in front of Italian art of the fifteenth century, particularly architecture, and all his subsequent work has been an exploration of it. It was not a matter of posing two antagonistic alternatives in art but the values of carving seemed to him to be the more ambitious and the more positive.

> The equal emphasis, the flowing radiant compactness, that evoke the recreation of a whole independent object, the utter demonstration of its brotherly yet differing parts, none of which is overborne.

Psychoanalysis provided an exact expression of these values. Gradually, in more and more detail, he has related these aesthetic modes to the conditions of earliest infancy, to the child's first contact with a beneficent or baleful world, and to the processes of splitting and projection and introjection with which it struggles for a stable ego. The Kleinian account of the conditions of earliest infancy, when boundaries

between the baby and the outside world are blurred, provides the content of his dissertations on a modeled relationship in art, with its undertones of envelopment and aggression. Carving is related to a later stage when the child, recognizing the separateness of the outside world, first grieves for what it now fears it has lost, and finds ways of restoring wholeness.

Adult art symbolizes these processes in the richest terms, taking hold of things and also elaborately redefining them, restoring what may have been menaced by greed and aggression. Specifically, art's processes parallel, mirror the processes of ego formation. It externalizes them. But not as a re-enactment only, because it resolves its material. Somewhere Stokes describes art as a kind of music woven round ancient themes.

He presses beyond this point towards criticism of the man-made world. For him the architectural environment is both the soil out of which the more specialized achievements of painting and sculpture grow and also their conclusion. Richard Wollheim rightly stresses this aspect of Stokes's criticism in his excellent introduction to the new book. A terrific attack is launched; the gasometer at the Oval is one of its targets:

> Innocent of tapering, the gasometer suggests explosive girth. A bad mother as well, possessing a bad phallus, it does not attempt to pierce and mingle with the vaporous sky but takes on bullying duties, namely to outrage the houses of the poor (with small apertures) that miserably cluster near that naked plant.

Such monstrous effects as he describes here are the harvest of cultural fragmentation. He cites also the partial, idealized representations of sexuality put forward in advertising, or

by guns, rockets, or the phrase "Be a man." Also that we rarely *look* at manufactured objects with an eye to their utility. "The aesthetic effect is usually split off in our minds from immediate benefits." Whether we like it or not, we search our surroundings for symbols of wholeness. But the urban environment has no integrating message. Hence the fragmentation as well as the heroic energy of our art.

In the light of this pessimistic, although admiring conclusion, Stokes's own paintings look particularly moving. In the gallery below, Lawrence Gowing is showing a group of landscapes and abstractions deriving from the study of landscape. An effect of the juxtaposition is to show Gowing as a coarser-grained though more adroit painter. Stokes's pictures are all smallish pictures painted from nature, worked over in tentative, pearly touches. They are restrained in the sense that there are no sharp accents, no points of stress. His drawing is clumsy – it shows up particularly in the figure paintings, where difficult transitions tend to be fumbled. The most important pictures are the still lifes. Tough, composed entirely of bottles, decanters, jugs, they suggest an obvious comparison with Morandi, and yet if one could compare the two, Morandi would be seen to be making his bottles heroic, weaving grandeur into them at the expense of their surroundings. Stokes achieves a wonderful continuity across the picture surface, in which space is at one with the canvas, and the shape between each object measures up to the positive form with a steady radiance. They are pictures which demand a great deal of attention, if only because of their look of opalescent softness, not easy to accept as the tone of such certainty.

171

ArtForum
September 1975

COMING AS I DO from London, where the sidewalks are called "pavements" and are made of neatly joined, level flagstones, the roughly poured, broken, unpatterned concrete that one walks on in New York is always affecting. My sense of the whole city is colored by that thin, random-seeming covering, a mere temporary shell thrown over the sand and mud which the ancient rocks that jut out of the grass in Central Park seem savagely to ignore. These fissured, pitted sidewalks are treacherous. I keep my eyes down. At the same time I am surrounded by buildings and an ever-changing panorama of reflections. Clouds and sunlight are inverted below the skyline. Roads of light open between the buildings. I am in a state of constant tension between up and down. The juxtaposition throws up a wholly unfamiliar view of man's works. And an unfamiliar view of myself. The city seems open, provisional, the luxurious and ramshackle upshot of certain freedoms which, in my European experience, are nothing but states of mind, or longing, and have no material presence – unless perhaps in childhood memories of treehouses, dammed streams, and improvised blockhouses under the kitchen table.

London's pavements seem to impart a sense of thickness and fixity. You walk on them as though the city itself were a building. Cracks and potholes are carefully attended to; surfaces swept. Garbage is less in evidence. Human dereliction is on the whole kept discreetly and perhaps hypocritically

out of sight. I find it impossible to dissociate my feelings about the evidence of human misery here from my sense – my taking in – of the sidewalk, and from the ever-present reflections of the sky.

What does any attribute of the outside world mean – what makes it worth commenting upon or isolating or trying to recreate on any level, whether that of art, at one extreme, or merely in fleeting recollection at the end of the day, if not by virtue of one's sense of connectedness with it? What does "whole" or "part" mean, or "open" or "closed," or "hard" or "soft" if such qualities are not cited in truth to our own bodies and our sense of ourselves and our orientation to the world? What would it be like to lose that connecting thread? Indifference, acedia, nausea, boredom, spleen, depression, alienation – they are all names for states characterized first by disjunction, loss of resonance and withdrawal. Of all the textbook signs of depression – cold skin, shallow breathing, slumped posture, weak voice – the crucial one, it seems to me, is lackluster eyes.

Perception functions in the same way for everybody, at least in the mechanical sense. I am not sure that we can do very much with that fact. The achievement of artists who have tried to extend the range of art by addressing themselves to perception at a purely functional level has been extremely limited (I am thinking of artists like Vasarely and Soto). The uses to which perception is put are cultural, and there is abundant material to show how far cultural differences between people shape what they see. Malraux and Gombrich have argued, though from very different angles, that art history is primarily the history of traditions of seeing based on cultural schemata. I suppose that what I am trying to describe – the sense of resonance and reciprocity between my eyes or yours and what we are looking at – lies somewhere between seeing "in the raw" and seeing shaped by culture. It is common experience only in the most general terms.

I can talk about the things I see and about what it feels like to see them, but I can never know what it feels like for you. I cannot get inside your eyes or into the fantasy and interiorization that is the keynote to your singular experience, any more than you can get into mine; yet we can agree on the high importance of firsthand testimony, given and received. Any effort toward a searching, cliché-free account of experience is a cultural increment.

If we could look at a drawing or painting as an object pure and simple (sometimes I think that I can, sometimes not), it must have a quality that I attribute to all objects. It should address me and render itself part of me. But of course other things intervene. The painting plays shifting roles – as representation, as organization – and, above all, as historically defined "work" within the context of art as a whole. Just recognizing a painting as a painting is a cultural action, and as soon as I have done that, everything that is specific in it will start to find a place for itself within the complex that might be termed what-I-know-about-painting. But it will still be there in front of me as an object and will be present for me to take in – with its attributes of size and surface, its open or continuous markings, its textures, pattern, and color. And in sum, it will be there as representation.

Representation raises special questions; for whatever a painting alludes to or depicts, the metaphors within it remain unverifiable in their scale and location. I have to take it on its own terms since I cannot verify what it represents, as I can generally verify another kind of object by touching it or maneuvering in front of it or scaling it alongside other things. Nevertheless, as representation, the painting faces me and renders itself up to the reciprocal experience that I have been describing. I am free to refer to its being as object – a rectangle of such and such dimensions, with such and such surface, its open or continuous markings, its pattern and color.

It seems to me that there is a major distinction to be made between this response to it as representation and object on the one hand, and my reading of it as a painting among other paintings, an item in a historical sequence on the other. At one pole, I am facing the painting in the absolute given of the senses; at the other, I am facing it out of an awareness of time and culture – that is a present which is more or less relative, a selected position. One position informs the other, no doubt, back and forth; but the contrast between them seems to me tremendous. I have the sense of different parts of myself being called upon or aroused. Here is one way of putting it: what I see and understand of a painting as a historical item could be – indeed has to be – totally altered by the accession of new information; proof, for example, that what I take to be a Rembrandt is a nineteenth-century fake, or the information that I am looking at a painting upside down, or that what I take to be a recent work by a certain artist is in fact an old one, or not by him at all but by another artist of whom I have never heard.

But there is no need for my response to it as a physical appearance to be shifted at all. Just as the truth of direct historical position *insists* on a modification, so the truth of direct experience insists on a certain constancy. Every fact, every picture that I see and place in time adds a further detail to the network of my understanding of the art of painting as a totality, rendering the mesh finer. And the sweep that I make with that net will, no doubt, be powered and directed by curiosity and intellectual appetite. It will also be affected by physical confrontation, the painting's address, the nameless sensation which both stimulates hunger and offers fulfillment. On that level, no facts, other than those I can take in at the moment, are germane.

Yet always one is up against factors that tend to split awareness: an overweening attention to art as the enactment

of art history, to art as the product of artists, and to artists as the exemplars of more or less mythic types. Such attention seems to be powered by a kind of fear, an anxious desire to contain art within its own boundaries. I am thinking of certain episodes within my own experience.

When in the mid-fifties I first saw canvases by Pollock, Still, Kline, and de Kooning, it seemed to me that painting had made a totally new definition of freedom. The structures that I was looking at owed nothing, or so it seemed, to the closed, self-contained, self-consistent notions of composition and pictorial syntax that my experience up to then had taught me to regard as mandatory. These canvases, apparently improvisations on a heroic scale, seemed both more rooted as objects in the material facts of paint and canvas than anything that I had seen before, and at the same time paradoxically more inward. Yet this inwardness had nothing of the willed, whimsical quality that I found intolerable in Surrealism. Inwardness in the New Yorkers had something headlong about it. It was passed over directly in the quality of the attack, the frank acceptance of painterly gesture and virtuosity as form-making factors; through open hesitancies and revisions, and the naked exposure of painting itself as a visible argument. It was carried over, too, in the man-sized scale and the invitation to close viewing and envelopment. Above all it was carried in the sense these paintings gave of being *seen*. Each nuance, each final decision was an episode in a dialogue with the canvas – a dialogue in which the eye faced and took in the visible facts of paint and canvas and the spatial readings built into them. The very terms of vision seemed to be recreated here – even in the matted cat's cradle of Pollock, even in de Kooning's reversals of figure and field. For all their abstractness, these canvases seemed nearer to the great figurative traditions than anything that was being done in the name of abstract

art in Europe, and for me at least that was not a mark against them, but the opposite. They were nearer to the figurative tradition, not, obviously, in terms of subject or compositional hierarchies, but in terms of spaces filled with seen forms.

177

Nonetheless, one was confused. The euphoria of this new experience of painting was touched by anxiety. As always when faced with something new and unfamiliar, it became urgent to form connections. I do not want to get sidetracked into an account of the ways in which New York painting was interpreted by European critics, although it is a fascinating story. Most missed the point completely. A few – Lawrence Alloway in particular – were informed about affairs in New York and became the recognized sources of information. A context was urgently needed. Everybody began reading *Art News*; Harold Rosenberg's famous text of 1952 in which he presented the term Action Painting was on everyone's mind. European art was ransacked for connections. Above all, statements from the artists themselves were collected and discussed like holy texts.

Quite quickly critical values began to accrue round the paintings. They began to speak as documents, as symbols of cultural positions, as statements or events in the history of the present. Central to the picture that was being formed of this new kind of painting was the idea of the destruction of the past, or of the artist freeing himself from the past in a continually renewed act of improvisation. Intentions were defined, or so we supposed, in the act of painting and not in advance. This suggested an exhilarating atmosphere of freedom in which dogma and stylistic consistencies withered away. (I must emphasize, by the way, that this discussion centered on only a few American artists, the ones who had been shown in Europe. The interpretation was as one-sided as it was romanticized.) "Form, color, composition, drawing are auxiliaries, any one of which can be dispensed with.

What matters always is the revelation contained in the act." The words are from Rosenberg's Action essay. The hierarchies of art were well lost: "… the end of Art marked the beginning of an optimism regarding himself as an artist."

Whether or not the artists discussed by Rosenberg recognized themselves in this account, it is certain that by the end of the fifties there were "artists" all over the world claiming a place within it: during a short period, it seemed that every art magazine one picked up was full of nothing but counterfeit de Koonings.

Compared with doctors, engineers, or business executives, artists are marginal figures. Committed to a kind of self-definition which has no necessary counterpart in society, artists have been exposed to myth-making and endowed with a semi-magical role which is both their passport in society and their trap. Theoretically "free" to do anything he wants, the artist is just as likely to fall into a stereotyped role as any respectable man-in-the-street. The difference is the huge symbolic value society chooses to place on this role. It seemed toward the end of the fifties that the work being produced in emulation of New York painting was nothing but a token; the badge, if you like, of a particular role.

The subsequent wave of interest in Duchamp here and in Europe can be seen as a response to this state of affairs. Works like Rauschenberg's *White Painting with Five Panels* (where the onlooker's shadow and the time of day worked on expectations aroused by a white canvas) included the literal collaboration of the viewer in the making of the picture. What matters, to repeat Rosenberg, is always the revelation contained in the act. But to whom did it matter, and to whom was it revealed? The involvement of painters with media outside painting during the sixties – happenings, dance, film, assemblage, mixed media, light and sound electronics – has its roots, it seems to me, in the mythic concepts

of action, and in the problems of audience and context raised by these concepts.

With the part of the viewer (audience) now integral to the work, the work itself could only be one factor in a larger relationship. "The better new work," Robert Morris wrote in a seminal statement during the mid-sixties, "takes relationships out of the work and makes them a function of space, light and the viewer's field of vision. The object is but one of the terms in the newer aesthetic." It was inevitable that this position should lead toward a reassessment of the way art objects were handled by commerce. The political situation during 1969–70 and the sudden surge of neo-Marxist enthusiasm clinched matters. A huge question mark was placed over the status of pictures and sculptures, the objects of art themselves. That question mark is still there. And under it the quasi-sanctified autonomy of art can easily be seen as a dubious smoke screen.

Scores of possible scenarios could be picked out from the tangled history of modern, self-reflexive art. What they would have in common would be their drift away from or avoidance of meaning in the firsthand; and their denouement in a sense of sickening ambivalence.

Vision locates the outside world for us. In its primitive stage, in the cradle, it is unfocused and undifferentiated. Boundaries between the inner and the outer appear to be unclear. Space is imprecise and frustrating. The sense of self and of the whole self-contained body as its vehicle is a daily goal. As this goal is gradually won, objects, other beings, are granted their freestanding existence. The achievement is hard-won, to be measured against continual rehearsals of earlier stages where the diffuse, undifferentiated environment threatens to overwhelm or to persecute, or to be available for omnipotent manipulation. Kind and harsh aspects of the environment are separated in an anxious denial of

180

wholeness. When this wholeness is accepted – wholeness of the body-as-self, wholeness of the other, the outer world as freestanding and autonomous – then Good and Bad are allowed to join and to interact. The possibility of love exists – a love which is more than invasion or envelopment, taking or being taken – but which can endure in a steady state because the whole object of feeling can be incorporated, good and bad, with a subject which is itself whole.

It is certain that the drive toward making art has a deep connection with these ancient experiences. Art means nothing to me if it is not symbolic in some way of the self and its struggle to define and stabilize itself vis-à-vis the outside world. Painting means nothing to me if it does not symbolize vision and the part vision plays in the definition of a stable body seen at a distance, a stable self-image, and consequently a stable, freestanding view of the outside world.

Those traditional criteria of *wholeness, balance,* and so on seem to me to have meaning only as qualities won in the face of opposite forces – fragmentation, collapse, chaos. When we say a painting works, it is as if we are acknowledging that the body is intact, whole, energetic, responsive, alive. This can be said irrespective of the cultural shaping that has been given to it – that is, irrespective of whether it is abstract or figurative, stylistically experimental, or conservative.

I see in the clearer recognition of this fundamental life of painting, a possible route out from the tyranny of art history – not art history as a discipline, but as a pseudo-subject matter for new art based on the idea that it has (or has not) been done before. Painting has found itself increasingly dependent on critical elaboration from the point of view of instant art history, whether from a social or a formalist position. It has arrived at a point where the content of a work is described only in terms of how one artist relates to another. A maze of such connections is woven into the background of

every artist, important or insignificant. It increases the capacity of his pictures to function as cultural messages: messages, that is, issued and received within the corridors of the institutions of art. It elaborates the code but it does little to open up their sensuous presences or their possibilities in the world at large. It is a hopeless position leading to narrower and narrower horizons, and the hopelessness is compounded because criticism has not yet begun to master a language adequate for the real issues: if we are stirred by a painting and attribute value to it as a result, how do we then connect these values to the world outside painting? For to have to choose between the carnal presence of a painting and its cultural status, to look at body and meaning as exclusive alternatives, is absurd, a grotesque dualism. And I do not see how the values that we attribute to art can ever be seriously endorsed until that dualism is overcome.

The language of a criticism such as I imagine would have to return to the art object again and again, and be ready to accord it its presence in the world of objects. It would need to open itself to visual experience at large and continually reflect upon that experience as upon a highly ramified aspect of life. I am tempted to say that painting would have to fend for itself as a part of that aspect of life, a ramification of it.

The canvas, surely, is present in front of us as a surface. The object and the viewer reciprocally address themselves. Just to do that, to face an empty canvas, opens up vast areas of feeling that go back and back into ourselves, into that which has been internalized from the outside world. And of course, the experience opens up paths which go out and out into culture. The starting point for these resonances is the canvas's frontality, its rectangular nature, its symmetry, confronting our own torsos, addressing our shoulders or our knees, our chests, bellies or foreheads with its flat surface. It has an outward direction, which we match, plunge into, or

break away from. But it is also surfaces outside us – the skin, the front of another body – a face perhaps, a breast, a presence which we know in ourselves as well as out there. It is a

182 wall, the essential unit of architecture as it is experienced. So it is a sheltering, dividing, containing, ordering boundary. But it is open too, a field, like the sky, like what I see when I close my eyes, like what I see when I open my eyes and there is nothing there. The canvas is both open and closed; infinite yet with precise dimensions; out there, exterior, fixed in space, yet in me and summoning up an array of presences which are interior to me.

Finally, it is recognizably a support for a painting, with all that that implies. That is to say, the moment I face it I am locating it and myself within a grid in which my lifeline crosses, so to speak, with the history of art. Whatever happens on the canvas, given we are dealing with an adult artist, not a child or a primitive, will, of course, be shaped by the possibilities given by the art of the time – even if that shaping takes the form of rejection. This shaping can be described.

What still eludes us is the inner dynamic. One way of describing body feeling and emotion (it has been touched upon by Erikson, Gardiner, and others) is by relating them to the libidinal centers defined by Freud: the oral, the anal, and the genital. In this way, specific qualities can be described by pairing: the mouth swallows quickly or slowly, sucks or bites, explores inward or outward, and so on. The sphincter retains or expels, the genitals intrude or receive. But these are crude and inadequate terms. One has only to try to find words for the experience of, say, holding something between one's teeth to realize how limited words are in their ability to describe physical sensations. And of course, what happens in the area I am talking about is that these primary sensations quickly take on qualities which are experienced in a general way, either all through the body or

by displacement to other centers, and the emotions that attend them are spread and transformed. I do not want to leave the impression that I am interested only in the tactile, or that the problems of criticism and the awareness of paint-ing must necessarily concentrate there. In the struggle for the whole self and for the freedom that this entails, the starting point must be the body itself. But freestandingness can only be achieved reciprocally. It is the hallmark of vision that it outstrips the reach of the body. It is the eye which acknowledges distance, separateness, while yet making con-tact and taking in and incorporating that which is distant. Painting, which is the language of the eye, has the same capacities on a high symbolic level. Color, shape, the self-contained interactions, their challenges and resolutions – they happen out there, at a distance, within the space of the canvas. Yet that space is finite, the surface of a particular canvas, and although I can scale myself to it in any way I please, look at it from any range, its dimensions are precise. I can measure it with my hands. It faces me by itself. Yet it answers my body – *is*, in a mysterious way, my body.

Somehow, through these paths, and in ways that I do not pretend to understand fully, painting deals with the only issues that seem to me to count in our benighted time – free-dom, autonomy, fairness, love.

Part III

Catalogue introduction to an exhibition of the same name
André Emmerich Gallery, New York
April 29–May 17, 1978

IN THE AUTUMN OF 1958, the New York art magazine *It Is* published a series of artist's statements on the concept of "all over painting." One of the artists was Al Held, then little known beyond the milieu of the cooperative galleries on Tenth Street. His statement reads: "I am not an all over painter. The rigid logic of two-dimensional aesthetic binds us to the canvas surface making it an end in itself, not a means to an end. I would like to develop from this not by going inwards towards the old horizon, but outwards towards the spectator. The space between the canvas and the spectator is real – emotionally, physically, and logically. It exists as an actual extension of the canvas surface. I would like to use it as such and thus bridge the gulf that separates the painting from the viewer."

The statement was not unique. The word "space" was something of a shibboleth in the pages of *It Is*. In that particular issue, the idea of painting projected into the viewer's space was invoked in several contexts ranging from analytical Cubism to the quasi-mystical celebration of "an American sense of space-on-space." (The phrase was Philip Pavia's). It was in the air, and in the next few years was to be worked upon not only from within painting but by artists like Rauschenberg looking for an extension of painting's limits, and sculptors like Morris who were reconsidering

the onlooker's own perceptual engagement with the work.

But looking back at this statement after twenty years, and knowing the massive œuvre that lies between, we can't help being struck by its succinctness and its certainty of purpose. This one idea is compelling enough to bind up together all of Held's ambitions for painting: ambitions which include a monumental and public art, and an art of meaning, capable of spreading its wings far beyond formalist aestheticism, the "rigid logic of two-dimensional aesthetic." He has lavished himself on this idea in one form or another, and has brought it to the kind of intensity that can only be generated through years of work. He has accepted the challenge that it implies to the nature of painting and its relationship to sculpture and architecture. In the process he has made a kind of painting which did not exist before.

For the last eleven years he has been working exclusively in black and white, in a linear idiom picturing regular shapes in perspective. The beginnings of this phase were simple and violent: a selection of massive boxes, prisms, and annulets tumbled together and strapped into place with thick uninflected lines. Since then he has explored every affective aspect of the idiom and developed each to a high level of complexity and refinement. These new paintings are as taut, as finely strung as delicate instruments, and yet one feels a terrific force within them. Each painting here – they represent the very latest stage of his thinking – yields a specific and unique experience [Fig. 7]. This is despite their sameness and their consistency. In fact it would be difficult to think of any group of paintings by a living artist whose effect and whose action is more highly differentiated, one from another.

No doubt this has to do with the searching way in which every element is considered as a problem. It is as though he

obsessively counts over to himself the factors by which the painting is read, lists clues, variables, certainties, ambiguities, and tests them singly and in combination, playing out the alternative moves, isolating the moments of sacrifice when, as it were, the loss of a tactical point is balanced against a strategic gain. I am using the imagery of the chessboard. Certainly he has agreed with himself on the rules of the game. The play is not developed by calculation alone but, like chess, is played by eye against a background of knowledge. And like chess, for all its apparent intellectualism, the game runs on intimations of life and death, in high anxiety.

Here are some of the factors which bear on the onlooker and on his sense of his place in front of the picture:

Perspective. We are faced with an array of regular figures projected in three dimensions. They appear to be projected either in isometric or vanishing-point perspective. But the vanishing-point projections have no common horizon. We are thrown in doubt on two scores. We cannot be sure that these are in fact regular solids. Sides only appear to be parallel and circles only appear to be circles – we could be looking at wedges or ellipses from special points of view. We can only work from the face value of the painting. Then too we are thrown into doubt about our own position, for if coherent perspective locates a horizon it also locates a viewpoint. Where are we? What does perspective mean if it does not predicate an eye level? Suddenly our own position becomes as open and as indeterminate as the internal space of the picture.

Largeness. One of the ways in which the boundaries between painting and sculpture can usually be described is by drawing attention to the way that what we understand of a painting is independent of the angle at which we view it. Sculpture "moves" when we move: painting does not. The

distortion of aspect that we see when we look at a painting from the side is readily folded back into our "normal" view of it. In sculpture, on the other hand, each successive view is a further ingredient in our construction of the whole. That whole, the totality of all its aspects, can never be seen at one time. We have to synthesize it ourselves out of movement, memory, and body-sense.

Held's major work is always large, and there have been certain crucial occasions when it has been gigantic. He has made two murals during the black-and-white period, one at Albany in 1971 and the other at Philadelphia five years later. The Albany painting was 90 feet long. Philadelphia was twice that. At this extreme, everything changed. Seen from either end, certain forms will do extraordinary things, apparently bending out from their neighbors or condensing into compact shapes that open at the slightest movement. Nor are these readings merely distorted views of what one has seen from the front. The change is so extreme that they strike the eye as unique in themselves. What one is seeing is a kind of anamorphosis but unlike the usual examples, there is no norm to which the distorted image can be returned. Once we have recognized the skull in Holbein's *Ambassadors* for example, the long tusk-like shape that we see from the front looks precisely like a distorted skull. We have fitted it into the stable background of the rest of the picture. Once we have seen Giacometti's two-foot nose fold itself back into the face full-view, our further viewings are precisely viewings-from-the-side. But with Held there is nothing certain to return the distorted images to; or to put it another way there is nothing to persuade us that *either* view, frontal or lateral is an anamorphosis of the other. All that we can say is that they shift extremely in relation to each other, and that their constellations seem more stable from some points of view than from others.

The sense of disorientation given by the uncentered perspectives is translated into a compulsion to keep moving. It is as though the energy of the painting is converted directly into kinetic response. Above all, there is the question of memory and of what one can hold in one's head of the totality of the picture. There is no question of being able to "see" the "proper" view of the painting from any of the viewpoints that one might choose. Each of these yields a special version of the picture, one no less authentic than another. The idea of exploring them, matching them, following clues until all these aspects join into one graspable memory feels like a life's work. The paradox is that in spite of the apparent simplicity of its terms, and its crystalline clarity, the painting is so complex that one has little choice but to live it, to experience it as something endless.

Scale and overlap. In the first black-and-white paintings, the bounding line of each of the forms was constant in its thickness and strength. There were no clues to be picked up from it to help the eye in its readings. Now there is a vast range of thicknesses, from bold bars to the finest threads. Almost always these shifts of thickness will subvert in some way or another our expectation, that is, our effort to read the image in conventional depth. It is the same with the forms themselves. A smallish box or prism will float, feather-light on the very threshold of the painting; something else, a part of another box, perhaps, heavy, massive, will be embedded somewhere behind. Nor will the function of overlap tell us any more than that of scale, for there is no predictable way in which we can predict the opacity or transparency of any form. Forms from behind interfere with forms in front. Fragments of larger forms will on one viewing take on a life of their own and only later, under different circumstances, are seen as joined to something larger.

In the latest works two features have developed which

complicate things even more. New elements besides the familiar dimensional boxes and prisms have appeared: small discs, oblongs, triangles, forms which have no location in depth or rather, whose location in space is even more problematic than the others. Some might indicate intersections of invisible forms or the crossing points of invisible grids. Others, by their gradations of size might indicate movements backwards and forwards, or simply viewing paths, or interruptions to those paths. Bounding lines, on the other hand, have become much more explicit in many cases, and are doubled or tripled to give them a dimension. This takes some of the ambiguity out of the figures since one can check one's reading against the clue contained in the crossing of the lines; but it makes the paintings even more violent. These corrections are often jolting. A huge prism, for example, might suddenly reverse its direction with an almost physical wrench that one is neither prepared for nor compliant with.

Surface and extent. Every feature that I have tried to identify gains force from the particular character of Held's surface – that flat, sanded-down, unbroken white ground. If his lines, which are drawn by eye and corrected and re-corrected, gave clues which betrayed their history, we could return the painting to the familiar activity of decision-making on a flat surface. We would see those marks expressionistically, as eloquent states of mind in time. But we cannot, and the emphasis swings over to us in space. Also, if the surfaces between the lines were inflected in texture or tone, harrowed by brush strokes, or for that matter, colored, we could return everything that we can see to the self-contained world of the canvas. Local changes would reinforce our choices in reading the picture and would help us to fix things in depth. This reinforcement is pointedly lacking.

When we recognize one of his forms, the white contained

within it takes on a different value from the white outside it. When we switch our attention to a larger form, perhaps enclosing the first one, there is a further transformation of the value of the white. This effect is unmistakable, although impossible to quantify. It is as though the whole white surface has a potential charge which can flow in any direction. If this charge was localized in "painting," that is, in variations of tone and texture, its energy would be bounded by what could be read as "painting intention."

There is a close connection between this feature and the way in which he allows forms to flow and drift in and out of the picture's edges. Both features imply openness; but also a larger system, or rather, a larger structure whose features are so inclusive that they can only be expressed in relationships, and of which each painting is a special view or example.

In most of the paintings here we can make out the presence of a vast overarching grid "behind" the smaller forms. Close to, this grid breaks down into fragments, and one's attention is taken by the endless play of readings, the flickering back and forth from the part to the whole, from forward to back, from inside to out, from solid to void, all the elements of recognition and interpretation in a furor of energetic exchange.

As one steps back, the grid reassembles itself, pieces itself together and as it does so, the dynamics of the forms in front go through yet another transformation. Individual forms gain a new scale and float free as if expanding outwards from the bowed lines of the grid. But those very bowed lines which seem to impart a sublime scale within the picture, serve also to return us to the real footage that we are moving in. We begin to "see" their extensions out here in the room, to see them as segments of circles whose centers we intuit in our own space. So the interplay between the world of the painting and our own space is hardly less

energetic than it had been in the Philadelphia mural, for all the great difference in size.

In front of these paintings one has to admit, finally, that one is seeing different pictures from different points of view. Furthermore, these different impressions do not lock together in memory so that one can carry away a compact synthesis of all that has been seen. On the other hand, what has been experienced is vivid. Somehow it is not to be pinned down into a fixed set of relationships, a physiognomy. Relationships are continually shifting, and it is *in the nature of their shift* that the real structure of the picture is to be found. It is this that locks together in memory. This is its meaning, which is to say, its meaning outside the realm of picture-making.

The history of representation is a history of models of the world. A Donatello relief, a de Hooch interior, a Tiepolo ceiling are all, in a sense, cosmologies. The point has often been made that the cosmology of the twentieth century lies beyond the picturable. In the heroic years of modern art some of its pioneers claimed precisely to be the spokesmen of a modern world view. It is a claim that has since been largely dropped partly out of honest bafflement, partly out of the development of vested interests and a general fall into pessimistic solipsism. Held is one of the few artists alive whose ambition has been serious enough to keep touch with this claim, and to have had the talent and intelligence to further it.

From a book of the same name by Andrew Forge
Harry N. Abrams: 1972

IN RAUSCHENBERG'S STUDIO there used to hang a small canvas called *White Painting with Numbers.* He has said that it was the first picture he ever did with which he could wholeheartedly identify. It was painted in 1949 while he was working at the Art Students League, and it seems that he painted it in a studio where Morris Kantor was holding a life class. The other students kicked up a fuss.

What was being protested against – the picture, or the nonchalance with which someone had turned his back on the class? Both, of course. If he had been eating a sandwich there or reading a book, there would have been no story. What the other students were facing was an ancient studio situation, that most problematic of all experiences open to a painter, which gets called "nature" but is really the whole of the history of art. Rauschenberg was refusing this challenge.

The point about the little picture that he worked on is that it was precisely true to the doubts that he felt. Incisive, positive in itself, it is genuinely noncommittal, culturally speaking. Monochromatic, it refuses the problem of tonality and color. Flat, it is true only to the canvas's tablet-like surface. It is indifferent to any spatial proposition except the fact that you can scratch through wet paint and expose the ground underneath. Its material consists simply of the physical properties of paint plus neutral symbols of information.

The episode of *White Painting with Numbers* epitomizes a great deal of Rauschenberg, his fastidious posture which includes both doubt and recklessness, diffidence and display. Is there not also in the picture itself, with its fretted key pattern that alternates between lines and boxes, figure and field, and its enigmatic tables of figures, something which foreshadows the qualities of his subsequent work? Neither composed in the way pictures are, nor reasonable in the way arithmetic is, it seems to open itself up, to face us with an extraordinary frankness, yet leave us suspended, asking questions and looking with enhanced vigor.

To draw anything – anyhow – is to comment upon it. There is no such thing as a neutral drawing, any more than there is drawing "as you see." This is not simply because of the infinite nuances of meaning that tradition has built into the conventions of drawing, but because a drawing is a closed system. Whatever is included in it is transformed by the system, made subject to it, and becomes more significantly a part of it than of anything else. It is like a state; its citizens are both subject to it and representative of it.

Everything that Rauschenberg did between *White Painting with Numbers* and the Dante drawings a decade later has the quality of an exploration outside the boundaries of this state. In the early fifties he had begun to collect objects in a spirit not far removed from the Surrealist *objets trouvés*: stones, timbers, and so on, sometimes isolated, sometimes juxtaposed, sometimes worked upon. At the same time, he was deeply involved in photography, and photograms of various objects on blueprint paper were published in 1951.

The all-white paintings of 1952 and their all-black partners were the upshot of an experiment in painting – or rather, in the making of painting-like surfaces – at the furthest perimeter of cultural language. They are on the brink

of being not painting at all since a white wall or a tarred fence would have served some of their functions – except for the task given the onlooker.

The dirt paintings, which he made in the autumn of 1953, "canvases" of soil packed into chicken wire and stiffened with waterglass, randomly sprouting with birdseed and weeds, seem at first sight like attempts to test to the point of absurdity that tradition of modern art, exemplified by Klee, which claims the right for art to work with nature's laws. In fact, they proceed from the opposite point, since what they demonstrate is nature working (as it must) as though it were a painting, not painting working (as it doesn't have to) as though it were nature.

With the black paintings, Rauschenberg said, he was "interested in getting complexity without their revealing much – in the fact that there was much to see but not much showing...." They were constructed on a mosaic of newsprint, torn and crumpled and pasted onto canvas. This launched the painting, giving a lively vibrating surface within which "even the first stroke in the painting would have its position in a gray map of words." Gradually this base of "other" material began to establish an equivalence with the paint, to become as much of a subject as the paint, causing changes of focus.

The red paintings which followed were on a similar base, an active mosaic of collage; but almost at once the "changes of focus" were openly deployed. *Red Painting*, a long narrow canvas encrusted with an intense blood-red enamel over collage, has endpieces of raw wood. In another work of the same title, red fabrics – some striped, some patterned – are used alongside the paint as an equal factor. The underlying collage is allowed to show through more openly. In *Red Interior* the role of the disparate materials as subject is freely

exposed, and it would be impossible – and irrelevant – to say in what way the boards and notices, the fabrics or comic strips support the paint: they are on level terms with it.

198 *Charlene,* the climax of the red series, has a strong rectilinear and frontal structure. The irregular, boxlike supports, tightly packed, draw attention to their edges. One is conscious of their making, in their sum, the total outside shape of the picture, but the notion of a frame as a boundary between the picture and the outside world – an aesthetic threshold – has to give way to something much more complex. The frames and battens of *Charlene* articulate the *inside* of the picture; they also throw its boundaries far and wide. The wall behind insinuates itself through a hole in the picture and becomes a part of it. And as to the flashing light and mirror, one can imagine them as frames emerging from the picture out into the world, creating a new boundary for it in the space one is occupying oneself.

The concave mirror traps whatever is moving in front of the picture. A red dress or a white shirt, a turning reflection can be caught there swelling and shrinking on its polished curve. It is constantly moving, and by its agency the picture moves constantly too, each value that the mirror traps transforming the values that are painted or pasted in. A blue dress will flash like blue fire, inverting the warmth of the picture; bare arms, a spectacular suntan will spread a brilliant cinnamon that irradiates every red note there.

The real light in *Charlene*, inside the picture, puts us in a new relationship in which we might wonder which side of the frame we are standing on. In Amsterdam, where the picture now hangs, the light is high and flat and the flashing bulb is like a sharp, dry point. Elsewhere one has seen the surface of the picture modeled by the light, glistening, dulling, glistening, as it has flashed on and off, and has seen the

picture suddenly take on the tawdry inertia of a bedroom wall flicked by neon across the street.

More than once Rauschenberg has related his intentions at the time of the all-white and the all-black paintings to the teaching that he received from Josef Albers. He had enrolled in Albers's class at Black Mountain College, North Carolina, in the autumn of 1948 after having read about him when he was in Paris. He was only with him for a short time.

199

Albers had shown that no color or set of colors was "better" than another, that anything could be made to work with anything else, given a sufficiently sensitive empiricism. This seemed to make the responsibility for choice a matter of individual taste or expressive purpose. But Rauschenberg has said:

> I was very hesitant to just arbitrarily design forms and select colors that would achieve some preconceived result, because it seemed to me that I didn't have any ideas that would support that. I had nothing for them to do so I wasn't going to hire them. I was more interested in working *with* them than in their working for me.

The further the implications of what Albers said were pressed, the more his case seemed to threaten the individual integrity of colors. There is a passage in *The Interaction of Color* where Albers suggests the image of colors as actors and different color arrangements as performances, for which the stage is the format.

> Acting in visual presentation is to change by giving up, by losing identity. When we act, we change appearance and behavior, we act as someone else.... Color acts in a similar way.

With which statement we may juxtapose Rauschenberg's remark:

> I didn't want painting to be simply an act of employing one color to do something to another color, like using red to intensify green, because that would imply some subordination of red.

Paradoxically, considering their minimal chromatic qualities, the white and black paintings were concerned, among other things, with the reinstatement of color. Their "emptiness" was simply the outcome of using color in stasis. Nothing is set in motion inside the picture, so nothing moves at the expense of anything else. At the same time, these pictures established two positive factors in relation to color which he was to explore in detail in the next few years. The first has to do with the color of actual things, self-color.

If we say "a white canvas," we think of a bare canvas ready to be painted on – an object. If we say "a white painting," we think of a painting in which white is the predominant color, either in area or activity, an art work, in a different category from an object. What Rauschenberg's all-white paintings did was to allow him to see the self-colors of an object as pictorial color; and to claim for his pictorial color choice the unnegotiable integrity which is the attribute of objects. The white of the white paintings had to meet the world as a worldly fact, not as part of a system, isolated from the inroads of contingency, and yet at the same time vulnerable to them. What is at issue here can be brought into focus by thinking of the experience of looking at a picture in changing light. As the daylight begins to go, we have the sense of something failing, being brought to a standstill. It is not that we lose touch with the picture as a physical object, but that our communication with it is interrupted, just as a

jet plane might interrupt our communication with a string quartet. It is its sense which slowly disappears. Not so the room in which it hangs. It is still there, and our relationship to it is changed but *not interrupted.*

The other lesson in regard to color stemmed from the experience of the all-black paintings. They were made up of a dense collage of papers, across which and around which and within which the black paint was applied in a varied range of densities and textures. The result was an extremely wide range of blacks, a chord of blacks in which each condition of paint and of newsprint under it contributed a specific vibration. All one color by any reasonable count, they were in effect as varied and as nuanced as if there had been many. Texture, surface, application – all had contributed a special timbre. There was no such thing, then, as a single color in different states; there was nothing provisional about any particular embodiment. How it happened *was* the color. And subsequently it is impossible to say much about Rauschenberg's color without also discussing whatever it is that is colored, whether one is talking about objects or about paint. It was on the basis of this view of color as an attribute of real things rather than as an idea or an essence, a privilege of painting, that he came later to absorb such a fantastic range of objects into his palette.

Nothing that Rauschenberg has done has been detached from an immediate context. He carries his work with him. He is the opposite of the kind of artist whose studio is like a hermit's cell or a laboratory, the only place where things are "right" and work can get done. Rauschenberg has worked in front of audiences and in museums, backstage in theaters, and in hotel bedrooms. If the situation has been intimidating or inconvenient, that in itself has been accepted as a formative ingredient, not as an excuse for stopping. Life has penetrated his work through and through, and each work, rather

than imposing a definition of art, springs from a question about the possible contexts in which art can happen.

202

"Ideally I would like to make a picture [such] that no two people would see the same thing," Rauschenberg has said, "not only because they are different but because the picture is different." John Cage has spoken of a music which envisages "each auditor as central, so that the physical circumstances of a concert do not oppose audience to performers but disperse the latter around-among the former, bringing a unique acoustical experience to each pair of ears."

"Is a truck passing by music?" Cage asked in the same text. Are shadows passing by or sprouting birdseed painting?

Rauschenberg has used chance not as a blind antidote to order but as a way of handling the streaming autobiographic current that is his subject matter. Chance has meant selection, in fact, not chaos. Nor has he used it to exclusive ends, disguised as a system with its own rules and its own internal determinants. It has been a concrete alternative to the problematic confrontations of the studio, an open horizon. If something just happens it is, from his point of view, more convincing than something longed for or willed that doesn't happen.

When he was building one of the sections of the Amsterdam *Dylaby* he was offered the run of a junkyard for material; he was nonplussed. He had not realized until then how much it had meant to him that his objects had just turned up – if not today, then tomorrow. He was not keen on having to select.

When he first worked on silk screens with color he had found it difficult to reconcile himself to the blatant unpleasantness of the silk-screen inks, until he had established that there were only certain colors available, that they were the only ones to do the job, and that, raucous as they were, they could not be improved upon. Then even the screaming pink

became possible, because it had taken on the status of a thing.

Whatever stratagem is used to court the unknown, there comes a point at which random material becomes polarized by the particular energy that is brought to bear on it. This is the paradox that fascinates him. He is equally sensitive to both extremes, to what he has called the "uncensored continuum" and to the finest aesthetic precipitation of it. His nonchalance is anything but evasive: it signifies a determination to accept *total* responsibility for what he does and to allow no prejudice, no *parti pris* to scatter this allegiance.

Of course there are preferences, favorite preoccupations, both formal and iconographic. The trailing horizontal line that wanders across so many canvases, a certain crispness around the edges of things, dearly held icons – birds, umbrellas, the Statue of Liberty – and to some extent these favorites threaten the freshness of his contact with material. More than once his obsession with biographical honesty has landed him in a seriocomic dilemma. A certain project involved the juxtaposition of a fountain and a clock. How was the clock to be kept dry? The obvious solution seemed to be some form of umbrella. But its obviousness was suspect. Was it more truthful to accept the personal cliché for the sake of the objective function, or to go on searching for a more recondite solution? Similar scruples surrounded his use of silk screens of President Kennedy, after Dallas had charged that likeness with an unforeseeable weight. He came to the conclusion that it would have been just as affected to have dropped it at that point as it would have been to have started to use it then.

Making or performing has for Rauschenberg the value of a kind of giving. Many of his works have a personal direction, and are, so to speak, addressed like presents. There was an occasion when a combine was made for an exhibition which secretly incorporated works by two other painters

who had been rejected from that exhibition; his own work served both as a sheltering vehicle for them and as a voice raised on their behalf. The idea of collaboration with others has preoccupied him endlessly, both through the medium of his own work and in an open situation in which no single person dominates. In *Black Market* he invited the onlooker to exchange small objects with the combine and to leave messages.

Painting is autobiographical, "a vehicle that will report what you did and what happened to you." Several works of the mid-fifties bear out this claim; for instance, the second version of *Rebus,* called *Small Rebus.* Above the row of color samples that divides the canvas laterally is a photograph of a single runner curving past an audience of figures in suits seated on a rostrum. Below, three athletes perform on a rope. Related to them is a photograph of what appears to be an ancient brooch representing a dog, its coiled limbs echoing the coiling athletes, and to the extreme left, a fragment of another gym picture just showing a handstand. At the right edge of the canvas is a family group, a snapshot, the father in shirt sleeves and hat, his feet apart, his shoulders high; the mother craning forward with her hands on the shoulders of a bare-footed eight-year-old girl. Beyond are trees and an open prairie.

The center of the canvas is pale, with pasted papers and overlapping gauzes and sparse scribbles of paint. One element is a map, or rather two maps, a section of Central Europe and a section of the Middle West, pasted up to make one. Left of it, eight postage stamps. On the left edge is a detail from Titian's *Rape of Europa,* Europa herself, and above is a bullfight photograph, a corrida, and a child's drawing of a clock face with no hands.

One doesn't have to strain the material in the least to read it as a meditation on his own youth, his family past, his

sense of identity. The family group is the only image which is unbroken by paint or anything else. It has peculiar sharpness. The single runner, at full stretch in front of his audience of judges, is ringed in black. The implications of identity are inescapable. Geography and history are implicit; athletic performance takes on the value of an individual life.

In the winter of 1958–59, Rauschenberg started to work on a series of drawings illustrating Dante's *Inferno*. He had found that it was possible to take a rubbing on paper from newsprint wetted with lighter fuel. The resulting impression could be amalgamated with other graphic media – with pencil, watercolor, crayon, and collage. His palette was now extended to include a vast range of printed material, limited only by the degrees of solubility of different printing inks.

He set himself to work exactly to the form of the poem, not to select particular passages, not to make a personal anthology from its images, but to make one whole drawing from each whole canto, thirty-four in all; and in the same spirit, each drawing was to be an inclusive account of the canto, not a mere evocation of the more striking pictures from it. Thus the arrangement of each page corresponds with the spatial events of Dante's journey, and the particular images find their place in a complex compositional relationship which corresponds with the unfolding of the poem.

Dante's allegory was a model for the cosmos, an inclusive picture of man's relation to God and to his own soul, as well as a detailed critique of his social and political behavior. There are times when it is possible to imagine Rauschenberg relating himself to Dante as Dante does in the poem to Virgil. Dante's hard wrought and practical imagery is like a bond between them, affirmed in the way that Rauschenberg rises to the problem of finding a live equivalent to Dante's engagement with the affairs of his own time: centaurs become racing cars; the farting devils of Canto XXI become soldiers in

gas masks; Richard Nixon, John F. Kennedy, and Adlai Stevenson stand in for Dante's contemporary political figures.

The transfer process had sprung a tremendous expansion of subject matter and put his hand on a seemingly inexhaustible richness. His use of silk screen in his painting follows from this.

In the silk-screen paintings he uses his material lavishly, like a man using his eyes and his other senses lavishly. The lights of the streets seem to stream through his studio just as once white shadows had flickered on the all-white canvases whose surfaces were opened to whatever came. Titles alone proclaim an engagement on a geographical scale. There is a picture called *Almanac*; others are *Creek*, *Overcast*, *Tideline*, *Sundog*.

In *Tideline* the following screens are brought together: top right, a section of ocean swell; center right, a helmeted fireman facing a blaze; bottom right, the foreshore of the Battery in New York City; below that, the dials of an aircraft and a football suspended in a field of white paint, anchored to a finger like a dirigible to its mast. To the elements – Earth, Air, Fire, Water – are added two factors of human control: Measurement and Art. Top left, a clock face; center left, a detail of Rococo molding. But the clock does not have numbers on it, and the legend printed above it reads "External Time Optional"; and the ceiling, its flowery convolutions bursting crisply through the veil of paint that frames it, is not so much an isolated artwork as a florescence on the surface of the picture itself.

The movements of the silk-screen pictures are oceanic. They make concrete a fantasy of the bird's-eye view, a total experience of the world, not through the assumption of omnipotence, an imperial exercise of style, but through a lark-like mobility that takes him threading through layer after layer of things, never at rest.

Barge, with which the first series of silk-screen pictures reaches its climax, deals with communication (antennas, roads, signals), physical prowess (football, swimming), discovery (space rockets, fly, latch key), places. The paint, brushed freely, dripped, splashed, sometimes roughly drawn, provides an active but stabilizing fabric within which the silk screens are articulated across the canvas's enormous length. At times the paint intervenes pointedly, contributing to the imagery, exploding here in a flare of light like a firework, elsewhere streaming in veils like rain.

Barge is encyclopedic. Like an atlas it holds out a promise of the entire world. There are intimations of weather, of day and night, of the seasons. Vast pictorial spaces are suddenly fixed, cut to size with a screen – which in turn evokes vast spaces – only precisely, outwardly, as defined in the rolling perspective of clouds or the frame of a half-completed building. A sense of place yielded by a photograph continually telescopes into a sense of infinity. And all over there is the recurrent theme of human structuring, communication, interpretation, purposeful and beautiful engagement with the world: the swimmer ploughs the water, antennas scan, the print of the painter's hand marks the bottom edge of the canvas.

Ever since the fifteenth century artists have worked with a concept of wholeness. It has been at the center of almost every definition of art. "A work is finished only when nothing can be added and nothing taken away except to the detriment of the whole": Alberti's formulation is still self-evident. Completion implies a self-contained organism whose internal structure sets it apart from "life" or "contingency" or the "world." This is so whether one is approaching the work from the position of its formal relationships or whether as a system of spiritual or psychological truths. In either case it is the totality of the work which justifies whatever claims

it makes, gives it its standing over against the contingent, sets it apart, charges it.

The white paintings which Rauschenberg exhibited in 1953 announced a radical alternative. In a sense they were whole from the outset – they had been white canvases all along – and this "wholeness" could hardly have been modified by what was added. Painting them was an almost invisible affirmation of what was already there. By the same token, as they continued to be what they had always been while he worked on them, they underwent none of that removal from the contingent that the completion of a work normally implies. They ended up as open as they started. Paradoxically, nothing was excluded from them, because nothing was included. And by refusing every articulation or accent from the field of art, Rauschenberg was accepting whatever articulation or accent the world happened to endow them with:

> I always thought of them as being not passive but very hypersensitive, so that any situation that they were in one could almost look at the painting and see how many people there were in the room, by the number of shadows cast, or what time of day it was, like a very limited kind of clock.

He was establishing an unprecedented degree of mutuality between the picture and its surroundings. Imagine a roomful of white canvases: we maneuver in front of them, expectations alert. Our shadow crosses them: they had been empty art-supports; now they vibrate, respond with the shadow of our presence. White is no longer a color like a sign but a drawn-out event which, starting at the brilliant edges, burrows deep into a furry gray, the center of our own penumbra. They are big enough to hold us and they move as we move, staying white.

It is an occasion which renews itself, with no carry-over, no idealistic message. It has simply to do with our awareness. Fifteen years later he was to mount a kind of electronic reprise of the white paintings. Spectators in a gallery found themselves looking at their own reflections in dark, scratched mirrors running the length of the room. Then as they talked or shuffled or coughed, their reflections were joined by the flickering, running images of white wooden chairs, piled up somewhere behind the mirrors. Overhead microphones, covering the entire gallery space, picked up sound and had triggered systems of lights buried among the chairs. It was as though the dimensions of the room, and even its stability were at the call of the slightest noise, unwitting or intentional, that the spectators made. They ended up using their eyes to attend to their own sound.

Works of art get used. At one level he will explore this fact critically in his work; at another he will act it out, as though through a charade. Such has often been the character of his exhibitions. There was one, for instance, when, as a corrective to what seemed to him an overly casual, stereotyped reception of current shows, he arranged with the Leo Castelli Gallery that instead of announcing a one-man show in the usual way he insinuated more and more of his pictures into a mixed exhibition, then replaced these paintings with combines, thus holding an exhibition virtually unannounced and one of which nobody who saw it could be certain that he had seen the same show as anybody else. Again, private usage has provided fresh material: the chair found its way into *Pilgrim* because, on a visit to a collector's apartment, chairs had to be moved in order to see the pictures. *Pilgrim* solves this particular problem. More than once he has painted in front of an audience. It has always been an enigmatic performance: in Paris the audience saw the back of the canvas only, and heard the painting through microphones wired to it. In Japan he

answered the questions of an eager audience by doing things to a painting. And repeatedly and sometimes for long periods he has given much of his time to the stage.

210 Rauschenberg has assumed that there is no aspect of art which does not demand examination; that to work under the spell of received ideas is to be less than free; that this applies as much to the social definition of art as to studio definition. He has seen to it that the world, that which is the case, is active *at every point* in his work. "I think the whole process of painting is a very local involvement," he told David Sylvester in a conversation in the course of which he stressed the way that the usage of art speeds up its decay.

> Actually I like all the investigation … that happens now. One looks forward to a painting finishing itself … because if you have less of the past to carry around you have more energy for the present. Using, exhibiting, viewing, writing, and talking about it is a positive element in ridding oneself of the picture. And it does justice to the picture that defies this. So that you may not accumulate mass as much as you may accumulate quality.

From a memorial service for Josef Albers
Yale University Art Gallery, New Haven
April 23, 1976

I AM SPEAKING for those of us here for whom the name of Josef Albers does not evoke a voice, an immediate human presence, but rather a unique and irreplaceable ingredient in the art of the twentieth century. His reputation and his achievement as a teacher were incomparable. He was of a generation of teacher/artists, pioneers who believed that art was more than a specialized professional activity cut off from life. That the development of seeing and form-making were not the arcane preserve of a creative minority, but like any well-rooted, intelligent, sane human skill, were central to life, and as such, of course, central to a full humanistic education.

At the Bauhaus, the fine artist and the craftsman worked side by side. Craftsmanship was in Albers's blood. Every account one hears of his teaching stresses his closeness to material, his absolute respect for the medium. There is a great deal of demystification to be done at one time. "No smock, no easel, no brushes," he told a colleague in 1950, "no medium, no canvas, no handwriting, no tricks, no twinkling of the eyes." The constituents of painting had to be unraveled, they had to be examined by themselves, line, color, the geometry of the support itself, all had to be explored as a craftsman would explore the factors in his job, but subjected to a more and more searching, and more imaginative, tension.

He brought to the study of color, I believe, a precision of observation, a careful sifting of evidence, and an experimental openness that was almost scientific. But he wasn't solving finite problems, he was uncovering mysteries. His great work, the *Interaction of Color*, which was published here at Yale, will stand, I believe forever, as one of the great repositories of painters' knowledge. But equally, it's a challenge to the future.

Color is approached through our perceptions here, through the individual's work with it, through his focus upon it, through the quality of his attention to it, but it's here I think that we begin to see how inadequate it is to view Albers merely as a pedagogue, as a narrow theoretician of painting. For in spite of his analytical insistence, the poet is always present. Forms, as he isolates them, speak back to him with a clear voice. Colors create situations. They attack each other, or they merge with each other. They argue, or they cooperate. The conjunctions of form and color generate a kind of life and the more pure and intense the comparisons that can be brought to them, the richer the analogies between that kind of life and the life which includes us all.

His main work, the work that guarantees him a place in the history of the art of this century, began only after he had been in this country for several years. The series, the *Homage to the Square*, occupied the last quarter of a century of his life. The still, well-founded form of the square, had immense significance to him, a meaning which will only gather force as time goes on. His colleague, Hans Arp, recognized it clearly in a poem which he addressed to Albers.

They have a clear and great content:
Here I stand.
I am resting.

I am in this world and on earth.
I do not hurry away.
I won't have anyone harass and exasperate me.
I am not a frantic machine.
I am not faint-hearted.
I can wait.

This waiting, resolute square became the stage for color and its lively interactions. The combinations of color, simple, unmixed color, laid on flatly and precisely, as a craftsman would, create endless situations in which one color converses endlessly with another. In the last second of the film extract that we are going to see in a minute, Albers says of his colors, "They are like people."

For us at the School of Art, Albers is still with us. His persona and his teaching are alive in those of our colleagues who knew him and were taught by him. For the rest of us, there is his work. And isn't this one of the things that art means, that a man's life and fiber can be invested in an object which stands beyond time as witness to his quality and in some measure in reparation for his death.

On Kenneth Martin's Writings

Catalogue essay to an exhibition: "Kenneth Martin"
Tate Gallery, London
May–June 1975

Kenneth Martin was born in Sheffield, Yorkshire in 1905. His parents came from the southwest of England. At the time of Martin's birth his father was a clerk. When Martin was sixteen he enrolled in the school of art in Sheffield where he began a traditional training in painting and drawing, traditional in the sense that it went on as though Cézanne had never existed. After two years his father died and he had to leave school and find work. For some years he worked as a designer, meanwhile continuing to paint and read widely. His room became a gathering place for the livelier students at the art school. In 1929 he gained a scholarship to the Royal College of Art and went to London.

The Royal College at that time was the gateway to any kind of career in art teaching in England, but it had little to offer Kenneth Martin. "The only thing I learned at the Royal College," he said in retrospect, "was when Will Rothenstein allowed me to go and copy at the National Gallery." A copy of Poussin's *Nurture of Bacchus* still exists and he worked from other painters, laying the foundations of his incomparable knowledge of pictures. It is characteristic of all his life that he should have gained the most important lessons independently.

The Royal College was important for another reason. It was here he met and married Mary Balmford, a gifted and

highly intelligent fellow student who was to be the most important influence in his life. Their development as artists proceeded side by side. The crucial turn toward abstraction was argued out between them. His flights of speculation, his struggle to find ways of articulating his ideas took place against the background of her dry common sense, and often the logic of her work suggested possibilities he had overlooked in his own. More than once they collaborated publicly. Mary died in 1969.

Their life was extremely hard for many years. Nobody could expect to live by painting in England during the 1930s. During much of the war Kenneth Martin was in an air raid rescue team in London. In the late forties they moved into a basement flat in Swiss Cottage where they raised their two sons and did their work. Shortly after the war Martin had begun to teach in art schools, and this was to be his main livelihood for many years. He was a brilliant teacher. He belongs to that family of artists to whom ideas are of cardinal importance, and whose view of art is in a state of continuous growth. Yet his teaching is always practical. Any classroom he was in became his own studio. Something of the range and intensity of his teaching (though not always its warmth) can be picked up from his writing, of which he has done a great deal.

One of the places where he taught for a few years immediately after the war was Camberwell School of Art in South London. Among his colleagues there were William Coldstream and Victor Pasmore. Kenneth Martin had got to know them during the thirties and had something in common with their position. What this amounted to was first a suspicion that the school of Paris was decadent and given over to fashionable avant-gardism. What was called for, they said, was a rejection of the cult of originality, of "genius," of anything that could be called "arty." Instead, Coldstream

216

suggested, it was time to look again at the Impressionists' claim to have been painting what they saw. In his own painting Coldstream worked rigorously and over long periods from observation from a fixed point of view. Every mark he made represented an interval or a direction in a plane at right angles to the visual cone. Theoretically this plotting took place without any aesthetic bias; and indeed, without representational bias either. That is to say, likeness accrued as an almost involuntary result of the plotting, not the other way round. Kenneth Martin was sympathetic to the rigor of Coldstream's position. He was interested in measurement and in the attempt to find an objective framework within which to canalize his imagination. He shared nothing of Coldstream's conservatism.

By the late forties Kenneth Martin had begun to question this enterprise. He began to look at those aspects of Post-Impressionism which had been concerned with isolating and ordering the elements of painting themselves. He looked at late Degas, Seurat, Gauguin, and above all, Van Gogh, meanwhile reading anything he could find on the theory of color and the geometry of design. His work became increasingly formal. He had made a long series of pastels and paintings of a view over a railway cutting not far from where he lived in which the observed data provided little more than an armature for his flat color combinations. He realized that these works were not saying enough about what he saw. The specificity of place had been refined away. At the same time, vestiges of representation were preventing the painting from coming into its own on its own terms. Abstraction from appearances seemed inevitably to attenuate the meaning of those appearances. He began to see that there was the possibility of working in the opposite direction – not distilling simple forms from complex data but starting with simple elements and working towards com-

plexity through a constructive process. This was unknown territory to him, only vaguely apprehended; but its offer was convincing.

There was no Museum of Modern Art in London, no Peggy Guggenheim, no Katherine Drier. There was remarkably little interest or sympathy for abstract art which many people thought of as an historical experiment which had largely been played out – this in spite of Ben Nicholson, or the fact that Mondrian and Gabo had been working in England only a few years earlier. Kenneth Martin and a small group which included Mary Martin, Victor Pasmore, Robert Adams, Anthony Hill, and Adrian Heath began to work together, putting on group shows and publishing statements. Their activities aroused a good deal of notice, mainly because of Victor Pasmore. His recent painting, exquisite landscapes and interiors in which both Whistler and Bonnard gave nourishment to an extraordinary lyrical talent, had become the object of considerable vogue. Pasmore's move into abstraction led him, for a while, to give up painting altogether. This was regarded by many of his admirers as a betrayal and aroused a good deal of bad feeling. Kenneth Martin had less to lose at that time. All the same, he knew that he was cutting himself off from many long-standing connections.

He now embarked on an extended search for information, reading whatever he could find in science and mathematics, his knowledge of which was limited in a technical sense but for whose concepts he had an infinite appetite. He spent long hours in the Science Museum and its library at South Kensington, studying the three-dimensional models of mathematical formulae and reading of the new geometries, and, in the Natural History Museum, exploring the morphologies he had found discussed in the pages of D'Arcy Thompson. To some extent his guide in these explorations

was Paul Klee whose theoretical writings Kenneth Martin admired. In particular, Klee had shown him the importance of process and had opened up a range of formative principles which had freed him from apprenticeship to the *look* of existing abstract art. From now on he was to work from the process to the object, from the forming to the form, never the other way round. This meant to work with simple elements, additively. The simplest beginnings yielded a rich repertoire in which number, sequence, interval, and rhythm could be considered in isolation and in relation to a general principle. The work grew as a sum of all the decisions made along the line of that principle; neither aiming at a look nor responding to the schemata of art, hackneyed or otherwise.

The range of Kenneth Martin's search for "hard" determinants in his art tells us a great deal about him. It has never been enough for him merely to think of his art within the context of the art world. He has always needed to look for broader connections. His work is, in a sense, philosophical. This is the scale of the value that he places on the constructive idea. We can sense this in his writing which is essentially pedagogical. When, as he often does, he writes about "the constructive artist" in the third person, we know that he is referring not only to himself but also to an ideal exemplar who stands for a wide cultural responsibility and to whom he, Martin, owes allegiance. Constructive art is a high and ambitious commitment.

Unlike Mondrian, he did not try to persuade himself that the new way announced Utopia. For him it promised even closer access to the world as it was. Nor did the new preoccupation cut him off from earlier art: just as he began to see nature with a new precision and a deeper meaning, so he rediscovered features in Signorelli, Titian, Leonardo, de Hooch, Rembrandt, and a host of other painters which per-

suaded him that his new insights connected with perennial concerns in the tradition of art. His first abstract painting was made in 1948. Soon he was working in three dimensions, using wire, wood, and cut metal. He had to teach himself the basic techniques of soldering, brazing, welding, and turning. The move into workshop materials was shared by Mary Martin, Pasmore, and later by Hill. The rationale for it was to be found in the history of Russian constructivism and in the immediate influence of the writings of Charles Biederman and the work of Vantongerloo with whom they were in personal contact. Theory apart, there was a strong pragmatic reason, namely, the need to cut himself away from the illusionism inherent in painting and to assert the new objectness of his work. Cutting, bending, joining, he was discovering *as a painter* the sculptor's special contact with the real. Throughout the 1950s and 1960s his main effort was in three dimensions, and although he has always insisted on the unity of his work in all its aspects, it was as a sculptor that he became known internationally. More recently painting and drawing have again taken first place in his work; but this is in no way a departure from a line of thought which started with his first mobile.

This was made in 1951. It was an event of great importance in the development of his ideas, not only because of the rich possibilities of a form unfolding in space and time but because of the simple necessities of its construction. Real materials, the actual behavior of joints, hinges, points of articulation, gravity, wind, light: all entered his work now as formative agents. To the painter-become-sculptor the limitations inherent in three dimensions have a special excitement. On paper a line can be pushed in any direction. A wooden dowel could only do certain things. It was limited by its physical nature. This limitation became a source of energy:

Each work can grow outwards by proportion, like a tree repeating its form, or a bridge arriving at a final and complete form.... Proportion becomes functional again ... not as an academic principle or a beautifier, but capable of rendering precise ideas and of assisting in the development of new ideas.

Since then each new departure has been both formative and questioning: "concept and material go hand in hand. Material can inspire – concept dictate material – material qualify concept." The fact that the first three-dimensional works were mobiles and introduced at one stroke certain mechanical necessities, as well as the real elements of light and shadow, gravity, and time, precipitated him into a new world in which, it must have seemed, there was no limit to the discoveries waiting to be made. Above all there was the power of the organic process itself, leading from the simplest beginnings to results of unimaginable complexity:

I believe that this is fundamental to the constructivist idea. That the work is the product of the simplest actions. It is not a reduction to a simple form of a complex scene before us, it is the building by simple events of an expressive whole. Our tools are like the notes on the piano. We can start with a simple sequence, we can order it according to one or two simple rules, the result can be like a fugue. That rests with the artist.

The first mobiles were made of series of rods, each of which was suspended horizontally from the one above. They swung freely within limited but fluid combinations of orbits, sometimes stretching far, sometimes closing up tightly. In spite of the simplicity of their construction, they offered complex readings which became further elaborated when

he began to attach metal discs to the ends of the rods, some colored, some mirrored. Then there was a further series called *Linkages* in which both ends of the horizontals were suspended, giving a cranking and opening and shutting motion of great beauty.

In 1953 he began to explore a new form which he called the *Screw Mobile*. In its simplest form this is a vertical metal rod with horizontal bars brazed to it at regular intervals. When it spins, the eye sees a solid of revolution with a changing kinetic contour. Every aspect of these spiral forms could be seen as subject to separate, clear-cut decision: the length of each horizontal, the width of the material it was made of, the angle at which it was set in relation to its neighbor, the direction of the spiral, clockwise or anticlockwise, the distance between each piece. Working with this limited number of variables he could invent an ordering system – the rules of a game which he would "play out" to its conclusion on the drawing board. The drawing would act as a template for the mobile which would grow from it. Later forms of the series are made more complex by the addition of further elements to the ends of the horizontals, thus introducing a counterpoint of spiral themes.

The invention of these spiral mobiles was of crucial importance in his development and much of his later thinking is due to them. It was by far the richest, most complex form that he had made. The form was pregnant: each version revealed its own special identity, its own kind of life. Something happened here which was paradoxical, mysterious, and stirring – yet it was the outcome of a train of thought that was not in itself addressed to paradox, mystery, or emotion.

The form itself could be considered as perfect, totally consistent within its own laws yet potentially infinite. Each aspect of its movement was distinct and evoked its own

special range of feeling. Downward, the spiral will bore swiftly, like an auger, joining its energy with gravity. Its upward movements soar, flicker with sudden changes of tempo, pirouette weightlessly as if defying gravity. But it is above all in the discrepancy between the stationary form and the moving form that the content of these works seems finally to lie. Contemplating the relationship between what can be understood about the thing as a structure and what can be perceived as a phenomenon, we are brought into a state of peculiar awareness. The still form is the logical product of an additive process, not always so simple but at least capable of rational analysis. The perceived character of the work, from its existence as a swept volume existing only in perceived time, to such surprising details as the play of light up and down its brass surface and the waxing and waning of its shadow – all this takes on the quality of a prodigal florescence out from the bare and disciplined idea of its making.

The spiral form is both closed and open, finite and endless. Recognizing its symbolic force, Kenneth Martin was to write about it as one of the "…primary attributes of nature used by artists from remote times to the present to express their position in and attitude towards the universe." The spiral symbolizes "dynamic and aspirational forces" and everything that is beyond comprehension, just as the crystalline stands for perfection, "the very refinement of order from which deviations are errors." But he is no longer concerned with formal perfection, rather with a forming process which itself corresponds with his view of life. "Life is variable and inevitable, recurrent and developable. For the individual it is essentially tragic." And:

> The work of art is never only a series of pure relationships; it is related to life. We may observe this immedi-

ately and directly through parallels with nature and with our own make-up. But it may go deeper, to dig things out of us. It is these correspondences which are important, which words can only express through poetry, which Mozart understood in music. These direct relationships of the physical and the spiritual within us.

The first linked and reflector mobiles had been ordered in their structure but open to chance in their movements. Currents of air, the touch of a hand, would produce a continuous and unpredictable unfolding of form. Martin became increasingly interested in indeterminacy and in the framework within which variations could be given free range. About 1965 he began working on a long series of structures which could be adjusted by the onlooker: the *Transformables* (1966), *Rotary Rings* (1967), the *Variable Screws* (1967–74) and the *Standing Linkage* (1970). In all these the onlooker could manipulate the piece himself, altering its relationships, and, in so doing, not merely discover his preferred arrangement but the ordering principles according to which it was made. The variable mobiles had a threaded central axis which allowed for the adjustment of the elements of the mobile; this meant that the participant became involved in balancing it and hence in the forming role of gravity.

This was the theory at any rate. Reflecting on it in a long paper published in *Leonardo*, Kenneth Martin expressed reservations about the level of response that he could expect from this:

> But on the other hand, is the search for the one and only solution, for the finite rightness of each part to the whole, the most important task…? The kinetic artist is interested primarily in work whose realness is expressed through change as movement.

The realness of the work, in fact, was experienced in the deep structure of the piece and this only became clear through the playing out of its endless surface variations.

The issue of indeterminacy within an exact conceptual framework was taken further in the long series of drawings, paintings, and prints called *Chance and Order* which has occupied much of Kenneth Martin's attention during the past nine years. In the simplest versions, a grid is set up on paper and its points numbered. Corresponding numbers are then drawn by lot in pairs. Each pair then becomes a line on the grid. Obviously no two drawings are the same, although the underlying structure remains the same in each sequence. It is as though that obscure dialogue which accompanies all art, between the idea and the object, is itself conceptualized and brought into clear focus. Each work can be seen as a single state isolated in a stream of possible states, both an example and a unique resting place.

I have emphasized the conceptual and systematic side of Martin's work for obvious reasons. I must now insist that he is no dispassionate ideologue. On the contrary, his search for order has intensity precisely because he is no stranger to its opposite. He knows as much about doubt and anxiety as anyone and a good deal more about wildness and amazement than most. His internal campaign against "the arty" and the cult of self has been waged so fiercely and for so long, not out of any rejection of life and imagination, but because it seemed to him that the latter-day romanticism on which so many of the assumptions of modern art are based is a betrayal of those very things. And the same is true of his dismissal of avant-gardism, of modernist historicism. The modern movement is heroic to him and not to be reduced to fashion. He has been at odds with fashion for most of his life and I doubt that he would be convinced of fashion's good sense if fashion suddenly went his way.

The importance of system to him is that it is precisely a framework for clear either/or decisions, for engagement with materials, for boredom and hence for play, and the darting, restless imagination, perversity, the ebb and flow of energy, curiosity, delight. Just as play mirrors life symbolically, so the ground for play in art symbolizes the artist's moral stance toward the world and his psycho-physical makeup. His delineation of that ground for play will be achieved through his own honesty and the awareness with which he relates himself to the world.

225

Kenneth Martin's sensitivity to and delight in his surroundings is extraordinary. To be with him anywhere – at the window of a train, in a Gothic cathedral, crossing a square or a busy street – is to be drawn into an endless adventure. Everything has to be counted, matched, compared, likened, contrasted; every change of scale, of incline, of surface, every opening or closure, every shift has to be explored. His eye is always looking for pathways, for varieties, and families of movement. He is strongly aware of how the body's feeling for wholeness and its own articulation projects itself into the outside world; and how the outside speaks back to us and finds its lodgment in our bodies. He finds architecture everywhere. He has described some of his works as "an architecture in epitome," thus warning us against seeing them as maquettes or models.

> Seeing the Maison Carré at Nimes or the Frauenkirche at Nürnberg for the first time I feel as if I could pick them up and put them in my pocket. Scale, that of the parts to the whole, of the whole to the environment and to oneself, speaks to one. It is not necessary always to be formidable.

And:

226

In the work of art scale is more important than size....
Things themselves, their relationships together and that
of the parts, are all related to us, to the different parts of
our senses. The touch of the palm is different from that
of the fingers, while the eye can explore both near and
far.... Miniaturization can hold the attention as much
as the large edifice – similarly and differently.... We are
not satisfied with the open stare but need the inquisitive
look as well. On the large desolate plain one looks for a
point of interest. The eye can go where the touch cannot
and can adjust itself to a new scale.

Art International
April / May 1978

THE PAINTINGS IN this exhibition are not typical of Helen Frankenthaler's work as a whole. Most of her work is very large indeed, and its character and meaning are closely connected with its size. With most painters, small works are likely to be studies or sketches or preliminary notes for large ones, but this is not exactly the case here. These paintings were generally made for their own sakes, and they demand to be looked at on their own terms. But in order to be clear what those terms are, I find that I must try to describe and comment on some of the characteristics of the large paintings – the work on which her style and reputation is founded.

From the mid-1950s onwards her work has proceeded from an extremely direct collaboration with the materials she is working with, that is, with the canvas itself and with the paint itself. The texture and presence of the canvas is never lost but remains an active constituent of the picture. So also paint is never allowed to give up its texture to color alone but preserves its fluidity, its transparency, its flow. The physical conditions of the studio become part of the picture itself. The canvas – it is in fact a fine, unbleached, unprimed cotton duck that she uses – is rolled out onto the studio floor in quantity. A first color move is made; paint floods out onto the canvas, transforming its emptiness, making a unique place out of a hitherto undifferentiated area. Each movement of color is like an event, evoking further

responses, further colors, further articulations of the space that is being made. Chords of color become more complex and more resonant as she elaborates. All this happens on a grand scale, using the reach of her whole body and involving swift movements from side to side and a continual circling and tracking of the periphery of the canvas as if around a cave or a pool. The painting does not develop towards a known or a knowable goal, for each of its stages is an open situation from which no fixed conclusions can be drawn. The artist is not mastering or overwhelming the canvas, but rather guiding, reflecting, coaxing, responding. The dominant moods are of wonder and celebration.

Frankenthaler arrived at this way of working as the result of an extremely precocious understanding of what had been happening in American painting while she had been growing up. Her student training as a painter had made her familiar with Cubism and other aspects of recent European art. When she began to look at contemporary American painting, and at Pollock in particular, she saw that something had been broken open, some mold had been cracked, and a new freedom claimed. Her first encounter with Jackson Pollock's painting, an encounter which was to mean so much to her later development, happened in 1951 when Pollock was showing an important group of new paintings at Betty Parsons's gallery. Barbara Rose's description, based on conversations with the artist, gives a wonderful sense of the excitement of the discovery:

> She recalls feeling as if she were "in the center ring of Madison Square Garden." She sensed the extraordinary physical impact of these paintings, the manner in which they appeared to surround the viewer, establishing a more intimate and direct contact between image and

spectator than previous paintings. She knew at once that this was where one had to begin: "It was as if I suddenly went to a foreign country but didn't know the language, but had read enough and had a passionate interest, and was eager to live there. I wanted to live in this land; I had to live there and master the language."

229

What she was able to see with a clarity that few others could muster was that Pollock's achievement, from the point of view of painting generally, was not its expressionist attack but its openness. By working on unstretched canvas on the floor and by interrupting the age-old messages of hand, brush, and surface, he had found not so much a new look as a new place from which to work. No longer to be constrained to confront the canvas against a wall, no longer to stroke or harrow its surface with brush or knife; no longer to wrestle plasticity out of impasto – these were some of the releases he offered. Technical freedom was a powerful symbol for other freedoms – freedoms from the dominion of European taste, from the pressures of European art history, and by extension, from history itself; for whatever else its content, Pollock's painting celebrates as no painting had done before, the here and now.

"On the floor," he had said in a much quoted statement, "I am more at ease. I feel nearer, more a part of the paint- ing, since in this way I can walk around it, work from the four sides, and literally be *in* the painting." This sense of being in the painting depended upon a continual con- tact with it, but a contact of a novel kind – not the tactile, inch-by-inch contact of the brush but something more extended, more athletic. "When I am in my painting, I'm not aware of what I am doing. It is only after a sort of 'get

acquainted' period that I see what I have been about. I have no fears about making changes, destroying the image, etc. because the painting has a life of its own. I try to let it come through. It is only when I lose contact with the painting that the result is a mess. Otherwise there is pure harmony, an easy give and take ..."

The fantasy that the work in hand has a life of its own is as old as the myth of Pygmalion. In representational art it is likely to be focused upon the figures depicted, or, by extension, to the features of the world they occupy. In abstract art this fantasy is likely to become more generalized in one sense, but in another to become more precisely attached to the properties of the painting in their physical actuality; to its shape and size and flatness, to colors and their interaction, to the dynamics of their arrangement and so on, all of which exert a pressure or persuasion on the artist even as he or she is manipulating them, mastering them, shifting them around. Pollock's "easy give and take" implies a condition of dialogue in which painter and painting are joined and act on each other in a series of exchanges that end only when *neither* side has anything more to say.

Nor is this sense of the life of the painting a private affair. Somehow it communicates itself, and indeed this is one of the powerful and engaging features of Frankenthaler's work, that we are drawn into the processes, the decisions, the responses to weight and density, to the speed of a direction or the almost palpable pressure of a color area, forward or back, up or down, *accellerando* or *rallentando*. Her work is wonderfully open in this regard, wonderfully candid; the actuality of her engagement with canvas is explicit in everything she does. But not – and this is an important qualification – not in terms that are expressionistic, bullying or invoking pathos. What is exposed and shared is nearer to

the detached, concentrated joy of an athlete. For the canvas, flat on the floor, unstretched like a sail or carpet is indeed a place. She has to walk around it, crouch over it, and her perception of it is as shifting as our perception of a room shifts as we walk around in it. To span it, to occupy it with her marks means that paint and canvas have to be treated with honor.

Now it is obvious that not all the features I have been describing find a place in the small pictures in this exhibition. Athletic give-and-take insists on an arena of at least body size. The kind of moves and responses out of which the large paintings are built are here miniaturized and reduced to inches. Some of the consequences are surprising and much more complex than one might expect. The small paintings do not lack grandeur; on the contrary, the best of them are massive. But their massiveness is, so to speak, remote. We are not drawn into them in the same way but rather read them as complete structures seen at a distance.

The contrast between the two modes of Frankenthaler's painting, large and small, causes one to reflect upon another aspect of her work, namely the way she uses color. From the mid-fifties onwards this has been an area of intense experiment. She is one of the most inventive colorists of our time. She turned to the exploration of color at a moment when few New York painters apart from Rothko were giving it much consideration. They had other priorities. Their mood was somber, crisis-ridden. Frankenthaler's insight into the new openness of painting led her to question long-standing prohibitions. During the years after she had begun confidently to flow transparent paint, letting its stain and soak the absorbent canvas, each painting became a triumphant flowering of color. She uses color with a perfect judgment, quite undogmatically, and with a wide range of mood. Her chords are always unpredictable. She allows for unexpected

associations of pure, spectrum color with earth colors or nameless mixtures which if used differently would have the value of gray. She challenges orthodoxy by bringing back into painting the pretty colors of rococo decoration, or of an impressionist orchard – pinks, lilacs, pale oranges, and limes – but energized and given new meaning.

Here again is a major difference between the small paintings and their large counterparts. It is a fact that the way a particular color affects us is a matter of its area as much as its hue or saturation. We are, so to speak, enveloped by a large area of color, and this is even more the case when that color is transparent and filmy and does not offer an unambiguous surface to the eye. I have already spoken of her collaboration with paint and canvas; the quality of this collaboration is nowhere more evident than in the way in which she will allow the raw canvas to act not only as support for the color but as a positive agent in the color structure of the painting, present as a source of light in each area of color and often bare and untouched as a color area in its own right. This feature recalls the role of the paper in pure watercolor technique which she is, in a sense, rehearsing on a monumental scale.

The earliest paintings in this exhibition were made when she was a student at Bennington. She was then working with the painter Paul Feeley who was teaching there. She has described the highly disciplined attention that he brought to the various styles of recent European art and to Cubism in particular. These early paintings, one a tight-knit cubist composition, the other a dark and somewhat expressionist still life, both show how closely she had looked at these examples and how well she had understood them. They are of course easel pictures, like their models. So are certain early landscapes – the very beautiful *Provincetown Bay* made during her first summer out of college, and a mys-

terious little line of trees some years later, both of which we can assume were painted in particular locations. The crucial break in her work comes in 1952 when after an intensive season of landscape painting she made her first large unbrushed painting on raw canvas. This was the seminal *Mountains and Sea*, now hanging in the Metropolitan Museum in New York. From now on the colors and shapes which she finds on the canvas will determine the content of the painting, not the other way round. There are many canvases here which have the appearance of footnotes or cadenzas to the themes of the larger works. Some, particularly of the late sixties, have the appearance of fragments of larger paintings, isolated and given a new focus through a shift of scale. These remind us that her procedure with the large paintings inevitably involves cropping – that is, that the edges of her pictures are not always a feature which is given from the outset but are found at some point in the making. In others, it seems as if the support itself had issued a special invitation – a fragile piece of rag, an offcut of linen, or one of those miniature canvases that can be bought over the counter. Many are in the form of intimate messages to friends. Then there are some which are indeed models for larger works – for example the outstandingly beautiful series of squares with which the exhibition ends – but these are more in the nature of meditations on a problem than literal models, for it is simply not in the nature of her art for an idea to be capable of transfer from one size or medium to another. Every new work is a new beginning.

Looking over the whole series, which spans over twenty-five years and mirrors her large œuvre in miniature, one might cast about for a unifying theme. The total impression is of extraordinary consistency, and yet the nature of this consistency is elusive. What finally is she painting? There are certain consistent schemata, of course, particularly in the

form of a wide-stretched, lateral sweep with intimations of shore-line and sky; there are sudden eruptions of quite violent forms like jagged brooches which stand out in contrast to the more generally lyrical and enveloping mood. And there is everywhere a predilection for transparency, for nuances of depth, for the oceanic. But none of these themes seem to be willed. She allows a generous role for chance and for the "life of the painting." Her decisions are sharp and incisive and inimitable, but they are made within the existing world of the painting rather than imposed upon it. The will is like a light, crisp touch on the rudder rather than the insistent driving of an engine. It is the beauty of sailing we are dealing with, not of power boats.

Her painting could be described as an art of pure sensibility – if it were not for the mysterious but unmistakable life that exists in each picture. Something is at work here at a far deeper and more demanding level than mere pictorial taste. I find myself returning to the idea of collaboration and to the fantasy that the picture has a life of its own. Collaboration in the sense I have been using it means much more than skill or a tasteful and sympathetic understanding of the materials: it means an ability to introject, to enter with the materials, to feel that each color or conjunction has a specific spark of life in it. What grows from this is the feeling that the picture "needs" this or "wants" that, as though it were alive and had its own appetites, its own rights to breathe and move and equally its own possibility of "death." What does this fantasy imply? It is simply the best way one can find of describing a state of mind which is so elusive and so condensed that words can only offer crude models for it. But if one were to try to spell it out in a more extended form, putting words into the mouth of the artist, it might be: "As I work, I attend so closely to the face of the painting in front of me that I lose sight of the boundaries between me and it.

When I see something that I have done to it, it is like a clue to further things I might do – it amplifies my intention. Trains of thought and feeling are set in motion which I have to complete, or at least, explore, and the impulse to do so is such that I cannot distinguish between what is interior to me and what is out there on the canvas. Naturally I attribute these desires to the painting rather than to myself, for it is only in the painting that they have concrete or stable existence, and the painting is the only means I have of either being aware of them or of acting upon them."

The transaction which I have imagined here – part argument and part reverie – seems to be carried through with extraordinary candor on Frankenthaler's part. It is unhindered by dogma, by an overdetermined theory of painting or by an allegiance to a particular image. What appears on the face of the painting is totally personalized. The broad unexpected forms, the slow turns in space, the sonorous spread of color, the sudden tightening of accents, closures, all are the material of her reverie and her action. Nothing is concealed.

Jack Tworkov's Geometrical Paintings

Catalogue essay to an exhibition: "Jack Tworkov:
Paintings 1950–1978"
Third Eye Centre, Glasgow
May 18–June 17, 1979

IN THE MID-1960S Jack Tworkov began to paint geometrical pictures that seemed to contradict everything that had gone before in his work. What was happening? Was this a conversion, like Mondrian's, to a new and exclusive philosophy of art? Was it something like Pissarro's shift to neo-Impressionism, the sudden persuasion of an older artist by the outlook of a new generation?

The change was far-reaching. Hardly a single feature of his earlier style survived. Carefully ruled lines, measured intervals, neatly filled-in areas took the place of broad, fast, free-hand drawing with a heavily loaded brush. Saturated colors and extreme values gave way to pale uncontrasted grays. Heavily worked and worried surfaces, with their history of studio hours and studio moods, were replaced by a decorous, dry fracture that tells us nothing except that first this was done, then that, then that. Perhaps most crucially, there was a move away from any form of suggestiveness. The abstract expressionist pictures had always offered a multiplicity of readings through which places and presences, nature and eros, were to be discovered lurking behind the material facts of brushmark and pigment. The geometrical paintings are the most completely non-figurative that he has ever done. They can be seen only as

what they are: geometrical structures filled-in in a certain way.

It is always more dangerous to try to interpret a dramatic shift of this kind, however tentatively, than a more gradual one. It implies violence, and that in turn implies a certain split in the artist's previous relation to his work. One searches the earlier work for signs of tension, for the contradictions that were later to become unbearable. The subject matter of abstract art is finally to be defined in terms of how the artist makes up his mind, the givens that he works with, the hierarchies that he sets up for himself. These questions spread beyond the immediate issues of style. They bear upon the artist's view of human behavior in the world. Tworkov's shift was precisely the result of a changed view of creativity in which he turned away from an exaggerated subjectivism that he no longer believed in and towards a situation where the impersonal structures of number and measurement could be worked with as givens.

The most articulate of artists, Tworkov has from time to time published his reflections on painting. In some of his statements of the late fifties we can follow the process of self-criticism that ended in his change of style. In a statement written for an exhibition at the Stable Gallery in 1957 he declared "My hope is to confront the picture without a ready technique or a prepared attitude – a condition which is never attainable." The faith of a whole community of artists was invested in this impossible goal. The kind of innocence, the unstructured sensibility that such a goal demanded was, of course, a myth. Awareness was awareness of one's knowledge, of one's non-innocence; yet awareness insisted on the pursuit of innocence and the playing out of a game that had to be lost. When Tworkov changed, he was purging himself of the sweet poison of a double bind.

Already his notes, published in *It Is* a year after the Stable

Gallery show, record his misgivings. The demand for inno-
cence, he wrote, was itself preconception that closed off cer-
tain possibilities:

238 "There is no conscious device for springing open the door
to the unconscious. This happens, if it happens at all, through
simple absorption in the work, through a simple yielding up
of the urgings of one's mind to un-ambitiousness, to un-self-
consciousness through self-acceptance." One begins to feel his
unease and his doubts about how clearly his generation –
and he himself – had been looking at what it meant to try to
paint. For one thing, the aim of self-definition could only be
conceived within the community of painters. An artist's
originality could only be seen as such among artists.

"The artist who acts as if he could have conceived his art
by himself, sealed off from other artists, is stupid – he
merely tries to conform to the idiotic romantic image of the
artists as primeval energy, as a demiurge. The continual
interaction of ideas among artists is the very condition for
the existence of an artist. There could no more be one artist
than there could be one man." And he concludes that an art-
ist "ought perhaps to acknowledge that all outside ideas are
really part of him. He ought to accept the others as facts of
himself.... Instead of being in a constant state of anxiety, he
can be in a constant state of absorption."

Absorption means so complete a surrender to the work
in hand that the self, far from being an inflated object of
attention, becomes lost to view in the work. Geometry and
measurement make their entrance on these terms.

A motif in much of his painting in the 1950s was a kind
of fence or thicket of parallel brush strokes, bent or forced
over to the right as if under tremendous pressure. Some-
times, as in *Barrier No. 5*, this motif will be opened up so that
we see through what appears to be the mesh of a vast net,
pulled or driven out of true. Seeing these paintings again it

strikes me that one is aware of a geometrical element, a soft geometry that is both responsive and opposed to other forces in the painting, the violent brushing, the improvised surface, the worried course of the painting. There is an atmosphere of struggle – the beating of energy against form, contradiction, springing back, renewed pressure – an atmosphere of difficulty in which the possibility of resolution is continually questioned. The mood is irritable, doubtful, effortful.

What happens later is like moving into the calm waters of a harbor. Geometry comes into its own because those anxious, stormy energies are put to rest. It can be seen now on its own terms, free-standing. What this change amounts to is nothing less than a change of thought about who and what an artist needs to be doing. Is existential anxiety the only mood in which authenticity can be achieved? No, and if I find myself *absorbed* in other moods, why should I pretend otherwise. Is alienation the only possible creative posture? Not if I find myself *absorbed* in "outside ideas," material which is common to the whole of mankind.

This is not the place to review all the many meanings and values that geometry has acquired in art. Obviously Tworkov is not using it symbolically as it was used in the Christian-Neoplatonic tradition. Nor is he using it as an aesthetic gloss, a guide to pictorial decorum, as it was its fate to be used in the academies. Nor yet is he using it, as Klee and others have, as an order of growth. His love for it is evident, yet he makes no special claim for it either as an aesthetic canon nor as the vehicle for ideas outside painting. Unlike some European Constructivists, he is modest about his mathematics. His geometry is likely to be no more than a simple armature of parallel lines derived from proportional divisions of the canvas, and their diagonals. One important group of paintings is based on a grid of eight

squares by eight on which the Knight's move – two along and one to the side – is plotted till it can go no further. In a more recent series, a square is quartered. The two outer sides of one of these quarters are cut at the Golden Mean, so that the smaller divisions are to the larger as the larger is to the whole. This provides a framework on which various diagonals are drawn, crossing to the vertical-horizontal divisions and making an open mesh of shapes – triangles, quadrilaterals, and irregular pentagons – from which he chooses the constituents of an image. He uses different colors to isolate or group different shapes found here, running some together, overlapping others, but treating them in a spare, understated way so that the working that produced them is always evident. They are as bare as paintings can be. We have nothing to look at except what was done, what choices were made. The ruled lines are intact on the surface. The thin paint is simply a regularly brushed infilling. The surface is as open and explicit as simple carpentry, and as accessible.

We recognize geometry as a given fact; we enter it without *parti pris*. It is utterly neutral, and one supposes that it is precisely this neutrality, this self-evident consistency that is valuable to him. He puts us all on the same level in front of these canvases, as if we were all cousins to that slave of Socrates who, in that beautiful story, was called in to prove the self-evident truth of a geometrical theorem.

From a book of the same name by Andrew Forge
The Florin Press
1985

NAUM GABO HAS A special place in the story of modern art. He exemplifies more clearly than any other artist the ideals, the optimistic vision of the future – so easily dismissed as Utopian – that were at the very root of the great experiment of the modern movement. He was a witness of those extraordinary events in Russia when for a short while artists believed themselves to be in step with the movement of society. He chose to remove himself when the time came, but this was so that he could remain true to his original convictions. He held his art to an unswerving course.

His development has an extraordinary purity. Largely thwarted in his life-long ambition to build public works on an environmental scale, he worked to the end of his life as if that ambition were an open possibility. It is as if exile, neglect, shifts of fashion, or disappointment had no power at all to dilute his energy or deflect the development of his thought, but on the contrary, could only intensify them. He is like an exemplar of that paradoxical injunction of Auden's that we should live each day as if we were immortal. His work has a unique relationship to time, remote somehow from the days and months of existence; yet it is altogether human. It gives a new meaning to the concept of classicism.

Naum Neemia Pevsner was born in Bryansk, Russia in

1890 – the last moment at which he could have known, as an adult, the conditions of pre-war Europe. He had four brothers and two sisters who survived infancy. One of his brothers, Anton, was a painter, only to be known as a sculptor many years later. His father, who owned a factory and metal foundry, had insisted that one artist in the family was enough and had sent Naum to Munich to study medicine. He arrived in the Bavarian capital in 1910. Before long he transferred his attention from medicine to the natural sciences and to engineering. Meanwhile, the ambition to do sculpture was beginning to form.

Munich was one of the main centers in Europe of experiment in the arts. Kandinsky had been there for many years and had made a formidable reputation as a painter, a philosopher of modern art, and as an organizer of dissident artists. His *On the Spiritual in Art* had been published in 1911. The *Blaue Reiter Almanach* appeared the following year.

Gabo knew his older compatriot and was aware of the activity that surrounded him. He was attending the lectures in art history of Heinrich Wölfflin, and encouraged by Wölfflin had made a walking tour of Italy, visiting Florence and Venice. He made several visits to Paris where his brother, now known as Antoine Pevsner, was working and saw the work of the cubists there.

Meanwhile he was absorbed by his studies in science; his imagination fired by the intellectual daring of the new work in physics. Einstein was being discussed by his teachers. Classical ideas of space and time were being displaced, and new modes of description were being developed that expressed their relatedness. The concept of mass, of the solidity of things, was in transformation, and even the atom itself had to be defined in terms of energy. Gabo's growing ambition towards sculpture had to take all this into account: "It had to be a totally different sculpture," he said in an interview years later,

"And it had to express a new way of looking at the universe."

At the outbreak of war, his father sent him money and instructions to wait things out in a neutral country. His youngest brother, Alexei, was to join him. The brothers travelled through Scandinavia, settling in Oslo where Anton joined them from Paris. It was here that Naum finally began to work as a sculptor, adopting the name Gabo.

His background in physics and engineering encouraged him to think of form as a dynamic structure rather than as a solid mass. He began to experiment with small stereometric cubes made from the intersection of two planes. The cube is postulated as an opening in space rather than stated as a closed form to be looked at from the outside. The eye could penetrate it and occupy it imaginatively.

He was using little pieces of cardboard, plywood, and sheet metal. He began to apply his thoughts about stereometric structure to the human head. The works that resulted are extraordinarily precocious. It is as though a fully-fledged artistic personality appears from nowhere – there is no body of student work, no apprenticeship to a revered model, just these fully considered and original pieces. The long incubation culminates in a formidable act of will that produces immediate and decisive results.

The conception of the head derives of course from cubist painting, and above all the cubist theme of transparency and the interpenetration of solid and void. Cubist sculpture had grappled with this somewhat clumsily. Picasso, Boccioni, and above all Archipenko, with whom Antoine Pevsner had for long been on friendly terms, had all attacked the idea of the sculptural mass opened up to space. But merely to name them is to bring out the specific character of what Gabo was doing. As George Heard Hamilton has written in an illuminating comparison between the Gabo heads and the Picassos of 1909 and 1910:

There is no trace of portraiture, such as is still evident in Picasso's pictures, and the ponderous mass of Picasso's bronze *Head* of 1909 has been abolished. Gabo's heads were composed of small separate spaces defined by the edges of planes, rather than by a single even if fractured mass enclosed by impenetrable surfaces. Space, rather than substance, was and remains his primary material.

He was soon using materials that were then unconventional in sculpture: glass, celluloid, mica. All his life he was to be interested in the development of synthetic materials, and the new transparent plastics that began to appear in the thirties found an immediate and formative place with him. Transparency was a key quality in his work which was always to be concerned with form as organization rather than as mass.

When news came of the February Revolution, the brothers lost little time in returning to Russia. The first years of the twentieth century had been a period of furious artistic experiment in Russia. Everything that had been happening in Munich, Milan, or Paris had been eagerly absorbed and reinterpreted. It was in the grain of the Russian attitude towards art to respond to it as a social statement: the autonomy of *l'art pour l'art* was no more acceptable to the Russian avant-garde than it had been to Tolstoy or Dostoievsky. Everything experimental in the arts was read as a critique of the status quo. The primitivistic element in Matisse and Picasso implied a rejection of traditional Western culture. Futurism had a special relevance in a country that, like Italy, was aware of its technical backwardness. The appeal of the Futurist Manifesto to the machine, to speed, to a life of the future shaped by technology, to the experience of city life, aroused a profound response among artists and poets of the left for whom its polemical anger at the past had a special meaning.

A remarkably numerous and gifted generation of artists, inspired with tremendous energy and, it seems, intuitively aware of the vast social changes that lay ahead, had made the equation between their art and the experience of their time. They responded passionately to the revolution when it came, whether they were Bolshevik or not. For a brief period it seemed that the ideological content of experimental art and the social inspirations of the time were in phase; perhaps the new art was to correspond with, even to contribute to the new society. It was a view that received qualified support from a few of the Bolshevik leaders, from Trotsky and most significantly from the new Commissar of Education, Lunacharsky, a sophisticated and cultivated man who had been in exile in Paris and had kept abreast of artistic events in the West.

Meanwhile, many older artists and those working in a conservative vein drew back from events. Their time was to come again under Stalin. The experimental artists took advantage of every opening that presented itself to proclaim their version of a new society, staging demonstrations in the streets, issuing manifestos, involving themselves in the tasks of public information. Under Lunacharsky the old Academies of Art and Architecture and the School of Applied Art in Moscow were amalgamated and given a new identity under the title Vkhutemas (Higher Technical-Artistic Studios). Many of the most radical artists were given teaching studios including Malevich, Tatlin, Rozanova – and Antoine Pevsner. Gabo, it appears, was offered a studio from which to teach sculpture and ceramics. He declined the offer, but played an informal role in the affairs of the school.

Recalling those days, Gabo was to say of the Vkhutemas:

It was both a school and a free academy where not only the current teaching of special professions was carried

out, but general discussions were held in open forums and seminars conducted among the students on diverse problems where the public could participate and artists not on the faculty could speak and give lessons.... Many ideological questions between opposing artists in our abstract group were thrashed out, and these gatherings had a much greater influence on the later development of constructive art than all the teaching.

These discussions ranged from the narrow, technical issues to far-reaching speculations about the future of art in a revolutionary society. It is clear that much of the discussions centered on the question: Is art, as it has been defined up to now, irrevocably bourgeois? Does it have to be based on private, subjective experience, and on objects that are unique and precious and to which a metaphysical value has been attributed? If the answer to these questions is yes, then artists who had taken up a Marxist position were bound to search for a new theory of art, founded on "objective" knowledge and on replicable and worthless examples and materialist values.

Kandinsky had been in Russia since 1914. Although he had been invited by the authorities to make plans for art education in the new Republic, he seems to have been somewhat isolated from these discussions. A central figure was Malevich, by far the most significant and influential of the older abstract artists. He had already painted the bulk of his Supremacist canvases by the time the Vkhutemas was set up. He had a following of younger artists, all of whom were painting totally non-representative, geometric canvases. Tatlin, five years older than Gabo, had made his most radical reliefs and corner constructions using untransformed materials in real space. He was now turning to the study of what he called "material culture" and to a concept of art

which would finally eliminate the barrier between the studio and the "real life" of the factory and the street. He also had a numerous and lively following which included Rodchenko, Stepanova, and Popova. They were unanimous in rejecting the idealistic elements in the older artist's position. The "pure" artist was obsolete in their view.

If the formal elements of art were to be explored, it was not to be in the cause of expression but in order better to understand them as factors in design, undertaken from a behaviorist point of view. The new artist must be a technician, capable of using all the tools and materials of modern production and of addressing himself to the needs of society. He must give up "speculation" and above all the fallacy that art is autonomous. Malevich adamantly rejected this, scorning the idea that usefulness could have any bearing on art:

> Do we have the slightest reason to assume that the things which appear useful and convenient to us today will not be obsolete tomorrow...? And shouldn't it give us pause that the oldest works of art are as impressive today in their beauty and spontaneity as they were many thousands of years ago?

Although Gabo was of the same generation as Rodchenko and Lissitzky – that is, a decade younger than Malevich – he remained convinced of the autonomous role of art and of the importance of its philosophical content.

> We were opposed to these political and materialist ideas on art and in particular, against the kind of Nihilism, revived by them from the eighties of the last century. It was this particularly which prompted the appearance of a public credo.

The credo was of course the famous *Realistic Manifesto* which appeared on walls and hoardings in Moscow on August 5, 1920. He had written it himself to coincide with an exhibition of his work and his brother's that they had put up in the open air in one of Moscow's streets. Antoine Pevsner also signed the *Realistic Manifesto*.

It was an epoch of manifestos, declarations, slogans, orders of the day. The artists were no less strident in their rhetoric than the revolutionaries. They had, in any case, the examples of the Futurist manifestos in which not only a new kind of art but also a new form of life had been violently invoked. Furthermore, there was a need to explain and to justify forms of art that all too easily appeared meaningless.

Very many of the pioneers of abstract art had felt compelled to write a great deal, and in the writings of a Kandinsky or a Mondrian one feels often enough that one is witnessing a willed rationalization as if in response to an unspoken reproach – perhaps from the historic past – that an art that does not represent cannot mean anything at all.

It is not easy to read these statements now. Their picture of the future is absurd; and it is painful to think that optimism such as theirs was foolish. The pathos of lost causes gives no solid ground for evaluation. At the same time, the work of these artists endures and has become an ingredient in our culture. Many meanings have accrued. The first rationalizations by which meaning was forcibly injected into abstract forms have been outgrown by our usage of those forms.

Gabo's case, though, is special. Not that his Utopianism was any better founded, but that he argues it. His writing is of intrinsic interest. It is more than mere assertion. The *Manifesto*, on which all his later writing is built, was written under extraordinary circumstances: a confrontation *in extre-*

248

mis with the question: What use is art? In rejecting the "productivist" answer, he did not reject the idea of art as a social force. Even though he held to his idealist position, he did not retreat into romantic solipsism but continued to develop his thoughts on the social responsibilities of art. Nor, in taking up an anti-materialist stance did he reject science or a scientific world view, but continued to grapple with the meaning of science and of art as parallel achievements of the human mind. Somehow both his work and his writing remain of a piece: they augment each other.

The *Manifesto* starts with a call to artists to recognize the unprecedented character of the modern epoch. Science is giving us a completely new view of the world. Can art make an equivalent account? Cubism and Futurism are all that the modern artist has as a guide, but they are of limited value. They have remained tied to a "purely optical reflex which has already shown its bankruptcy with the Impressionists." And as to the Futurist's celebration of modernity, their "arsenal of frenzied automobiles," the scale of their attention is wrong: "Look at a ray of sun ... the stillest of still forces, it speeds more than 300 kilometers in a second ...," and "What are our earthly trains to those hurrying trains of the galaxies?"

He now makes an important statement about the relation of art to time. "No new artistic system will withstand the pressure of a growing new culture until the very foundations of art will be erected on the real laws of life." What this seems to mean is that it is the task of the modern artist to redefine art in such a way that it enjoys a constant relationship with life, rather than a shifting one. Such a relationship would need to be fundamental. The existing relationship is superficial. He calls on artists to agree "all is fiction."

He is invoking the idea of an art that would observe the same necessities as science does in relation to nature. But

250

the artist, like the scientist, is himself part of nature. Until now the polarity of observer and observed had been sustained by a fiction; scientific theory, artistic style, they are all mirages that give an illusory correspondence, a semblance of understanding. Now – and this must be the reason for his title *Realistic Manifesto* – the possibility is open for a closer, more literal, and more truthful relationship between art and the world outside art.

By renouncing representation, art can find this connection in the forms of space and time. Art is no longer to be evaluated on the basis of beauty, sentiment or stylistic association. He conjures up a new kind of artist, disciplined, objective, infinitely ambitious:

> The plumb-line in our hand, eye as precise as a ruler, in a spirit as taut as a compasss … we construct our work as the universe constructs its own, as the engineer constructs his bridges, as the mathematician his formula of the orbits. We know that everything has its essential image: chair, table, lamp, telephone, book, house, man … they are all entire worlds with their own rhythms, their own orbits. That is why we in creating things take away from them the labels of their owners … all accidental and local, leaving only the reality of the constant rhythm of the forces in them.

It is a new kind of artist. But when he begins to define the features of his formal program, it becomes clear that in many respects what he is describing has a long classical pedigree. His five principles are all directed against illusionism and towards a statement of essences.

Color is renounced as accidental and superficial. The reality of a body is in its material. Line is renounced as a descriptive element, for description is an "accidental trace

of man on things, it is not bound up with the essential life and constant structure of the body." But line is affirmed as a direction of force or rhythm. Pictorial volume is renounced and space affirmed as depth. Sculptural mass is renounced in favor of the engineer's concept of strength. Finally static rhythm is renounced – "a thousand-year-old delusion" – in favor of real movement: "kinetic rhythm as the basic feature of our perception of real time."

A document written some months after Gabo's, and possibly in response to it, gives us a sense of the violence of the controversy between the two camps. Signed by Rodchenko and Stepanova, both ardent communists, the statement was written for an exhibition of Constructive art. It ends with the slogans "Down with art. Long live technic. Religion is a lie. Art is a lie. Kill human thinking's last remains tying it to art. Down with guarding the traditions of art. Long live the Constructivist technician."

The fact that the argument was being conducted in increasingly political terms made it difficult to contest. Gabo was not a Marxist. At the same time, the official climate was beginning to change as the chaotic conditions of the immediate post-revolution years gave way to organization, and an increasingly effective bureaucracy. The regime was becoming less tolerant of experiments it could not understand. Lenin, whose opinions were probably colored by his first-hand knowledge of the Dada demonstrations in Zurich, had condemned experimental art as "left-wing infantilism." Official taste was far more inclined towards the academic middle-of-the-road: "They revered that kind of art, hated ours, and one day the workshops which had been given to our group were suddenly closed."

Caught between the devil and the deep, Gabo realized that there was no hope in Russia for the free development of his ideas. When the opportunity arose, he asked permission

to leave the country. The regime was still flexible enough for this to be granted, and in 1922 he traveled to Berlin where he was to stay for eleven years.

252 Among the works Gabo made in 1920, the year of the *Manifesto*, was a kinetic sculpture that he called *Standing Wave* which consisted of a straight bare wire of tempered steel. This is mounted vertically on an electric motor that causes it to oscillate at a constant speed. A wave is set up in the wire, and, to the eye, it becomes a long slender solid form, as transparent and tremulous as the wings of a humming-bird yet as precise and still as a perfectly turned vase. This simple and mysterious work embodies in a very pure way many of the terms he has set out for the new sculpture. All its characteristics as form – its volume, rhythm, and color – are the consequences of its action. It is what it is out of necessity. It can have no other form while it is in motion. The form we see is not an object but an action. There could hardly be a more concise expression of the perception of reality that he had gained from his interest in physics; the perception that Whitehead was to express as follows: "For physics, the thing itself is what it does.... It obstinately refuses to be conceived as an instantaneous fact. It is a state of agitation ..."

The *Standing Wave* was, for Gabo, an experiment and a provisional demonstration. It was a path he was not yet ready to follow. The drawing *Design for a Kinetic Construction* of 1922 is as complicated in its indicated movements as the wave was simple. This drawing is partly a diagram of movement, partly a projection of forms. It appears to represent schematically a sequence of forms on a vertical axis, each one of which follows an orbit of movement. Some directions are indicated by arrows, others by repeated dotted lines reminiscent of the Marey diagrams.

These indications are only partial, and if one tries to fol-

low them to their conclusions one is soon baffled. Lines sweep, oscillate, spiral, rock, but there is no indication of the coordination of these movements nor of their conclusions. Nor is there any information in the drawings about the mechanisms that would have made these movements physically possible: no bearings, no linkages, no drive. It is a drawing of a thought about movement, and compared to it the imaginary machines of a Duchamp or a Picabia are models of mechanical practicality.

Most of Gabo's work from the twenties takes the form of drawings or models for constructions that have a strong flavor of architecture.

If the new art was to speak for a new world, what more appropriate mode could it find than the language of the monument? Many of the abstract artists on both sides of the debate were inspired in this direction, and made projections for imaginary buildings whose dimensions speak vividly of the artist's omnipotent optimism. And they had found encouragement from official opinion. More than once Lenin had called for propaganda monuments to celebrate the revolution and its heroes. Tatlin's *Monument to the Third International*, an official commission, was the most famous response to this challenge. But of course Tatlin's model was above all an appeal to the imagination. Its specifications could hardly have been taken literally by anyone: a third of a mile high, its parts revolving at different speeds and in a diagonal axis, slogans projected onto the clouds from its summit. Combining the imagery of an Eiffel Tower, an observatory, and a howitzer, its impact was above all visionary. "It seemed to me that I had glimpsed the twenty-first century," Ilya Ehrenburg said, recalling his first view of it. On the other hand, Trotsky, not unsympathetic to experimental art, jibbed at the confusion of fantasy and purpose: "I cannot refrain from the question: What is it for?"

Nor do Gabo's projects conceal their fantasy. They remain on the side of art, yet an art that is drawing its imagery both from machines and buildings. They look like models but without any of the literalness that architect's models always have. We do not know how high Gabo's towers are "meant" to be. They do provoke a certain scaling down of one's attention. There is something in their proportions, the ratio of large to small forms, of height to base, that suggests a monumental scale. They offer an experience of the sublime in miniature. But no one could mistake his *Model of a Monument for an Observatory* of 1922 for a literal model for a structure of monumental scale. For it is the sculpture itself we are looking at, not a three-dimensional description of something else, and it has to be seen on its own terms. We see it less as a model than as a sculpture in which "modelness" is part of its content. Projection, the thrusting out of the imagination into a Utopian future, is given definitive form.

Column of 1923 was the culmination of this group of work. The sculpture that followed involved a change of scale. The monumentality-in-miniature of the towers gives way to a scale nearer to that of a small machine or an instrument. This was an obvious way to explore his ideas about movement. The *Column* itself had suggested the potential of movement, in spite of its architectural look. One can imagine its horizontal fins sliding up and down, or the open circle placed at its base rolling.

One can hardly look at the later pieces such as the *Monument for an Institute of Physics and Mathematics* without being drawn into some sort of speculation about the possible functioning of its transparent vanes, its turn-screws, and delicate suspending arms. Perhaps its function is balance. In the Yale *Construction in Space with Balance on Two Points* it is not in the least clear how that balance is achieved. The

eye has to explore the structure analytically and try to understand the complex symmetry of the piece, the way that one form mirrors another or counters it. It is an equation in mass and gravity that one is called on to work out; and in the working of it there slowly accrues a sense of the space that its parts articulate.

The immediate pretext for Gabo's journey to Berlin in 1922 had been an exhibition of new Russian art sponsored by the Soviet government. Abstract art was strongly represented. The exhibition opened at the Van Diemen Gallery in Berlin, later going on to Amsterdam. 1921 had marked the reopening of contacts between Russia and the rest of Europe and from now on the work and ideas of the Constructivists were rapidly absorbed by avant-garde movements in the west, particularly in Germany where strong left-wing sympathies among artists and architects combined with a concern to unify the arts in the service of society. A vital part in this exchange was played by the architect-designer-painter El Lissitzky who designed one of the rooms in the Van Diemen Gallery. Staying on in Europe for several years, he and Ehrenberg edited a multilingual magazine in which the new tendencies from all over Europe were published side by side with the Russians. He formed active connections with the de Stijl group in Holland and with the Bauhaus. It was here at Gropius' school that, for a few years, the principles of productionist constructivism were put into practice. The International style in architecture and design was created out of this joining of movements.

But Gabo's position remained distinct. He had close relations with architects and designers but the character of his own work was self-contained and idealist. Sculpture was not the same as design. He was an artist as the term was traditionally understood. Yet he never relinquished a sense

of the social role of his art, nor of the extreme responsibility he undertook through it. It was a difficult and ambivalent position to hold.

256

From the late twenties his work begins to move away from the planar, rectilinear character it had had up to now. It begins to deal increasingly with curved surfaces: funnels, cones, long curving strips that seem to spiral out like an expanding orbit, only to return to a still starting point. Looking back on the change, he commented:

> The angular structure of the stereometric cube which I had applied in my previous constructions.... I found in elementary stereometry. It soon proved insufficient to many an image which was growing in me where the vision of space as a sculptural element had to play a greater role.... I felt that the visual character of space is not angular: that to transfer the perception of space into sculptural terms, it has to be spheric.

Certain of his undertakings of the Berlin period may have influenced his thought in this direction. One was his involvement for a short while with the ballet. He and Antoine Pevsner had shared an exhibition at the Galerie Percier in Paris. One of the visitors had been Serge Diaghilev, always on the lookout for new talent. A commission followed. *La Chatte* with sets and costumes by Gabo, assisted by Pevsner, opened in Monte Carlo in 1927. The music was by Sauguet, the choreography by Balanchine, and the theme, surprisingly for a "constructivist" ballet, was from a fable by Aesop. Little remains of the enterprise except drawings and photographs. There are sketches for the costumes and the set and photographs of the completed set and of the dancers wearing their costumes. Gabo cannot have been unaffected by the experience of working with dancers in real space. It

appears to have been a truly kinetic production in which the stage revolved. The photographs make it clear that he was using the space of the stage in a completely open way, not bound to the frontal axis of the proscenium.

A project for a *Fête Lumière* for the city of Berlin, unrealized and known only from drawings, must also have opened up new channels. It deploys clusters of searchlights, and one imagines the whole sky above the Brandenburg Gate drawn and shaped by light. What more dynamic example could there be of a spheric perception of space than that opened up by the sweeping beams of a searchlight?

In 1932 Gabo moved to Paris where his brother had been established for several years. Both became active in the group of abstract artists called *Abstraction-Création,* through which he made his first contacts with English artists such as Ben Nicholson and Barbara Hepworth.

From the early thirties onwards there is no more imagery in his work that suggests machines, instruments, or buildings. His sculpture becomes more compact, less obviously additive in its structure. The sense of a miniaturized monumentality vanishes. At the same time its topology becomes more complex. Each work presents a "problem" that invites exploration, a movement of attention in and out, a search for the origin of each curve, and of its development and return.

While he was in Paris he looked at nineteenth-century mathematical models in the Institut Poincaré which, for very different reasons, had also attracted the attention of the Surrealists. The *Construction in Space (Crystal)* [Fig. 8] of 1937 is a development of one such model that illustrates a mathematical formula in three dimensions. This is probably the nearest he came to using mathematical material directly, and he later stated that he had been able to find nothing in mathematics that would help him towards a graphic expression of his vision of space. This may have

been true in a narrow sense but the conception and technique of these models was surely of importance to him, based as they were on an intention that was similar if not exactly the same as his own.

A mathematical model is like a three-dimensional graph. Each piece of it is an item of information that is determined by its place in the complete structure. A work of Gabo's like the *Linear Construction in Space No.* 2 of 1949 is, of course, not concerned with information in the same sense. But there is a point of comparison that must not be overlooked, that is, the connection between cause and effect in its formation.

One of the most powerful elements in the work is the membrane of strings, opaque or transparent according to how one looks at it, that wraps the two intersecting rigid elements. The character of the plane that the strings make is the inevitable consequence of the way that the stringing is done. It is a function of the profiles of the rigid elements, the regular spacing of the notches that hold the strings, and of the sequence in which they are threaded. Certain formal and procedural decisions have led inevitably to a final form. And just as the vibrating wire in his early kinetic experiment can only make the shape that it does because of certain causes, so in this work there is a taut connection between one cluster of decisions and their physical consequence. Gabo was himself to demonstrate the force of this connection by stringing versions of one of his pieces in different orders, producing different forms. It needs some effort of imagination now to see how radical a contrast this way of working made with a tradition of thousands of years of art in which the character of a form reflects style, propriety, taste, convention, expression, illusion, and so on, and the sculptor's procedure was rendered more or less invisible by skill.

The technique of stringing, coupled with the improved

plastics that were now available, opened up vast possibilities. He could now span the space subtended by his stereometric planes by a transparent membrane. Furthermore, this membrane, being made of separate strings, could penetrate and turn back on itself. The space occupied by the sculpture could be imagined as infinitely plastic – almost as if it had layers that could be peeled off from each other or folded back, or as if it went through a gamut of densities, heavier in one part, rarified in another. In a work like *Linear Construction in Space No. 2*, the rigid elements appear to be opposed to each other in Right Left/Left Right symmetry, but this feature is made extremely elusive by the ever-changing curve of the plane made by the strings. The eye searches for a confirmation and a development of something it has only apprehended fleetingly. The "movement" of the work is like a gradual unfolding of the symmetrical aspect of its structure.

Movement in a different mode is offered by the works made out of opaque materials. One aspect of the *Spheric Theme* of 1937 is its challenge to the idea of "inside" and "outside." A concave plane from one view is convex from another; inside from here is outside from there. Nor is this merely a matter of viewpoint, for as one explores the surface and follows its transformations it becomes clear that the whole is moving in the same way. It seems as if an inside view of the outside and an outside view of the inside dwell in the same form simultaneously.

During the thirties he had begun occasionally to carve in stone. He also made paintings. Both developments seem to indicate a move away from the futuristic and monumental aspirations of the twenties, and towards more familiar categories of art objects for galleries and rooms. External conditions may have had a bearing on this change. Both Moscow and Berlin had been in social turmoil, alive with

hopes and fears, obsessed with futurity. Paris, where he went in 1932, was by comparison a conservative milieu in which the subversive demonstrations of the avant-garde took place against a reasonably stable background. The art world thrived. Several sculptors of his generation in Paris were turning away from their earlier experiments towards more traditional techniques: Laurens and Lipchitz are examples. And when Gabo arrived in London he found himself among artists to whom the discipline of direct carving and a sense of truth to material were important ingredients in their aesthetic.

England was a backwater in which only a very few artists and architects were responsive to events in Europe. But this small group – it included Ben Nicholson, Barbara Hepworth, Henry Moore, and Herbert Read – was extremely active, and Gabo was drawn into its orbit. He found a studio in the part of Hampstead that they lived in and was soon taking a part in the polemical battle for the modern movement. His name shows up in many events of the London art world, in broadcasts and debates and as one of the editors, with Nicholson and the architect Leslie Martin, of an ambitious anthology of Constructive art. *Circle* was the first attempt in England to draw together all the different strands of the modern movement and to present it as a truly international phenomenon. A list of its contributors reflects the influx of European artists and architects who had or were about to move to England. There was a strong emphasis on architecture with contributions from le Corbusier, Breuer, Neutra, Gropius, Mumford, and others, and there were articles on science, philosophy, and education as well as art. Gabo contributed two important articles.

He had married Miriam Israels in 1936. With the outbreak of war the family moved to Carbis Bay, Cornwall, where several of his friends were established, and it was

here that their only daughter Nina was born. They remained in Cornwall until 1946 when the final move was made to the United States. The connections he had made with friends in England continued to mean a great deal to him, and he was later to demonstrate his feeling for those years by important donations to the Tate Gallery that included a unique collection of drawings and small models that represented, in embryo, the outline of his entire life's work.

It was while the war was still in progress that Cyril Connolly's *Horizon* published an exchange of letters between Gabo and Herbert Read that contains a moving statement of his aims, pitting his art against the conditions of the time. Speaking of his forms as images of "the state of mind I would wish the world to be in," he says "I think that the images they invoke is the image of good – not of evil; the image of order – not of chaos; the image of life – not of death." And later: "I try to guard in my work the image of the morrow we left behind us in our memories and forgone aspirations and to remind us that the image of the world can be different." In the same letter he expresses an almost mystical relation to natural phenomena, the source of what he mysteriously calls the "crude content" of his art: "I look and find them in the bends of waves on the sea between the open-work of foaming crests; their apparition may be sudden … but when they are over they leave us with the image of eternity's duration…. Sometimes a falling star, cleaving the dark, traces the breath of night on my window glass, and in that instantaneous flash I might see the very line for which I have searched in vain for months and months."

So far, apart from his ephemeral encounter with the ballet, he had had no opportunity to do anything on an environmental scale; yet that scale and that engagement with a public space was always implicit in his work. Perhaps it was the force of this ambition that ensured that he was always to

keep his œuvre intact, for throughout his travels he had been able to guard his drawings and models, the seeds as it were, of the public art he dreamed of. When he arrived in America it was just twenty years after his first exhibition there, when he, Pevsner, and Van Doesburg had shown together in New York. He had been well represented in Alfred Barr's influential *Cubism and Abstract Art* exhibition at the Museum of Modern Art and he had visited the United States in 1938 when there had been more exhibitions. Now at last opportunities began to present themselves for large-scale works, the first being a commission for a construction for a new space at the Baltimore Museum of Art. Some years later came the crowning opportunity, the sculpture for the Bijenkorf Building in Rotterdam. The work was installed in 1957, and in it the earlier image of the column and the later organic, spherical theme are combined in a magnificently economical open monolith. There were several other public commissions and in addition Gabo was able, during the last fifteen years of his life to make, or have made, definitive versions of earlier pieces. The *Constructed Head No. 2* of 1916, for instance, was remade in Cor-Ten steel in a version over five feet high. A six-foot version of the *Column* of 1923 was made only after Gabo had learned of a new process in glass making that gave him what he needed at the required size. Perhaps the most elegantly successful of these later versions was the *Torsion* of 1929 which went through several stages of enlargement, culminating in a fountain ten feet high now installed in front of St. Thomas' Hospital, London.

Nothing expressionistic or confessional seems to have been allowed to affect the course of his development. His work does not argue either with the other art of its time or with itself. It has a special kind of autonomy, a purity of standing that detaches it from the dialectic of art. Gabo was aware that his position vis à vis time was distinctive.

Constructivism, he states, is a new start. It is not a revolution in art in the sense that Impressionism or Cubism were revolutions that fought against and finally overthrew previous styles. Cubism was the last of such revolutions, beyond which nothing further could be done. His analysis of the cubist attack on earlier styles tells us much about his own intentions:

> Instead of taking the object (that is the outside world) as a separate world and passing it through his perceptions producing a third … namely the picture … the cubist transfers the entire inner world of his perceptions with all its component parts (logic, emotion, and will) into the interior of the object penetrating through its whole structure, stretching its substance to such an extent that the outside integument explodes and the object itself appears destroyed and unrecognizable.
>
> That is why a cubistic painting seems like a heap of shards from a vessel exploded from within. The cubist has no special interest in those forms which differentiate one object from another.

This revolution brought art itself to the brink of its own destruction. He implies that Dada, the rejection of art itself, was the consequence. A new beginning was made possible, not by reaction against cubism, but by simply walking away from the whole issue of representation. Once the descriptive element had been dropped the way was clear for an entirely new kind of art where Form and Content were one and the same thing.

As an ideal criterion this is one that has a long history. It has been used as a definition of Classical over Romantic art – and vice versa. Taken literally, it begs many questions, but Gabo's main point is clear enough. By dropping descrip-

tion, at least two irrelevant layers of meaning are done away with: the object of description, and the manner in which it would be described. The work is reduced to a form. What else is left?

264

Gabo's answer is worked out along two main lines. The first is the familiar claim that forms, shapes, colors are inherently effective:

> Every single shape made "absolute" acquires a life of its own, speaks its own language, and represents one single emotional impact attached only to itself. Shapes act, shapes influence our psyche, shapes are events and beings. Our perception of shapes is tied up with our perception of existence itself. The emotional content of an absolute shape is unique and not replaceable by any other means.... The emotional force of an absolute shape is immediate, irresistible, and universal. Our emotions are the real manifestations of this content.... Shapes exult and shapes depress, they elate and make desperate; they order and confuse, they are able to harmonize our physical forces or disturb them.

This claim, which takes us back to Seurat, Van Gogh, and Gauguin, is one of the foundation stones of modern art. It has come under heavy fire from those who would stress the sequential, language-like aspects of art and have affirmed the meaning of each work within a chronological structure.

Gabo contests this, and insists on the autonomy of each work. The Constructive idea:

> ... has revealed a universal law that the elements of a visual art such as lines, colors, shapes, possess their own forces of expression independent of any association with

the external aspects of the world; that their life and their action are self-conditioned psychological phenomena rooted in human nature; that these elements are not chosen by convention for any utilitarian reason as words and figures are, they are not merely abstract signs, but they are immediately and organically bound up with human emotions.

Again, there are many questions begged. Is there really some "natural" level of human experience that lies below all layers of culture and yet is still accessible? It is a long time since even perception has been considered totally "natural," totally acultural, and it is difficult to uphold the universality of any human reactions beyond the level of the reflex. And is it possible to consider lines, colors, shapes, and so on independently of any association with other aspects of the world? Experience is continuous and seems to involve unremitting connections. These connections and comparisons do not have to involve descriptive transformations, but we can hardly censor them out when they do.

Objections of this kind, of which Gabo was well aware, help us to see the implications of his position more clearly. At the back of all his assertions is an ardent drive towards universality. Consciousness, he repeats, is the only frame of reference we have. The grandeur of both science and art is that they are both hammered out in the face of an external world, a nature, that is finally imponderable. They are man's best efforts at knowing. But the vision of science, its theoretical constructions, can only be stated in its own terms, and these often cannot be pictured by the mind's eye, nor grasped by the senses. It is a perennial responsibility of the arts to represent a cosmology, and this is more than ever true in the twentieth century. "It is only through the means

of our visual and poetic arts that this (scientific) image can be experienced and incorporated in the frame of our attitude towards the world." Each work is to reflect his consciousness. It is a construction that embodies an image.

Gabo had used this word in the *Realistic Manifesto* when he had spoken of the "essential image" of things such as chairs, books, telephones, and so on. "They are entire worlds with their own rhythms, their own orbits." He returns to the idea in a less mystical vein, many years later. The image is opposed to the symbol. His work, he insists, is not symbolic, for a symbol is a secondary construction, a short-cut to communication arrived at by common consent. Symbols stand for something. Images are something in their own right. It is by the formation of images, he says, that the mind gives shape and structure to its perceptions. "They are the building blocks of our consciousness which in their entirety constitute what we call reality." Scientists use symbols for their measurements and calculations, but the aim of their work is the formation of images, mental constructions that correspond to a view of reality. And so with the artist. Because he is working with actual materials, his image is a primary form and it can provoke feeling by its power as a form.

This was how he understood his responsibility. But interaction, apprehension, *use* was vital. "A work of art," he says, "with that alone which the artist puts into it is but half of itself; it attains its full stature by what time and people make of it."

What in fact is to be made of his work? Obviously his distinction between symbol and image is to be taken seriously. We have to resist the temptation to read an individual piece of his as "standing for" a particular cluster of attitudes, a symbol for the scientific worldview, for purity, for perfectibility or any such idea; for this would be to reduce it to the status of an emblem. And yet, as with all non-figurative art,

there is much to persuade us to do this. The *tabula rasa* has been heavily captioned. We must explore each work in the primacy of its structure.

In *Linear Construction in Space No. 3, with Red* of 1953, an open form is established by the intersection of two open shapes. Are they at right angles or not? These shapes are joined at a central axis. How? They are open, like complicated frames, and colored, each one having an area of red and an area of white. What is the nature of the shapes themselves?

One soon discovers that if the opening in them is attended to, not just as a hole but as a shape in its own right, it attaches itself to the lower or the upper half of the bounding shape, first to one, then to the other. That is to say, the bounding shape can be seen as incorporating two interlocking shapes, each of which is completed only by the inclusion of the opening. The space demarcated by the opening has two identities or values, one as the missing part of the upper half of the bounding shape, one as belonging to the lower one. Having seen this as a characteristic of the shape of one of these two planes, can I now "see" it as a three-dimensional characteristic of the two planes in intersection?

It would be tedious to try to spell out exhaustively every possible "problem" set by this piece. Such an account would be very long-drawn and would bear little relation to the excitements of looking. It would need to include questions about the ordering of the strings, the structure of the interlocking triangles in the center and their relationship to the outer form, the location of the central axis and its balance, the ordering of color, and the qualities of opacity, transparency, reflectiveness, and indeed every identifiable feature of the piece. But the point is this: each answer that one might find would have a certain resonance, a certain overlay of feeling. It would have the quality of a personal discovery, a dawning of the kind expressed in the words "I see!" with its

connotations of figurative and literal enlightenment. One might say that the meaning of the piece is the sum of all those discoveries, set against one's sense of its totality, its character as a whole.

And what of that totality? Although Gabo's later works are instantly recognizable, they are remarkably unrepetitive. Each work has a firm and distinctive identity. His word image is appropriate. But there is a feature that all have in common, namely an implication of symmetry. This is rarely borne out exactly, but the question "Is this truly symmetrical?" is never far from one's mind, and is often the motive for one's exploration.

The eye is drawn in to a search for the origin of a form, in trying to understand its order of construction or the secret of its balance. And in this search it will discover a spiraling outwards, or an inversion or a mirroring that will imply a center.

This implication is the condition for the organic quality of his work; for a living thing is unimaginable except in terms of symmetry at some level. The notion of a three-dimensional mandorla often presents itself in front of his sculpture. Like the mandorla, like a living bud, they present powerful images of integration, whether on the personal or the cosmic level. Each of them is centered in a specific way. And like a dancer, whose center is both the source of her outflung movements and the still core to which they return, each work seems to speak to us of energy and repose; of space taken over and charged with time; of a miraculous still speed.

Catalogue essay to an exhibition of the same name
Robert Miller Gallery, New York
March 16–April 24, 1999

MORE THAN ONCE in interviews, William Bailey has spoken about key events in his formation as a painter, of his studies with Josef Albers in the early fifties, of contact with some of the Abstract Expressionists, of his travels in Europe and the Far East – and of the stylistic impasse that for several years blocked his horizon. "I simply couldn't deal with it [painting]. Everything seemed to disappear with the next mark I made." Then, on his way home from the East, he found himself in Athens and in the museum of the Acropolis he discovered "a room full of feet that had broken off sculptures." These fragments affected him as nothing had before. "It was all I wanted to look at – those feet, because they were so pure, so mysterious," he told John Gruen and, describing the same moment to Mark Strand he said, "They were elegant and beautifully carved and seemed to have weight and meaning and tension and density. They were feet and at the same time they were extraordinary sculptural experiences." With this discovery fresh in his mind, he had stopped in Paris and renewed his acquaintance with Ingres, the *Grand Odalisque* and the *Valpinçon Bather*. Back in his studio in the States he started to paint a figure in an interior. Something had opened. It was "a figure in a measurable space and it seemed terribly important to me – that painting really opened the door."

We can feel even now the "terrible" importance of WB's figures, descendants of that first presence that had broken the lock on his talent and shown him the kind of painter he was to be. Since then his reputation has been largely associated with his still lifes. But the figures have always been there, appearing in ones and twos, brooding over the more accessible still lifes, difficult, yet clearly playing a major role in the internal drama of his art. This is the first time he has shown nothing but figures, an occasion.

You could say that the history of still-life painting has taken it, over the years, from a painting of objects as emblems (of riches, nourishment, transience, etc.) to a painting of representation and reflection on representation. But WB's still lifes don't fit into this sequence in any obvious way. As to the figures, if we ask ourselves who they are and what are they doing, the only answer seems to be that they are posing. That means that they are models. But *models* painted out of one's head? The fact is that you can't get far with his painting unless you come to terms with them as inventions, as achievements of the imagination. He projects an imagined world: over there on their tables and shelves, like distant hill towns, the rows of vessels. Here in this corner a naked woman stands or reads a book. It is a world projected with the insistence of a recurring dream and painted with an almost secretive reserve that makes each picture into some sort of riddle: "A sleeping world or one that thrives / on changeless being – who can say?"

What the still-life subjects and the models have in common, of course, is that both belong purely to the province of painting. They don't exist beyond its borders. A table set for lunch is already halfway out of the studio and the model with one shoe on and making a phone call has already left.

With the figures the stakes are higher than with the still lifes. For one thing Eros has broken cover and is running in

plain view. For another, the figures touch that live wire, bio-logical recognition: we don't (can't) respond to the propor-tions of a pot with the same directness as we do to the proportions of a figure, nor is the frontality of a table the same as the frontality of a face. WB has his way of making his figures, with their large extremities and long legs and lines that are neither sumptuous nor angular. They belong to a tribe as unmistakable as the tribe of Bonnard or the tribe of Paul Delvaux.

"Almost all of Bailey's figures," Mark Strand has com-mented, "bear certain resemblances to the work of others." Strand finds a "neo-classical mixture of remoteness and sensuality" that summons up David and Ingres. About the 1986 painting called *Portrait of L*, he says that the figure looks as if she had stepped out of a Balthus. Other paintings suggest Corot. All this is so, but what needs to be added is something about the particular quality of these resem-blances. I can't see academism or homage or attack, still less ironic appropriation. WB's dealings with the past seem to take place at a far deeper level than any of that, somewhere in the innermost reaches of his imagination. It is as though he knows that the admired art of the past places a charge on his present, as though he recognizes the legacy as a task. Discussing a book that deals with kindred ideas, Adam Phil-lips has written that one way of describing legacy-as-task "would be to say that the dead are very demanding; and that we keep in touch with them, keep them alive, by imagining they still want something from us...." This sounds exactly right. An act of imagination that takes responsibility for the unfinished business of the past is inseparable from a pres-ent awareness of mortality. This is where an indelible line is drawn between academism and a living responsibility to tradition.

However clearly he sets things out, however tight or sharp

his definitions, I am always left with a feeling of remoteness, of something beyond what I can see. Nothing is set up to invite me in. There are no welcoming diagonals and in the still lifes the table-tops are rigorously straightened as if to wish away the observing eye. And consider the absence of communicative gesture and the impassive evenness of the figures. Or how they look at you. Often the eyes are a single dark tone without internal drawing, reminding of those late Poussins where the figures have eyes like statues; and of even more distant eyes, the eyes of those funny portraits from the Fayum that, like WB's seem to be focused on some far-distant horizon even as they look straight at you.

But this feeling of remoteness, of confrontation at a distance, can't be attached to particulars. It derives in the end from the unbroken wholeness of the pictures, their dense and distant tone. This is their strangest and most wonderful attribute. It is what lives in one's memory long after particulars have faded. It is hopeless to try to isolate a single aspect. Whatever you focus on elides with some other feature. You can't tell where "what" becomes "how" or how becomes what. You can't catch these pictures aslant. There are no breaks in the fabric, no half-moves to give entrance to his thought this side of the canvas. It is all out there, facing you. The surface, thought of as the way he brushes paint, is indistinguishable from the surface thought of as representation. Wood, metal, skin, earthenware, hair, all have the same matte texture, un-highlighted, intangible, there but not there. Is this brushing or brushed? How or what? The question is even more bewilderingly unanswerable if one puts it to the light in his pictures. Light there doesn't play or break or flicker or glow but seems rather to press. It presses onto the whole canvas from the front, molding every form with the same steady weight. Its quality isn't located only in the way forms are modeled. It is a matter of value, meaning every color-change in the

whole picture, every threshold that takes us from warm gray to cool gray, from brick red to leaf brown to mushroom-pale skin or back to gray, now greenish, now tending to gold. This finally is the foundation of his painting, a total all-including color structure that makes light, a unique light, and where everything has to work and minute misjudgments of weight or saturation can wreck the lot. This is the basic fabric, woven with bated breath, achieved in intense concentration and stubborn will and longing. It is the upshot of an objective task *and* an inner picturing. One can only guess at the tension and turmoil spent on silent calm, or at the hours this timelessness cost. The final mystery of these paintings is that we feel intimations of that energy even in their stillness, and of intense life in their reserve.

Euan Uglow

Catalogue introduction to an exhibition of the same name
Salander-O'Reilly, New York
December 2–31, 1993

UGLOW'S PASSION IS LOOKING. The techniques of measurement that he inherited from William Coldstream became for him a narrow conduit into which all that looking meant could be compressed.

The eye, suffused with memory, distracted by expectation, deceives itself. Typically a painter working from observation will measure only in order to correct. At the least, measurement shores up the relationship of the picture – thought of as a flat plane – to the model depicted. The marks that such a painter will make in the course of measurement are marginal, banalities usually erased. They belong to the "working out," no more. This, at any rate, is the common sense view of the matter.

But with Uglow, mad about measurement, the marks of calculation are part of the fabric and meaning of the picture. We look past them to the craggy, chunky, faceted forms of his models, human and otherwise, only to return to them, realizing that it is through their agency, his markings of interval and alignment, that we see the forms at all. His calibrations of the picture surface form its context and its condition. They lay out the rules of the game.

One doesn't have to look long at these pictures to realize that the marks of measurement refer to far more than the proportions internal to the model. Measuring extends to the

edges of the canvas. The whole view subtended by the picture is measured and its intervals welded so insistently into the canvas that one sees that the threshold between the picture and the world it depicts is very low indeed, open to traffic in both directions. We are in a still-life world where the same will is visibly at work on both sides of the canvas. Some of his measuring marks are both calculations and representations: a vertical line is a vertical line; it also represents a plumb-line. Calibrations on the surface of the picture may match calibrations on the wall behind the model. One thinks of Chardin and his delicate and monumental pyramid of raspberries, of Ingres, of Cézanne, and above all of Poussin and the ambition contained in the word *tableau*, picture and theater both, a demonstration in which nothing is neglected.

For these pictures are not constructed in a spirit of open-ended empiricism. They are not "realist" – if that wobbly word is taken to mean, as it once did, that nature knows best. Uglow's theater has embraced artifice, as for example, the near edge of the model's platform in *Root Five Nude* which was cut in a curve such that it made a straight horizontal from the painter's point of view. This particular case happens to be documented, but one imagines that every painting carries within it some secret correction to the anomalies of observed perspective, to over-speedy recessions or over-abrupt disjunctions of figure and field. The corrections are made out there, not on the canvas. It is the strenuous task of painting to reconstruct these wonders from a single point of view, the one location in the whole world from which their meaning becomes clear; to reconstruct thcm so that they do not present themselves as corrections but as the clear-cut features of style.

Style is achieved under tremendous tension – the exact viewpoint, the exact match, the long, drawn-out accumulation of measurement – a tension that is challengingly projected

by the poses his models take, testing to strength and patience and stamina.

The paintings of figures present a world of willed stillness. The paintings of fruit or flowers bring time to the fore. Fruit shrinks and collapses, flowers wilt. The measuring continues, insistently tracking the passage of time, juxtaposing the ideal timelessness of the studio with the processes of decay. Fruit as tender and fragile as peach or pear is locked into an aspect as hard as carved granite and then watched and tracked as it changes, its fullness and vulnerability never lost sight of. Side by side two pears skirt the vertical line that bisects the canvas, the pear on the right transgressing the symmetry, leaning to just cut that line, the gap between it and its companion charged with energy, Uglow's licks flashing across it like electric sparks jumping.

There is an Egyptian note in all his pictures, with their insistent frontality, the symmetry of the poses, the way background and foreground lock in relief, the sense of life held in stillness. In contrast to this, I find myself thinking of Dürer's engraving of the artist using a drawing machine. There is the same sense of demonstration, the same atmosphere of energy violently constrained as a bit of the three-dimensional world is stitched and nailed with marks on a flat plane. What else happens in that room of Dürer's, part study, part earthly observatory, a place given over to the wonders of projection? The same question arises here. There is nowhere else to be except face to face with his theatre, at touching distance, it seems, to his protagonists whose movements strain against stillness and a clock without hands that ticks the months away.

Looking, engaged in like this, brings us to a peculiar awareness of time. The object of attention looms up, separates, stands still. But at the moment that contingency is

suspended it re-enters with a new brilliance – the light changes, a petal falls, you can hear her breathing. If this paradox were to fail, constancy would hold no mystery, nor for that matter would life itself. Stasis is death, but the discovery of stillness in life is an achievement of high imagination. It is one of the great themes in art, perhaps the greatest. Uglow is in touch with it.

Geometry Turning into Place:
Notes on Jake Berthot's Landscapes

Modern Painters
Spring 2002

CHANGE

"MAKING PAINTINGS is kind of like being a snake," Jake Berthot remarked some years ago. A snake sheds its skin every once in a while, and so does a painter. The difference is that the snake is still a snake, but the painter "doesn't know what shape he is – one time he is shaped like a dump truck, and the next he's shaped like a butterfly."

When he said this he was talking retrospectively, looking back over twenty years' work, a succession of changes. There had been a time when, on the run from the all-absorbing enchantment of Milton Resnick with whom he had been close, Berthot had made numbers of drawings of imaginary sculpture, diagrams of impossible objects. Boundaries were the issue – boundaries between painting and sculpture, frames, the meaning of edges. He came into his own with the "notched" paintings (*Lovella's Thing* is a key work), where the framing role of the canvas is set askew from the framing role of the frame. What exactly happens when the inner world of the painting butts against its surroundings?

The brush meditates on this question. *Eye, Arch and the River* absorbs the frame into its internal structure, where it comes and goes with the shimmer and flux mirrored there.

A few years on and it is as if the frame has migrated to the center. Geometrically regular shapes, ovals, oblongs, or capsule-shapes, are the general objects that he manipulates to particular and unrepeatable states, opening them to transparency and a kind of spectral monumentally (*Bather*), or locking them into an event of light (*Green Oval, for Myron Stout*).

Dump truck? Butterfly? The shock of his metaphor was prophetic. Five years ago he showed, astonishingly, paintings and drawings of trees. The drawings, in particular, made an unprecedented contrast with the primitive emblematic drawings that he had shown only a few years before. Where had the hand that made these graceful and nuanced pencil drawings come from?

The work that immediately preceded the trees was a series of predominantly red paintings. They were aggressive and highly charged. At the time, one saw them as the latest round in his continuing battle with the issues that he had made his own, the problem of meaning and expression in a purely formal context. In retrospect, the red paintings look rather different: titles like *Grief for That Past* and *Over the Past* take on a more pointed meaning. One begins to see the passionately brushed red both as an affirming note of challenge, a forward thrust, and as a cancellation of earlier states. The scarlet rectangle that is the hero of *Over the Past* floats triumphantly forward like a banner. Traces of earlier states, cold, gray, can be glimpsed like an abandoned battlefield through tatters in the red. Revisiting these pictures now, one can almost smell the urgency of the desire for change.

Berthot has always worked out of the conviction that painting itself has a moral dimension and that the movements of the brush, the decisions taken on the picture surface, given intensity of purpose, become conduits of true feeling. This conviction is in the grain of his artistic personality. Irony is completely foreign to him, as it was to the Rothko/

280

Pollock generation with whom he has, in some respects, more in common than with his contemporaries. Painting is an act of faith, involving the whole self. It strips bare. The drive is for authenticity, that shibboleth of the Abstract Expressionists. But Berthot has been around for a long time, and he knows how heavily land-mined that area is. Truth of feeling is always menaced by its counterfeit. Hence the tremendous power of the promise of change: anything to cauterize the possibility of self-parody, the pains and anxieties involved are cheap at the price.

It is important to stress the internal quality of his restlessness. The changes he initiates are registered against his own necessities. They have nothing to do with novelty in a public sense. They are reckless.

SOMETHING GIVEN

"You have more freedom if you know what you are going to paint," Berthot said recently, and in the same vein, a few years ago, "I'm not interested in searching for form and developing it through the act of painting. I've always wanted something given … something I could watch and build on without having to find it, kind of like someone who paints a still life …." When he said that, he must have been thinking of the ovals and oblongs that were the central presences in the paintings that he was doing then. In the recent paintings, the givens are relocated in complicated ways.

For a start, they are not the landscape site itself, for these are not *plein-air* paintings. They are works of the imagination. The first given is the elaborate grid that underlies each image, most clearly seen in the drawings. Some critics have failed to see the essential part played by these grids, mistaking them for leftover traces of studio mechanics. But they

are integral to the final image. Their role is generative. They stand behind the particulars of trees and fields, a sort of Emersonian one, choosing and informing the disparate events.

At its simplest, the grid is based on regular divisions of the panel or paper, a kind of linear folding into halves, quarters, and so on, working from the center to the sides and also from corner to corner. The first divisions are thus proportionate to the whole rectangle. Sometimes the vertical/ horizontal elements take precedence, sometimes the diagonal. He plays one system against the other, two themes in counterpoint. As more and more divisions are made, the grid begins to take on the character of a web stretched across the surface, the vertical/horizontal strands enhancing its frontality, the diagonal strands pressing back into an imagined depth. Slowly a spatial reading emerges.

The grid states the hard geometrical fact of the rectangle. This is one side of the equation. The other is fluid, the polymorphous flow of fantasy and desire that answers the rectangle, accepting it as its field, its home, and ultimately transcending it. Only Berthot knows how or when the trees appear, the spaces between them falling back into distance, their broad bases rooted in a lattice of lines. As the image of the forest grows on the page, the grid is broken into here and there, shaded over and in places erased. So in all the drawings we witness metamorphosis, geometry turning into place, the flat grid becoming distance and depth, ruled lines transforming into the organic, flowing lines of the trees. We are presented with his working process. It is as though his thinking and his imagining are diagrammed together. It is as though the particulars of view and viewpoint are projections of some deeper order, parts of a greater and more extensive whole: "Outlines and surfaces become transparent... causes and spirits are seen through them."

A SPACE YOU COULD LOSE YOURSELF IN

It is now six years since Berthot left the city. His new studio is on the fringes of an oak forest, near a disused quarry. Not long after he got there he began to clear brush and to open vistas among the trees – each oak felled, an act of drawing. There are many windows in his studio. He does a lot of looking.

In the painting called *Before Yeaple Path*, the massive tree trunk is to the right of center. Light, as from the head-lights of a car, falls on the trunk at a point just below the spreading of its branches. Some light spills past the tree to the wood beyond it. Everything else is darkness. The tree has an overwhelming presence. It stands over against us immovably, yet it is altogether alive. It is like a body. The splash of light that models its muscular surface is a momentary intrusion. It is also the condition of our seeing it.

These are profoundly romantic paintings in the sense that aspects of the natural world are recognized as "organs of feeling," in Constable's phrase. These great trunks give us back something that we recognize in ourselves. Yet there is nothing expressionistic here, nothing leaks into pathos or mime. There is just the vertical solidity of the trees, close to, wrapped in mysterious darkness.

The newest paintings of all signal another change. In them Berthot has drawn back, concentrating on the middle distance, allowing a foreground and visible areas of sky. They are traditional landscape compositions. *Meadow's Edge* [Fig. 9], with its dark *repoussoir* on the right, and the shallow zig-zagging pathways that lead from the foreground to the horizon, is structured on principles that go back to the seventeenth century.

There is a strong flavor of retrospection in all these paintings, and not just because of their dark all-over tone

and their traditional composition. Their surface is very different from the pictures that preceded them. The frontal immediacy of the earlier paintings was augmented by the paint itself, the movements of the brush. The trees were drawn and modeled in clear-cut declarative strokes, working forward to the front of the canvas from a dark ground. In the latest paintings the dark ground is still in evidence, but the paint is thinner and transparent and applied in scumbled or glazed layers and the surface seems to dissolve and fall back into darkness that cannot be measured. As the eye explores the layers that shadow over the lights, it seems that Berthot's musing over depth and darkness and invisibility becomes present in the paint itself.

These pictures raise all sorts of questions. What kind of pictures are they? Easier to say what they are not. Clearly, they are not ironic appropriations. They are far too self-contained. There are no margins, no sidelines from which to play the knowing spectator. To enter them at all is to be absorbed in their world. They are wholeheartedly what they are. Are we then witnessing a conversion, a rebuttal of earlier heresies à la de Chirico? Absolutely not. However great the surface contrast with his earlier work, there is a continuity of feeling that overrides. The snake is, after all, the better metaphor than dump truck or butterfly. We are in the presence of the same vision, worked through in a new key. Berthot is invoking certain of his forbears – Inness, Ryder, perhaps others less obviously, visionary solitaries with whom he claims kinship.

Auden remarked somewhere that art allows us to break bread with the dead. Berthot has always been frank about his debts and affiliations. Generosity is one of the things that has made him a great teacher. Many of the titles of his pictures have been dedications. One of the darkest and most numinous of the new paintings is called *Approaching Night*

(for Ryder) [Fig. 10]. A silvery, ghostly tree stands alone under a brownish sky. The last trace of day shows as an orange gleam in the horizon. High in the sky overlooking the tree is a passage of thicker color that floats in an ambiguous relationship to the brown glazing of the sky. It could be a cloud, or it could be some presence that looks down in inscrutable concord with the dark land below. The painting is a remarkable statement of time and place experienced as an image of solitude – and of brotherhood across the years with an isolated and completely independent mind.

Catalogue essay to an exhibition:
"Graham Nickson: Dual Natures"
Frye Art Museum, Seattle
May 12–July 16, 2000

YOU CAN THINK of all Graham Nickson's paintings as representing a stage. Our position as viewers is in the seventh row center of the orchestra. The central axis of our viewing dominates every aspect of the picture. It is reinforced by a ruler-straight horizon (*Georgica Bathers*, 1984–96) [Fig. 11], or by a spread towel that defines the plane of the foreground (*Nexus*, 1984–94) or by the perspectives of tire tracks or boardwalks that lock our viewing into position.

The frontier between the ground plane and what rises up behind it – typically the sky, but sometimes the wall of a building – will be clear-cut, stated with schematic clarity. Usually this hinge between "stage" and "backdrop" makes a key division of the picture, sometimes bisecting the short side of the canvas, sometimes making what looks like a golden section. These ratios will be developed elsewhere, in the placement of figures and in the division of the various fields of color.

What happens on the "stage" itself is marked by extreme formality. Although we tell ourselves that the figures are "bathers," the word feels a bit too fun-loving for these disciplined, self-absorbed athletes who do impeccable headstands, raising their limbs with such perfect control. These are not scenes of casual frolic: a woman stands rigid, her

arms upraised, pulling into a sweater that makes a heavy red triangle over her head. Her knees and the muscles of her shoulders are tense. She occupies a position at the dead center of a double square canvas, $8' \times 16'$. Her chin, all we can see of her face, rests in line with the waterline, which itself cuts the painting in two horizontally. The rigid formality of her pose is equaled by the formality of her placement in the picture and the formality of its divisions.

The figures are naked or nearly so. But there are props that they work with, clothes that they pull on or step out of, towels, the A-frame stands that lifeguards perch upon. In a number of pictures, a wooden footbridge features as a kind of framing architecture, offering different levels for the figures, rough-hewn echoes of the marble balustrades and staircases that divide and complicate the spaces in Veronese's grand compositions.

This geometric world is presented to us without distortion, without a sense of geometry being imposed as a stylistic manipulation. That is the point. That is why the metaphor of the stage comes back again and again in our viewing. It feels as if the figures are superbly, meticulously controlled actors, finding their places to a hair's breadth so that the geometry of their placement and action is revealed to us only from our place in front of the stage.

At first sight these paintings are declamatory. Their aggressive, emphatic color, their muscular structure seems to promise vivid expression. But they are deadpan. This is their oddest feature. As depictions they withhold. For all the warmth of the sand, the bathers stand in frozen silence. On the other hand, something is going on round about these pictures. They are asserting an allegiance to a pictorial tradition and without irony or reservation, claiming a place in a line that would include Puvis, Degas, Seurat, Gauguin, Cézanne, Matisse – all of whom saw themselves as belated

tyros of the Great Tradition and all of whom recruited bathers as neutral, secular stand-ins for goddesses and heroes. This is the measure of Nickson's ambition.

Born in 1946 in Lancashire, Nickson comes to London and is trained in a particular discipline of drawing from observation. It is a discipline devoted to unprejudiced looking, suspicious of expressive subjectivity, averse to anything arty. His training takes. Much is determined by it. In London he learns the great collections like the back of his hand. A brilliant student, he goes to Italy in 1972 with a Prix de Rome. He is in the footsteps of generations of northern artists going south. Now the wonders of Italian painting come back to him in the context of southern light. As if searching for an antidote to the austerities of his northern background, he paints scores of studies of sunsets and sunrises, exploring areas of his palette that he had hardly dreamed of and, at the same time, breaching interesting taboos. Sunsets?!

Is it possible that, pondering the course that his own development might take, he found himself paraphrasing the slogan said to have been written on the wall of Tintoretto's studio, "The drawing of Michelangelo, the color of Titian." How would such a paraphrase have gone? The drawing of the Peckham Road and the color of a sunset over the Bay of Naples? That, at any rate, would be one way of putting the program of these vast compositions, which he began to show after his move to America and which he is developing still.

Perhaps something like that is still running in his mind. He has always shown his drawings on equal footing with his paintings, as if offering them for side-by-side comparison. Many of the drawings are extremely large and worked so heavily that they read at the same distance as the paintings. There is nothing tentative about them. They could be said to function like the paintings. The chiaroscuro of charcoal and paper allows for more abrupt modeling, more rugged

geometries of form and, in some cases, for more unified light. So setting the two side by side, drawing and painting is not, as it might be for many painters, to say something about the formation and process of the painting so much as to rehearse before us one of the oldest and densest of studio arguments: black and white or colored? Florence or Venice? – the very argument that Tintoretto had challenged with an impossible synthesis.

His color is extreme. Even in the watercolors that he has been making in the last few years, when he has again been working directly from dawns and sunsets. Here he has had to come to terms with the disobediencies of both the motif and of the medium. Perhaps for this reason the watercolors have a warmth and an unpredictable sensuality that the acrylics seem to exclude in the interest of a timeless order. The rising sun won't keep still for him nor will the water-color submit meekly to his intentions. Even so, he drives it to the limit, forcing it to exchange its transparency for dense saturation and its watery flow for strong contrasts and chunky, incisive drawing.

Indeed, in all his work there is a sense of something being pushed to a limit – a limit of saturation, of tonal contrast, of dissonance. What establishes the limit is a certain conception of light. This is where the line is drawn beyond which color would run berserk. The light is always violent, whether the blazing, dangerous noon light of *Atlantic Bathers* (1976–82) or the troubled sunset light that turns skin to the color of flame and shadows on the sand to an electric purple. And he will set off these flaring discords against pitch-black clouds or ponds of indigo that stretch the length of the picture.

The metaphor of the theater comes back. This is light as spectacle, a moment of transformation when for a few min-

utes the setting sun works alchemy on our surroundings and familiar things are transfigured by light colored to breaking pitch. It is when I recognize this moment of theater in this color that the altogether contemporary dialectic of his pictures comes clear to me, and I am able to read in their tight geometries something fragile, as finely balanced as the bather's perfect handstand – and, so the light tells me, as transient.

Observation: Notation

Catalogue essay to an exhibition of the same name
New York Studio School
October 17–November 13, 2000

Nothing is more strange in art than the way that chance and materials seem to favor you, when once you have thoroughly conquered them.

JOHN RUSKIN
The Elements of Drawing

Although there is something arbitrary in our notations, this much is not arbitrary – that when we have determined one thing arbitrarily, something else is necessarily the case. (This derives from the essence of notation).

WITTGENSTEIN
Tractatus 3.342

WHEN GRAHAM NICKSON invited me to suggest an exhibition for the Studio School, I thought I would indulge myself with a sort of autobiographical sketch and bring together examples by artists who were of particular importance in my own formation. Some of the people here were my teachers and friends – Coldstream, Martin, Stokes. My only meeting with Bomberg was on a crowded tube train from Elephant and Castle to Hampstead, but he was such a strong presence among people that I saw a lot of that it feels as if I knew him. In the 1950s and 1960s I had long conversations with Giacometti and John Cage. For the rest – for

years I copied and read Sickert, treating him like the *How To Do It* books that he loved. I copied my first Van Gogh when I was twelve and saw the big exhibition in Paris in 1938. I first saw Klee at the National Gallery in London in 1946. The first Mondrian exhibition I saw was in The Hague in the mid-fifties. Some of his writings, I already knew. As to the Antique Torso, I don't know what to say except that Greek sculptural form has haunted my imagination ever since I first saw photographs of the Elgin marbles at the age of eight.

There must be painters who have never had to ask themselves "What kind of painter am I?" but it is hard to imagine. It is a specialized and particularly painful version of the question that any individual has to ask in their quest for self-awareness. You try to answer it in terms of affinities but that is double edged: where does warm comradeship end and the chill of exclusion and envy begin? And what is to be made of luck, good or bad, and its part in events that above all things you want to be responsible for? If only learning were as straightforward in our game as, we imagine, it must have been in the past. But learning itself is ambivalent. On the recto side of the coin, the welcome lesson is felt as nourishment, aspiration, empowerment; on the verso as second-handedness, impotence and loss of autonomy.

It is a post-Romantic problem and a major theme in the story of modern art. It can't be an unconnected fact that for the first half of the twentieth century painters were preoccupied with the elements of painting, its grammar and syntax, its parts. Stripping down was tonic. "When difficulties stopped me in my work," Matisse told Apollinaire in 1907, "I said to myself 'I have colors, a canvas, and I must express myself with purity, even though I do it in the briefest manner by putting down, for instance, four or five spots of color or by drawing four or five lines which have a plastic expression.'"

SICKERT 1860–1942

Walter Sickert started life as an actor. He studied with Whistler and was a friend of Degas. He was a wit and he loved to write, above all about drawing which he saw as the fountain-head. He defines drawing, with mock simplicity, as "The extraction from nature, by eye and hand, of the limiting lines of an object." Of course, lines don't exist in nature, but nor do words. Like words, lines were conventions, symbols with clear meaning. His theory of drawing was in the perspective tradition: you drew as if you could imagine the page as a transparent plane between you and what you were looking at. Drawing must be made at sight-size because this was the only way in which the distance between the drawer and the drawn could be particularized. Like Degas he thought the idea of painting directly was absurd. He painted from drawings and increasingly from photographs that he transferred meticulously and then painted at high speed in simple, clear-cut stages. He was insistent that a painting had more than one life – seen at a distance and seen close to.

Every mark he made as a draftsman is charged with wit. He was the best artist England produced during those years.

COLDSTREAM 1908–1987

When, in the 1930s, fed up with the dishonest mystique of avant-gardism, William Coldstream set himself to *really* do painting from observation, he took Sickert's transparent plane as his work place. But drawing had to be reduced even further, reduced to terms that could be proved. He approached the canvas like a cartographer, plotting the location of each feature within the vertical and horizontal coordinates of the canvas, measuring and re-measuring the

intervals as seen one-eyed from a fixed position. All thought of the overall image was postponed. The picture was expected to "accrue", an essential term, to take care of itself while he concentrated on the real business, which was verifi- cation. The image that in the end "accrued" had extraordinary weight and nobility, a grandeur of form and at the same time a mysterious openness. "Think of the canvas as a web," he once told me.

SEURAT 1859–1891

I remember standing with Victor Pasmore, another of my teachers, looking at Georges Seurat's *Le Pont de Courbevoie*, and trying with much screwing up of my eyes and standing back to see the wonderful granular surface of the painting as descriptive. "Don't bother about optical mixtures and all that balderdash," Pasmore barked, "Can't you see that he was mad about making dots? That's the point."

I came to see that if Seurat was mad about dots, Coldstream was mad about measurement and this too was the point. It made no sense to approach either of their eccentric systems of notation as transparent, to try to see "through" them to what they represented. The true weight of content in their work could only be approached in the notation itself and in their all-or-nothing commitment to it.

STOKES 1902–1972

Best known as a writer, Adrian Stokes was also a painter and poet. The essential theme of his writing on art was a distinction he made between what he called the carving approach and the modeling approach. He first formulated it in front

of buildings and sculpture of the early fifteenth century in Italy. He soon expanded the idea to include painting. He came in contact with Melanie Klein during the thirties and discovered extraordinary parallels between what he had been saying and the ways in which she was describing the stages of childhood development. His later writing is cast in the language of psychoanalysis. At its simplest, the carving-modeling contrast turned on the matter of how an artist related to the material – stone, clay, canvas, paint, and so on. The carver saw it as freestanding with its own inherent characteristics.

To the modeler it was raw material to be omnipotently shaped. It was the difference between a Donatello relief and a Bernini fountain, between the young and the old Cézanne, between Coldstream and late Bomberg. The best art in the carving mode was still and whole and looked back at you from a distance. The best art in the modeling mode eliminated distance and enveloped you, swept you away. Much of his later writing was about contemporary art and its relation to society and, although carving and modeling were still key issues they tended increasingly to interpenetrate rather than oppose their values.

Among a limited circle of artists and writers Stokes had a high reputation, but his work was little known by the public. Many people found his writing unreadable and he rarely showed his painting. He was self-taught as a painter. As far as I know he never drew.

KLEE 1879–1940

The first exhibition of abstract painting I saw was of Paul Klee at the National Gallery in London just after the end of World War II. What surprised me about it was the various-

ness of the work. A year or two later there appeared an English translation of the famous lecture that Klee gave at Jena in 1924, *On Modern Art*. Here he radically redefines the nature of a painter's will. He describes the elements of painting: line, value, color. Then he begins to develop a series of metaphors for the making of a painting. It was a process, like growth. The picture was organic, like a plant. It was like a building. It was like a journey. It grew in time, cell by cell, brick by brick, note by note, step by step. The painter's part was not to stand outside and observe; still less, to formulate grand expressive ideas. It was to be the agent of the picture's growth, the intermediary between nature and the elements of line, value, and color.

MARTIN 1905–1984

Kenneth Martin loved to draw from the figure and to wrest clear shapes from the complexities of the model and to find ways of drawing that ran counter to the anatomy-based Florentine ideal of figure drawing. "Objective" was one of his key-words. It meant the hard opposite of soft artiness. When, inspired by Klee and the Constructivists, he abandoned representation, "objective" meant inventing rules and playing by them. They were not rules of taste or aesthetics but rules of development, numerical permutations to begin with, played out in line or in given materials, brass washers or store-bought copper rods. Later he injected chance into these games, plotting structures with random numbers. Chance, courted within strict formal frameworks became his Nature – the mysterious and infinitely various Other that he made rendezvous with in as many different situations as he could devise.

BOMBERG 1890–1957

Coming from a poor Jewish emigrant background, David Bomberg first studied with Sickert. Then he went to the Slade where he learned to draw like a Florentine and began to win prizes. This was in the years just before the first World War. While still at art school he began to paint semi-abstract figure compositions of incredible precocity and daring. By the time he was swept up in the war he had a reputation as a "modernist." The war destroyed the optimism and utopian energy that had fired his abstractions. He began to paint directly from nature and continued to do so until the end of his life, often under extreme conditions. As time went on his painting was based not so much on optical observation as on tactile empathy. He painted as though seeing were touching. Oil paint and charcoal, the most malleable of materials, became the medium of his "seeing" although reaching, groping, stroking, kneading would be better words. He described his goal as "the spirit of the mass," a phrase that inspired his students of the 1940s, among whom were Frank Auerbach, Leon Kossoff and Dennis Creffield. Manipulated paint in all its plasticity allows for the double reading of the head in *The Man* (1937). The paint becomes the imagined form, a form so vividly internalized that the distance between himself and the imagined head seems to vanish.

Bomberg was shamefully neglected during his life and, he died in poverty. He never saw an exhibition devoted to his later work.

FEEDBACK

As a student trying to understand what was involved in painting from appearances, it was natural to look at the

(then unfashionable) Impressionists. One thing that was obvious was that the *plein-air* enterprise set in motion a specific kind of feedback, a reciprocal effect between the drive to represent and the effect on the eye of the results. Examples: poplar leaves in sunlight or reflections broken by ripples or falling snow. Each of these phenomena provoked a certain kind of brush stroke, a responsive broken touch. This touch, seen on the canvas, had an effect on the eye that was more than merely descriptive but had its own, almost autonomous energy.

Consider the ink drawings that Van Gogh made in the summer of 1888. They go through three distinct stages. The first group is worked with the aid of his perspective frame. Then, on a five-day outing to Ste Maries-de-la-Mer he left the frame behind. "I want to get my drawing more spontaneous, more exaggerated." In all these drawings he is using ink lines to place things in perspective and also to identify – to make rocks look like rocks, vines like vines, thatch like thatch, stubble like stubble. Everything suggests a sympathetic notation. Then, towards the end of summer he starts a sequence of drawings from his paintings. These are addressed to painter-friends, Émile Bernard, John Russell, Paul Signac. Now the notation that he had evolved in the interest of description explodes into a new key. No longer closely tied to topographical fact, the whole lexicon of slashes and curlicues and jabs and dots combine in an autonomous chorus. Notation, it seems, generates his subject, not the other way round.

An equally astonishing interaction between motif and notation happens in Mondrian's drawings between 1910 and 1915. He is moving tentatively towards the grid, groping along a path that will bring him in the end to his irreducible theme: vertical and horizontal relationships. En route he draws the church tower at Domburg, half-demolished buildings in Paris, scaffolding, the scintillating sur-

face of the sea, the sea cut by the vertical of the pier. Each step takes him farther from representation and at each step his chosen motif supports him and offers interpretations of his journey.

298

CAGE 1912–1992

I have no thoughts about the importance of John Cage's music – that is for others – but I know I was haunted for years by his stories in *Silence* and the questions they posed about frames. "Is the sound of a truck passing music?" goes the famous question. What would it entail to hear a truck passing while you were listening to music and to incorporate the sound into the music? First, you would have to redraw the frame around the music. This would be like manipulating a figure-field relationship. Second, you would have to revise or even suspend all thoughts of consistency and of the if-this-then-that-ism that seems to be a necessary part of recognizing any kind of structure. This leaves one faced with an anxious vacuum. Third, to fill that anxious vacuum with the thought that it is your own perceptual processes that would be doing the structuring, not the composer's art and not the truck's driver.

With this in mind, take another look at Pollock or late Mondrian or Monet's *Nymphéas*.

GIACOMETTI 1901–1966

It amused Alberto Giacometti's daemon to endow various everyday oddities of visual experience with the disturbing force of hallucination. The fact that things get smaller as they go away; that noses stick out; that a person could look

at you and then turn away, or cross the street, and still be the same person. These were endless half-threatening mysteries. Drawing could control them up to a point, but not cure them. Pencil and eraser, coming and going, could make the transparent rays of vision opaque, the abyss palpable. His triumph was to find distance in sculptural form. It was an outrageous achievement. The nostalgia of distance and the bite of presence fused into each other against all sense, and left standing, whole, still, timeless.

Coldstream admired Giacometti greatly, though the surrealist element brought out a dry smile. Giacometti was interested in Coldstream, admired the matter-of-fact intensity, found the space *ordinaire*.

My first and deepest thanks go to Ruth Miller Forge 301
who, at every moment in the long process of this publication, offered me encouragement and support in all the choices that had to be made. I would also like to thank John Dubrow, who, at a crucial moment, drew the attention of David Yezzi at *The New Criterion* to this project. Rebecca Hecht, Associate Editor there, has made the process of bringing the materials here to publication form easy and pleasant. I am deeply grateful to her.

Many other people have helped me in other ways. The late Bruce Laughton shared his memories of Andrew Forge and passed on to me a listing of articles, signed and unsigned, that Forge had written in his earliest days in London. Sarah Sands and Joseph Ryan kindly gave me copies of the compilations they had made of his many later writings, confirming me in the choice of his works that I had made. David Fraser Jenkins, as ever, was a sympathetic reader of the writings, by Forge and myself, that I entrusted to him. I would like to thank Nicholas Fox Weber and Anne Sisco for help with the material here on Josef Albers. I am also grateful to Lucas Elzea for allowing me to use the image of Andrew Forge that appeared in his film *Andrew Forge. A Portrait.*

Here at Bryn Mawr College I would like to thank Lisa Saltzman, Christiane Hertel and Steven Levine, with whom I discussed this project. Margaret Kelly helped me at many moments with computer questions, large and small. And last but not least I would like to thank Johanna Best who worked hard and long to reformat into a consistent computer form the many different texts in which Forge's writings had originally appeared. Without her this enterprise would have foundered.

I am also very grateful, now as in the past, to the Faculty Research Funds at Bryn Mawr College, which supported the costs of this project.

302

A Note on the Type

Observation: Notation has been set in Kingfisher, a family of types designed by Jeremy Tankard. Frustrated by the paucity of truly well-drawn fonts for book work, Tankard set out to create a series of types that would be suitable for a wide range of text settings. Informed by a number of elegant historical precedents – the highly regarded Doves type, Monotype Barbou, and Ehrhardt among them – yet beholden to no one type in particular, Kingfisher attains a balance of formality, detail, and color that is sometimes lacking in types derived or hybridized from historical forms. The italic, designed intentionally as a complement to the roman, has much in common with earlier explorations in sloped romans like the Perpetua and Joanna italics, yet moderates the awkward elements that mar types like Van Krimpen's Romulus italic. The resulting types, modern, crisp, and handsome, are ideal for the composition of text matter at a variety of sizes, and comfortable for extended reading.

SERIES DESIGN BY CARL W. SCARBROUGH